CG GALAXY

II Top Chinese CG Artists and Their Works

Huoshen CG Workshop

CYPI PRESS

CONTENTS

PREFACE 005

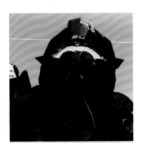
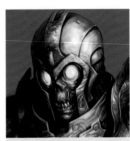
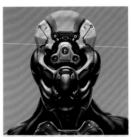
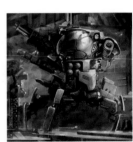
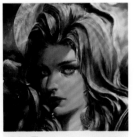
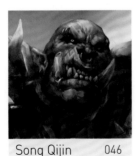
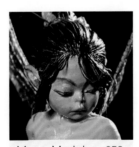
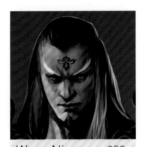
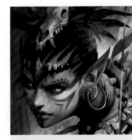
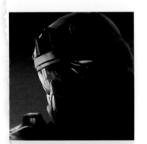
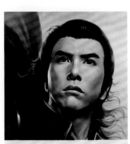
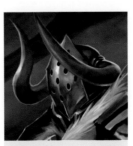
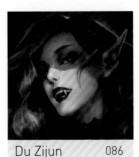
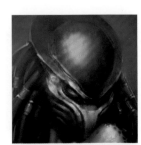

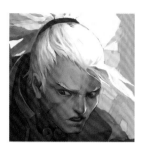
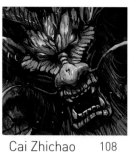
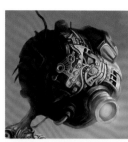
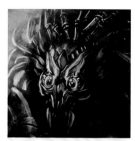
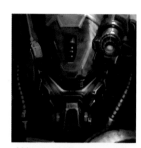
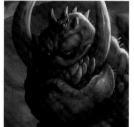
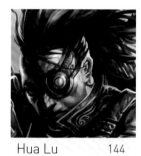
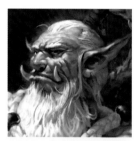
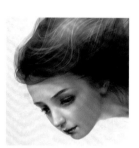

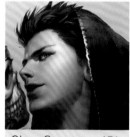
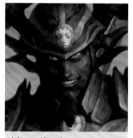
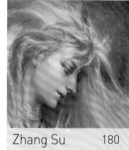

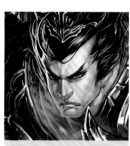
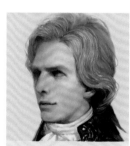

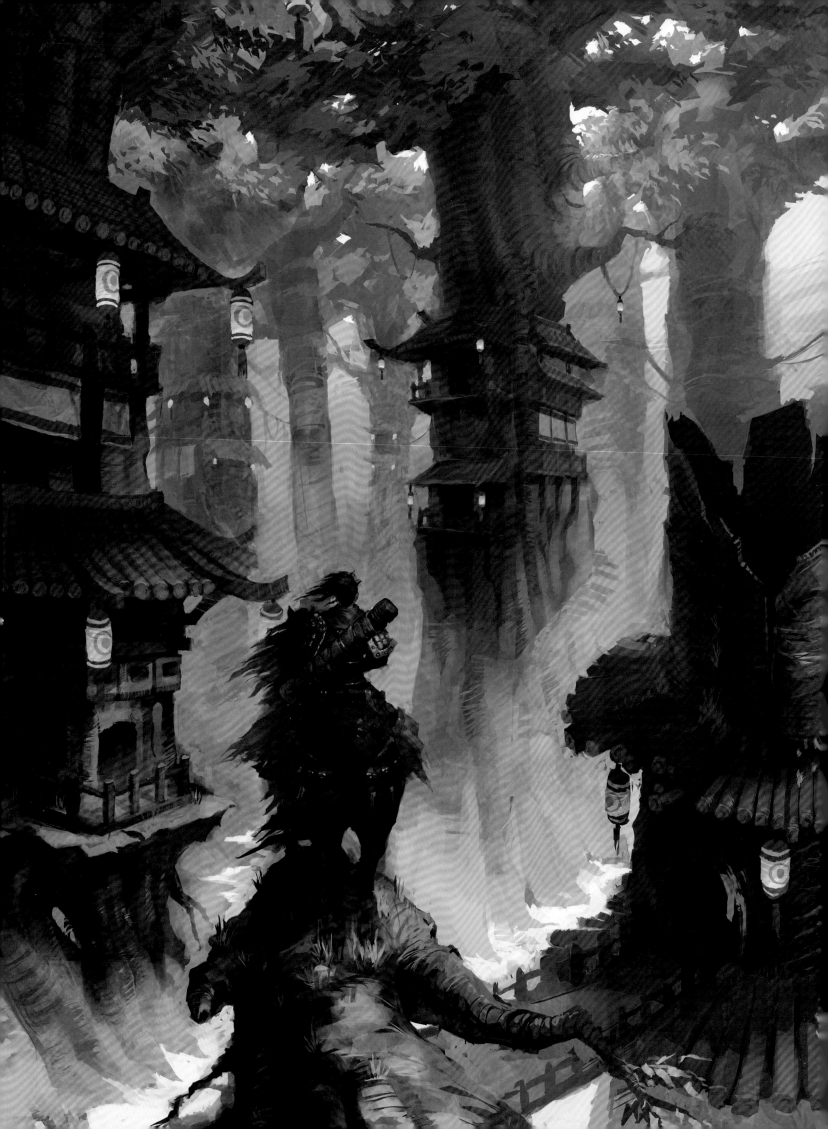

PREFACE

"*CG Galaxy II: Top Chinese CG Artists and Their Works*" was jointly planned and edited by CYP International (CYPI) and Huoshen.com. This publication, which has taken more than one and a half years to prepare, aims to display the best and latest work by Chinese CG artists.

Thirteen years ago, Huoshen.com was still just the Huoshen Island Community. I define it as our "lonely island" period, as few Chinese artists were engaged in the CG industry at that time. In 2000, we still submitted our work via email and waited for bloggers to update Huoshen portfolios with 64K bandwidth connections; none of us imagined that our community members would become important designers in the international movie and game industries.

We started conducting research and analysis in 2006 to help young digital arts students. Through this process, I came to understand the "10,000-hour Rule" evidently applies in the field of art. For many beginners in digital art the basic foundations, creative tools, learning materials, vision and other fundamental conditions are very similar. Many of the basic conditions, such as training, publication of work and social environment have become more fair and transparent. Considering the increasing equality of opportunity, the quality of output increasingly depends upon the time and effort invested. Perhaps improved access to opportunities has made the competition tougher compared to a decade ago, when simply painting and taking photos was enough to secure fame. Despite this increased competition, young professionals in digital arts have been given something more valuable—fairness.

I often talk with friends in the industry and we sometimes sketch out our ideas for the future. My conclusion is that in the context of increasingly free information flows, perseverant digital artists will be increasingly free to choose who to cooperate with or work for. Hopefully, they will have more free time and financial freedom if they work hard enough and are able to successfully attract followers. For this reason, I often advise digital artists to leverage their social network and media presence to establish their brand as soon as possible, to construct an extensive fan base, but also to explore and create their own unique styles. Every step is a step toward freedom.

I would like to dedicate this book to the painters who have never put down their brushes, to media platforms who support painters and all the people who still dare to dream.

Chen Changjiang
Founder of Huoshen.com

Li Jian

Screen Name: Foguang Puzhao (Universal Illumination of Buddha's Light)
Blog: blog.sina.com.cn/lijiancastle
Profession: Concept artist

栗
鉴

L
i

J
i
a
n

PROFILE

Li Jian graduated in 2008 and joined EA Shanghai in the same year. He moved to Beijing in 2011 and has worked in Zynga ever since. Engaged in creative work as an artist, he is a game fan and movie maniac.

INTERVIEW

When did you first get interested in art? What made you become a professional artist?

I started to show interest in art around the time when *Fist of the North Star* was popular. I had no formal access to art until middle school, when I chose a fine art school out of love for painting. It was then that I made up my mind to enter the game industry. I thought of giving up art during my training in traditional art, but fortunately, my passion for games and art carried me through.

Your works are marked with evident personal styles. Sometimes, it helps to accurately establish the flavor for a commercial project. How do you communicate with your clients?

My personal portfolio is suffused with my personal style, but as a professional, my personal style is not a panacea for every project and every client. Thus, I have to put myself in the clients' shoes and take care of their interests and the project. I have to think from their perspective and identify an art style that fits them. If clients already have explicit requirements, I will communicate with them to fully inform myself. I will creat work upon their requirements and hopefully present them something unexpectedly brilliant. I think this is also a source of pleasure for those engaged in this industry and a necessary capability for a concept designer. Looking at all my commercial work together, you might be fooled into thinking it was done by different people.

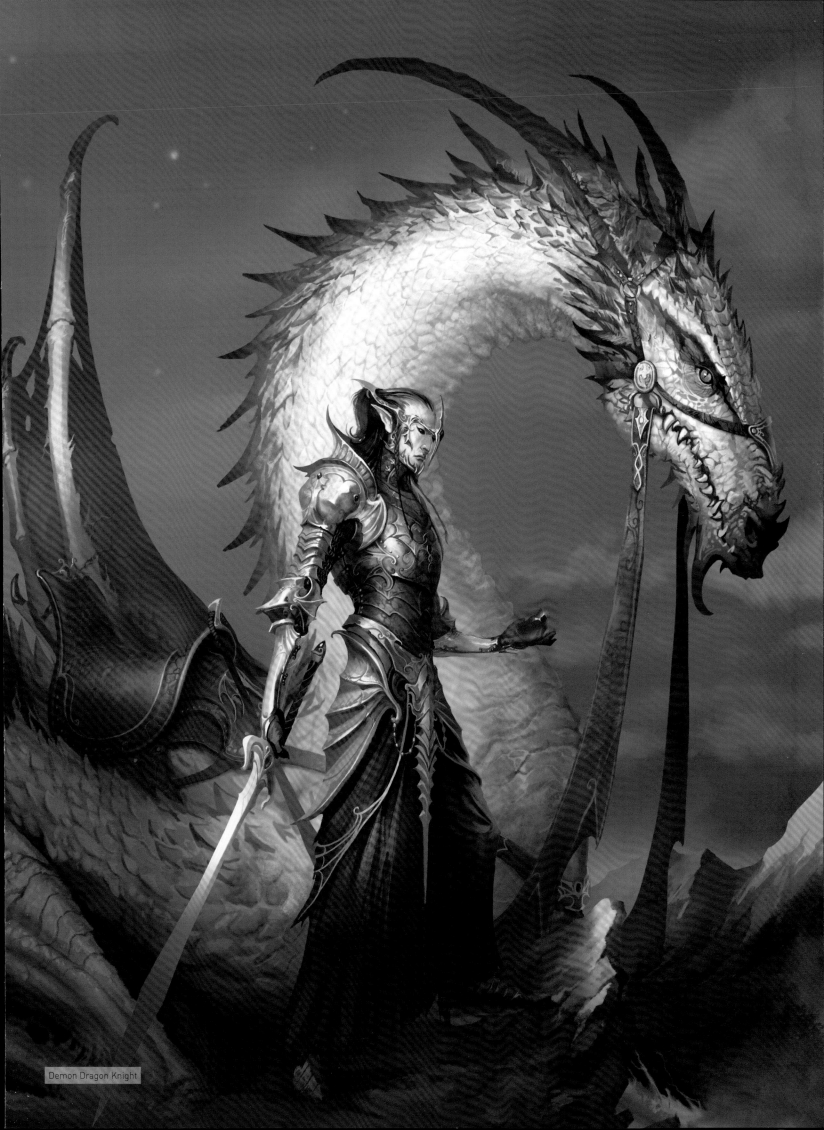

Demon Dragon Knight

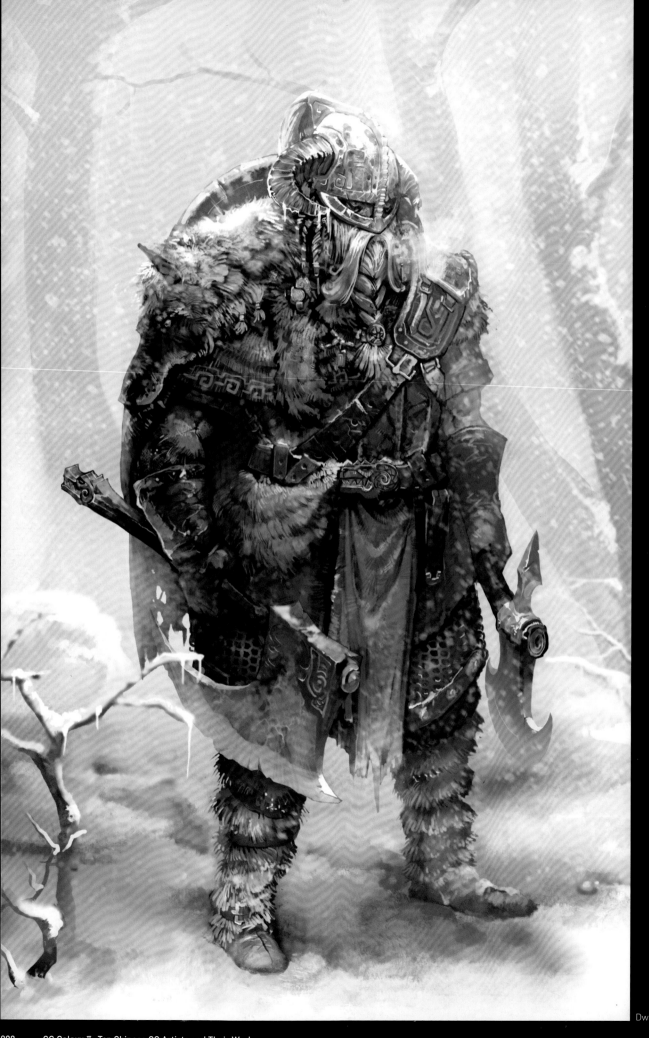

Dwarf Warrior

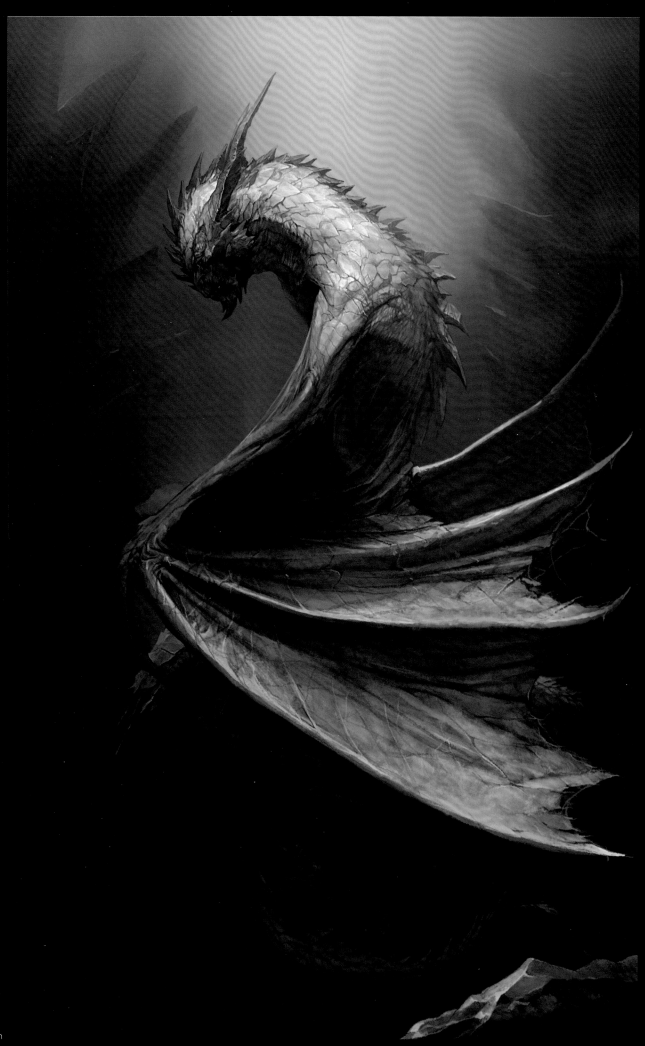

Dragon Man

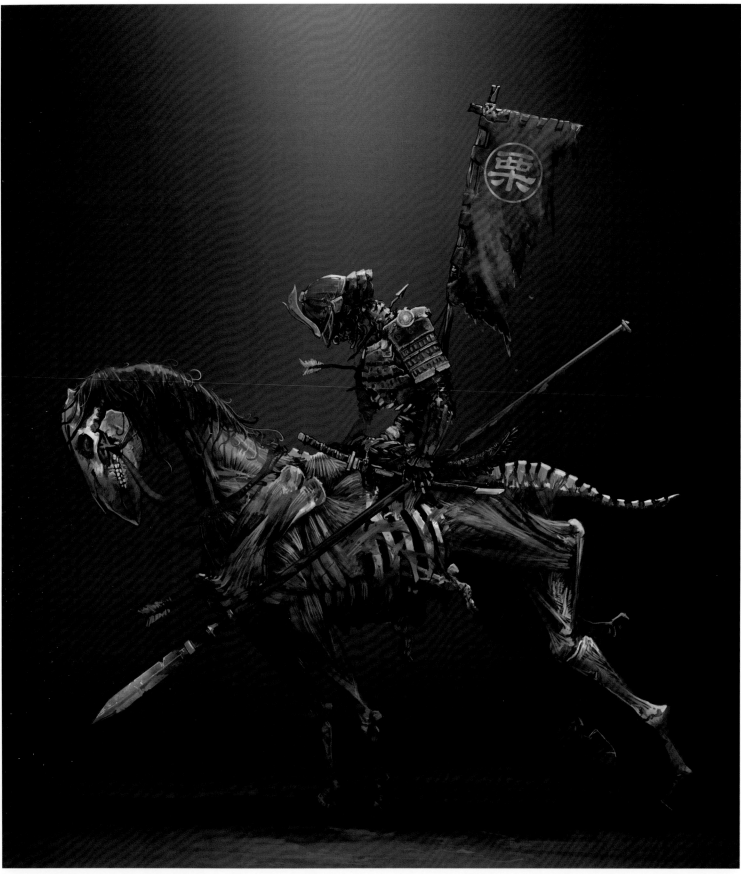

Zombie Cavalryman

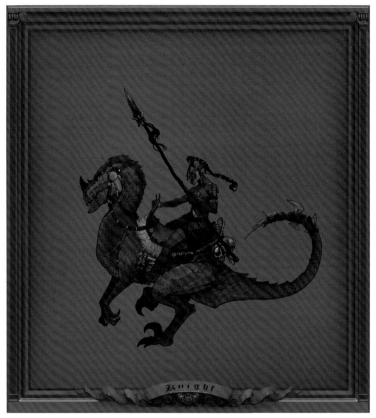

Nargacuga Cavalryman

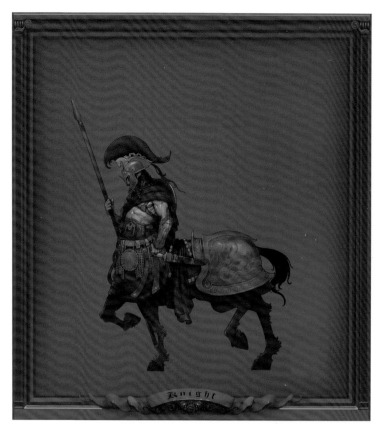

Centaur

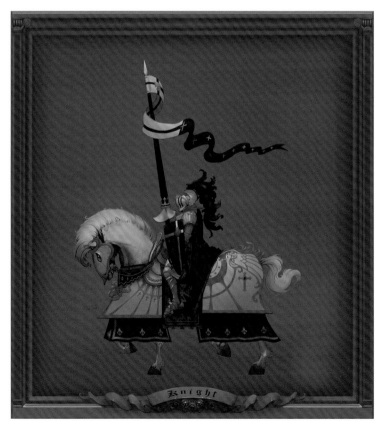

Cavalryman in White

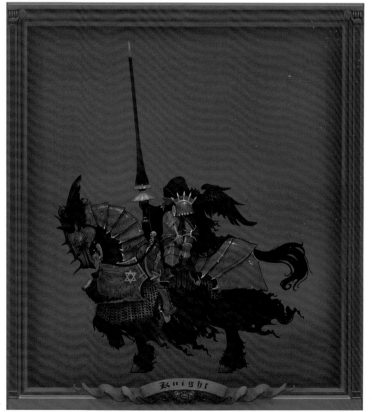

Cavalryman in Black

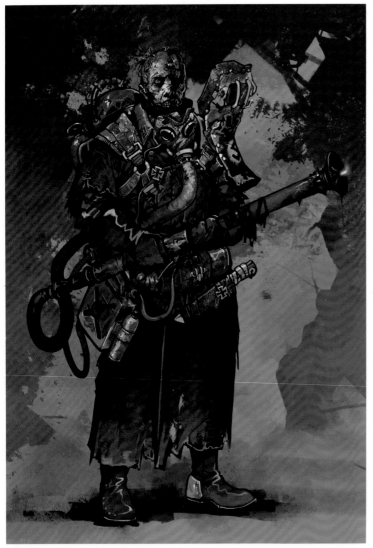

Empire's End—Flame Thrower Infantry

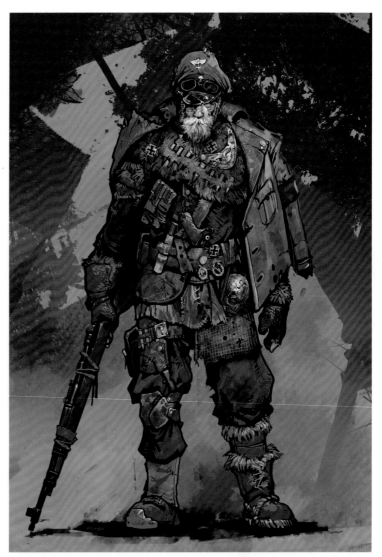

Empire's End—Sergeant

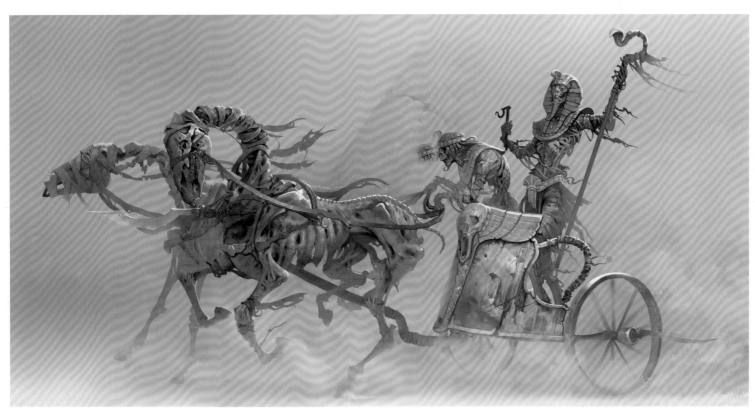

Mummy

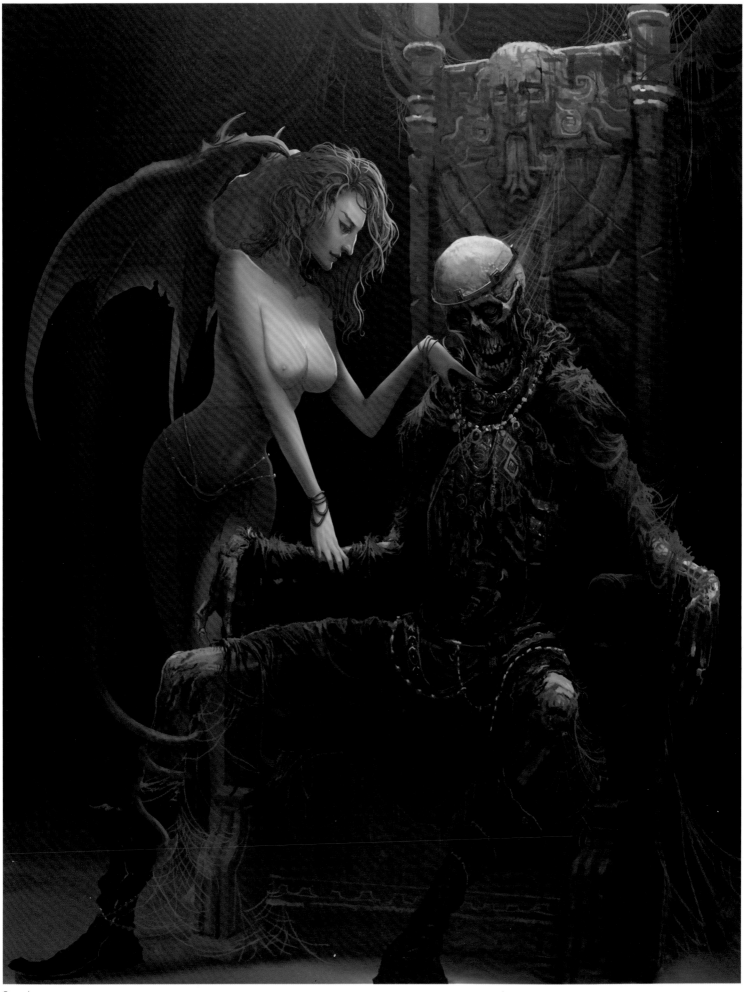

Succubus

张
欢
欢 Z
 h
 a
 n
 g H u a n

 h
 u
 a
 n

Zhang Huanhuan

Screen Name: Lanbzhh
Blog: blog.sina.com.cn/u/1525387824
Profession: Freelance artist

PROFILE

After entering the CG industry in 2005, Zhang Huanhuan established Moshen Animation Studio (literally "Demon & God Animation Studio"). He also worked as art director for FeelTV-Film Animation Co., Ltd., leader of the 3D team at Shanda Games and board member and technical director of CHING CHAK. Among other accolades, his work won the Best Work title at the Third China International Animation Exhibition and Championship at the China Original Game Contest. He was invited to the tour exhibition of the Lisbon Animated Film Festival in Portugal.

INTERVIEW

What do you think is the most important element in the creative process? What is of overriding significance in enhancing creativity?

I think the most important thing in the creative process is to focus less on results and learn to derive joy from the creative process. To me, there are no shortcuts to enhance creativity. It requires the long-term accumulation of resources and continuous improvement in aesthetics. Many ignore enhancement of artistic edification, which is a mistake. Technical problems are easy to address, either through training classes, books or online courses, but artistic edification can only be honed with the passage of time. Therefore, we should develop a habit of watching, listening and observing. A good piece of work is usually subconsciously sourced from real life.

What's your plan in the years to come?

I plan to publish a personal portfolio and then produce my own animation works. Of course, it will be a long journey to achieve these goals and will require continuous efforts. Objectives and plans are necessary to remain motivated.

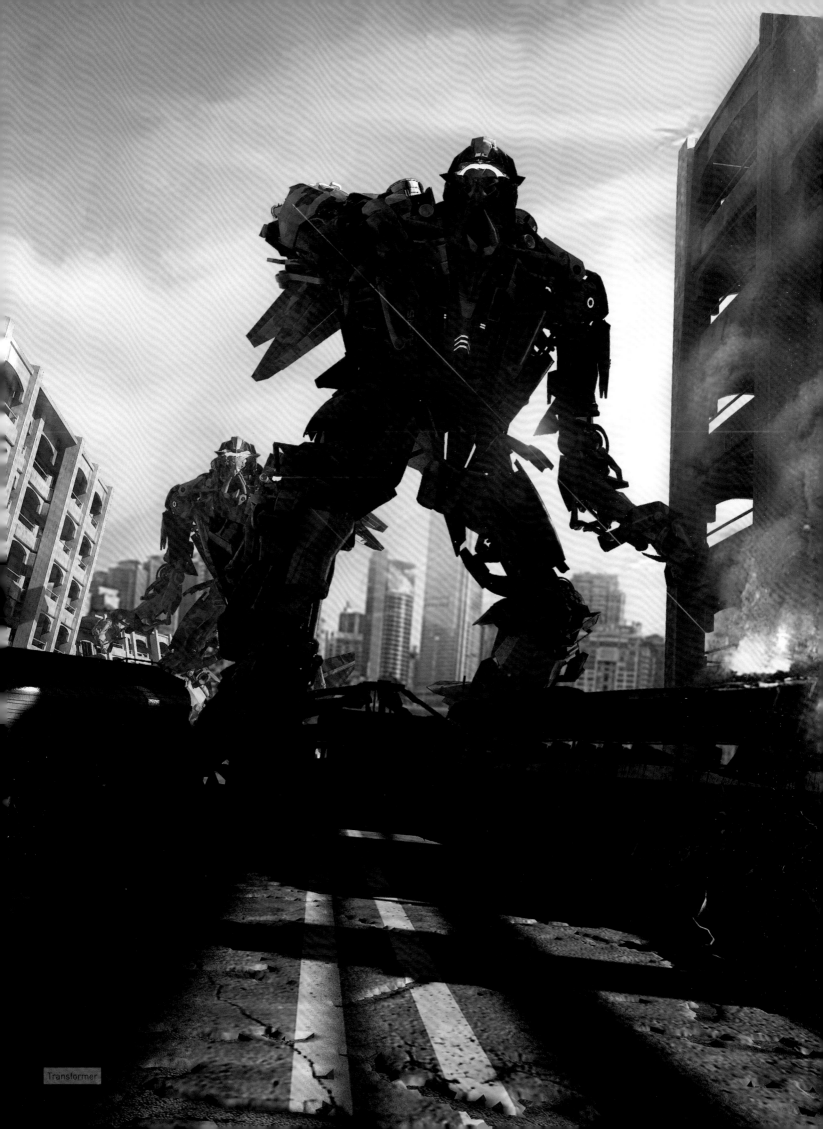

Transformer

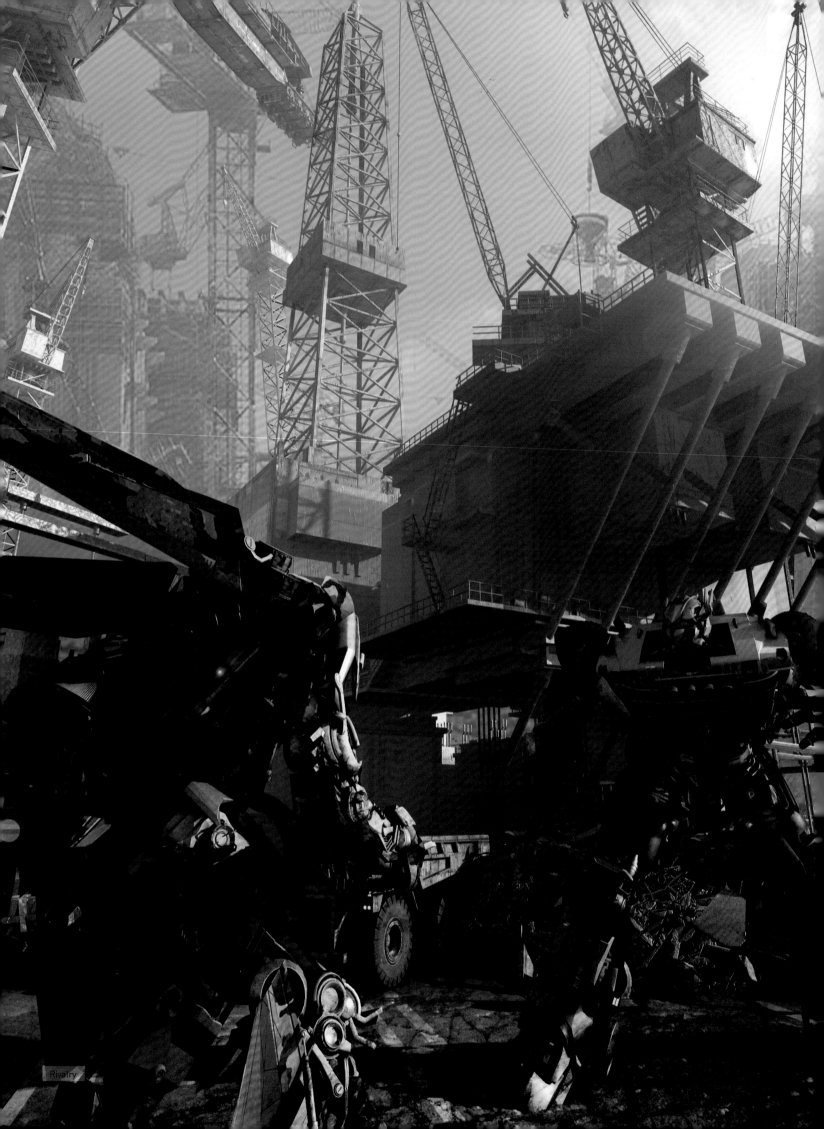

Rivatry

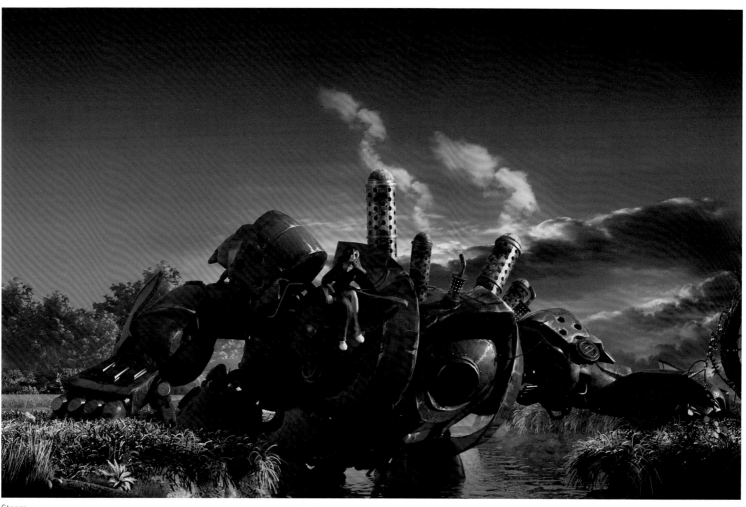

Steam

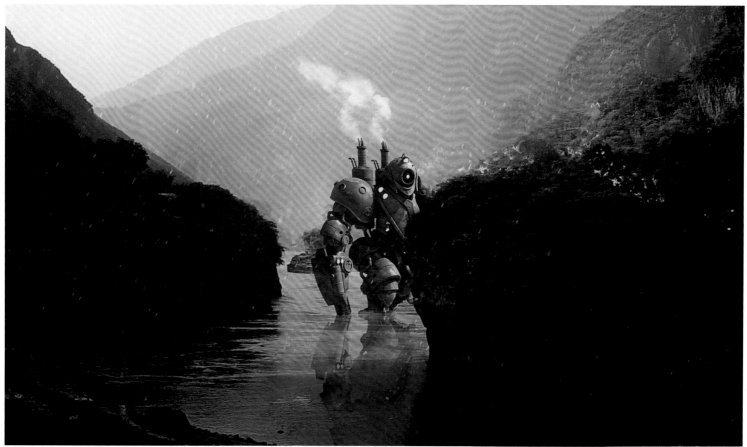

Wader

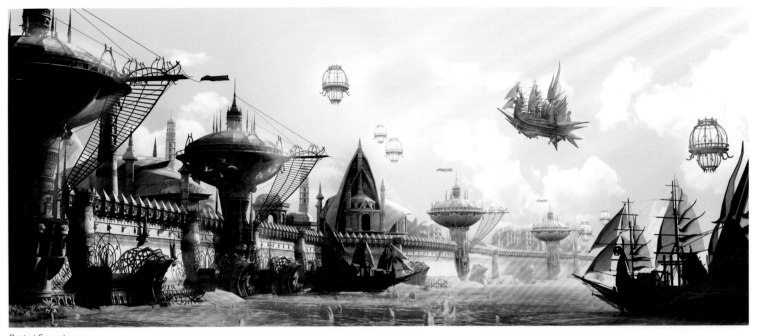
Port at Sunset

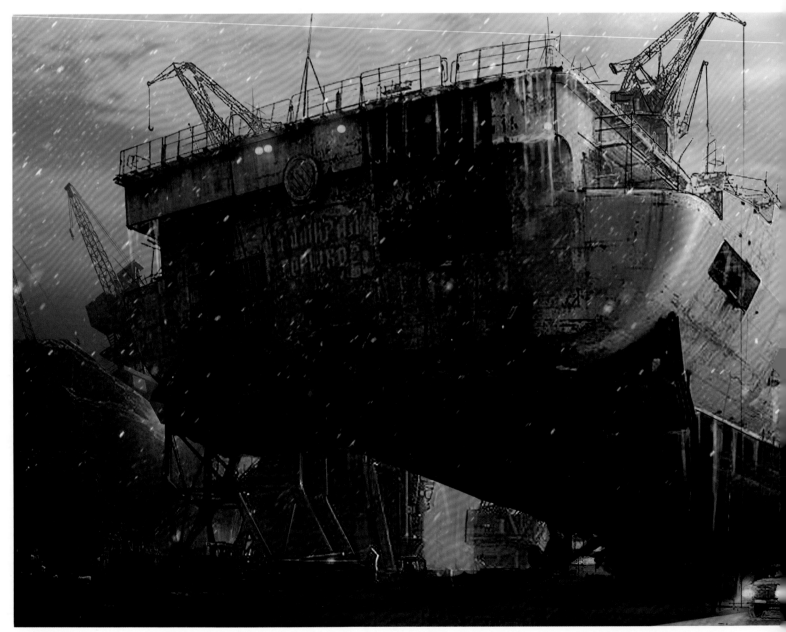
Frozen Port

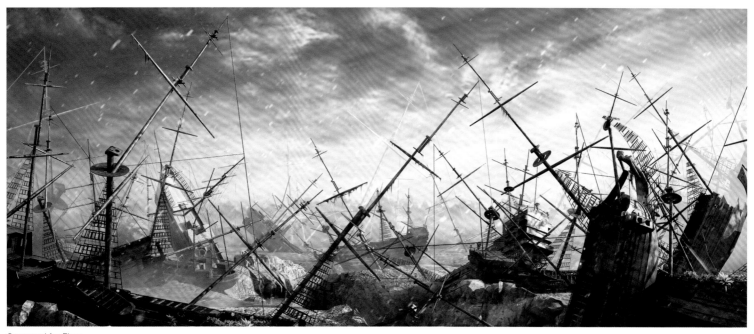

Graveyard for Fleet

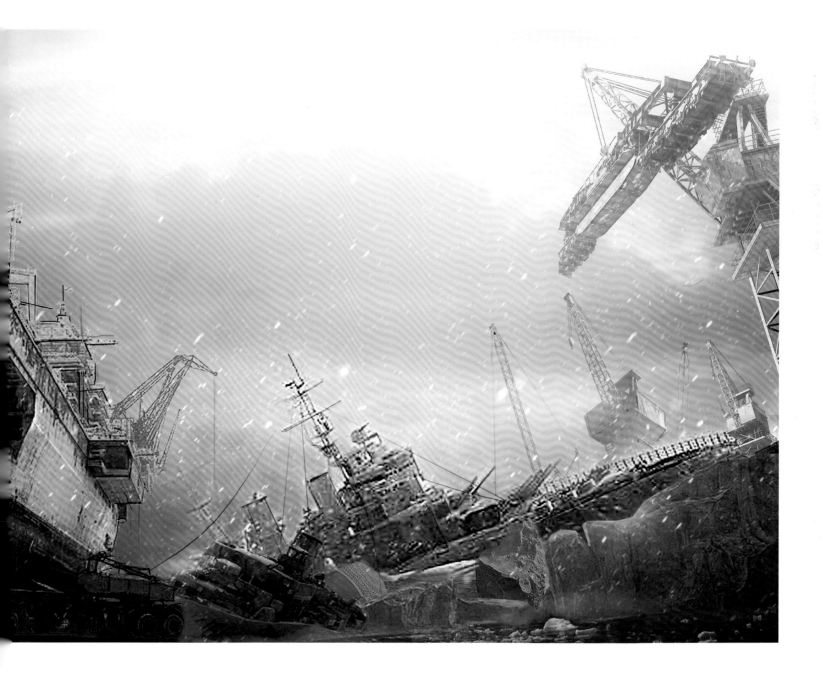

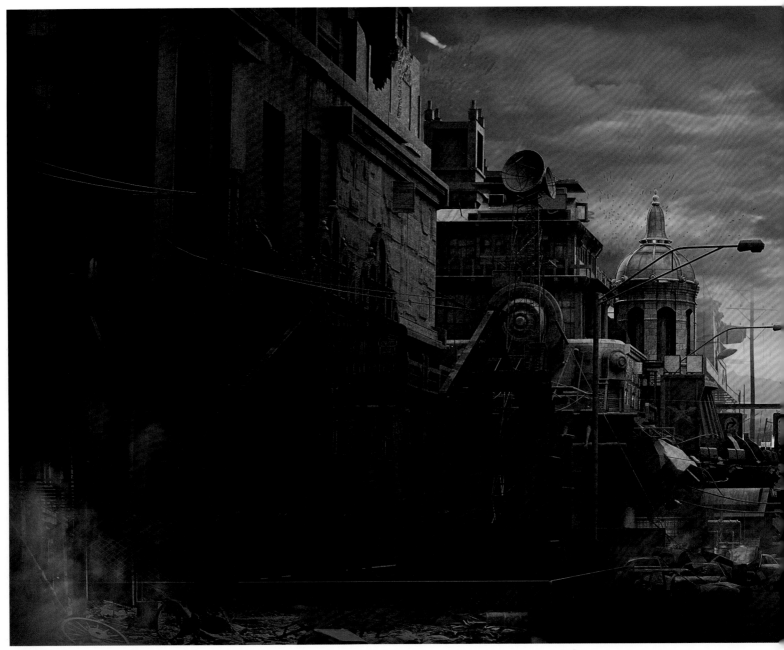

Street 01

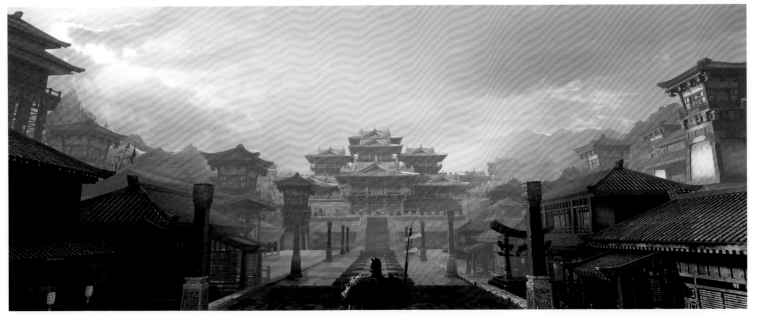

Xianyang Palace

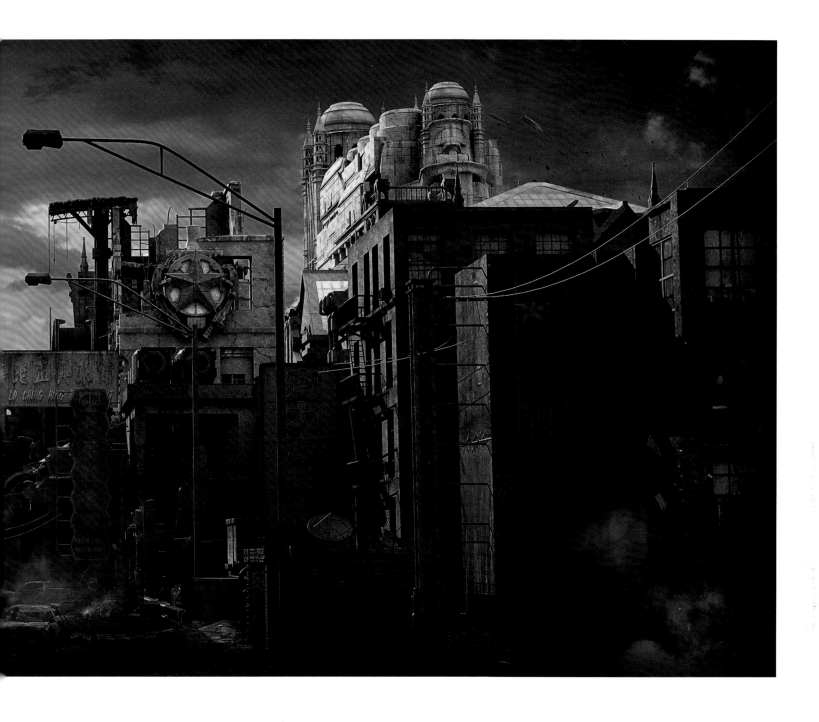

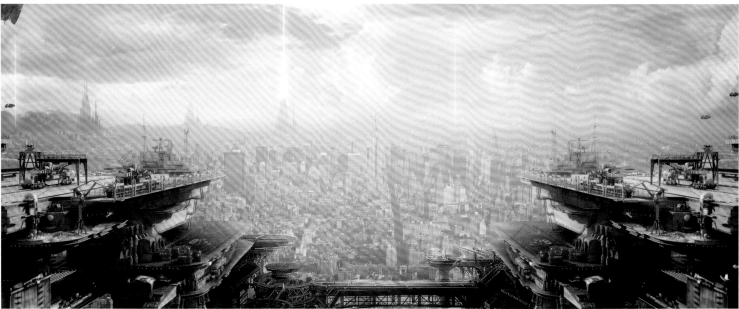

Airport 02

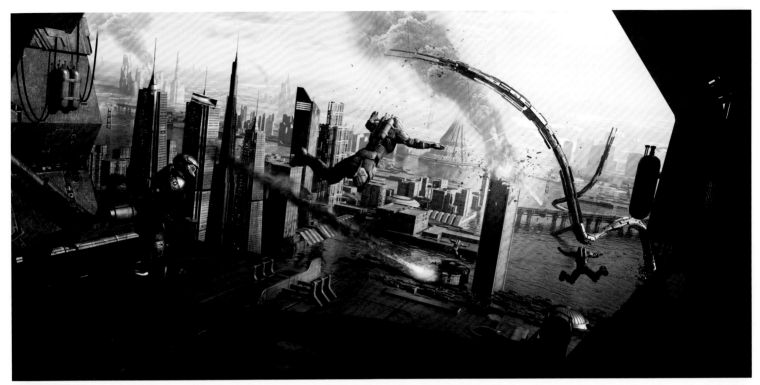

Leap Forward

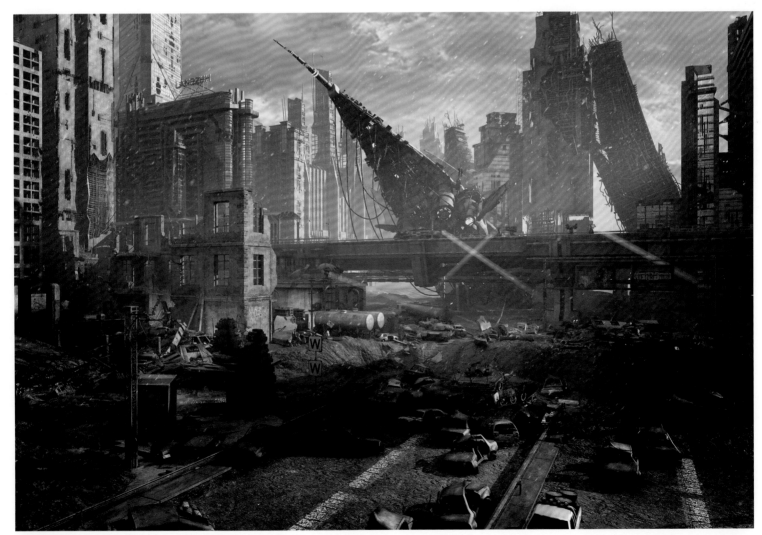

Tears from Heaven 01

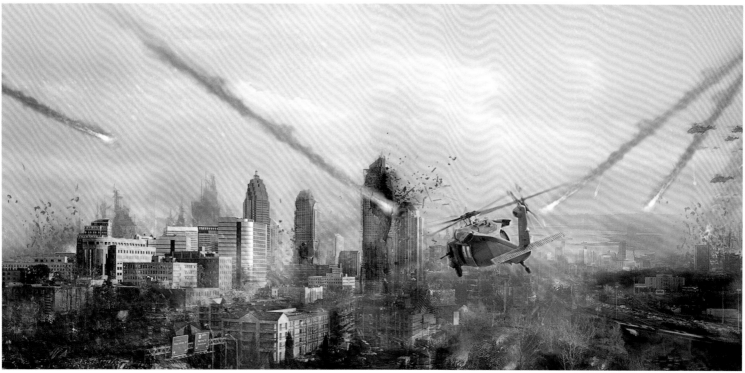

Conquer

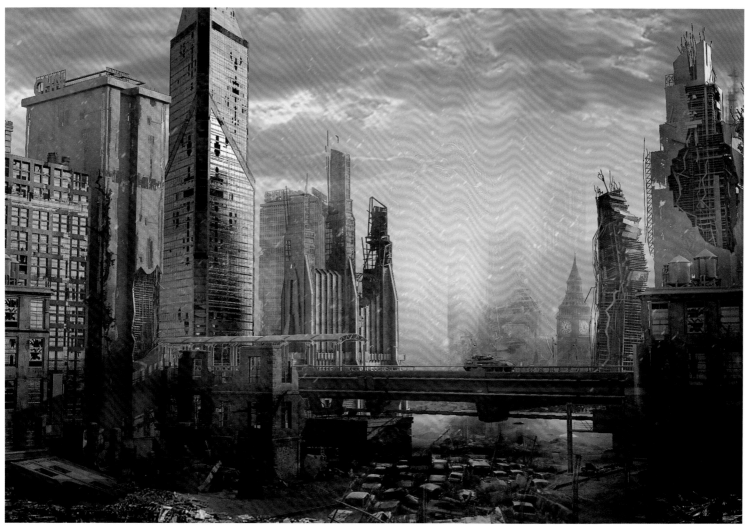

Tears from Heaven 02

Zhang Xiaobo

Screen Name: Bozi
Blog: blog.sina.com.cn/bobobobobo
Profession: Illustrator, game concept artist, animation director

张　晓　波　Z　h　a　n　g　X　i　a　o　b　o

PROFILE

Zhang Xiaobo graduated from the School of Animation at Beijing Film Academy. He works as project art director, illustrator, and executive director of animated movies in a game company.

INTERVIEW

How long have you been in this industry? What has impressed you most?

 I have loved the game industry since childhood, and found a job in a game company even before graduation and have worked there for six years. I started painting in elementary school and finished painting a volume of comics by the fourth grade. I even dreamed of publishing it back then. After entering this industry, what has striken me most is how hard it is to change what you love into a profession. When it is a hobby, you do it for interest or for fun. But when it is for a salary, it's much more complicated and you often have to rack your brains. Therefore, what awaits ahead of you is both joy and pain.

What do you like to do in your spare time?

 I like playing games and watching animation. I also like to dig into the relationships between different characters or chronology in my favorite games or animation works. Sometimes, I'm so fascinated by certain works that I cannot hold back my creative urges. I do not have much spare time as I'm too busy in recent years, but I manage to squeeze in some time to appreciate the work by my peers and precedents, which is quite a precious experience for me.

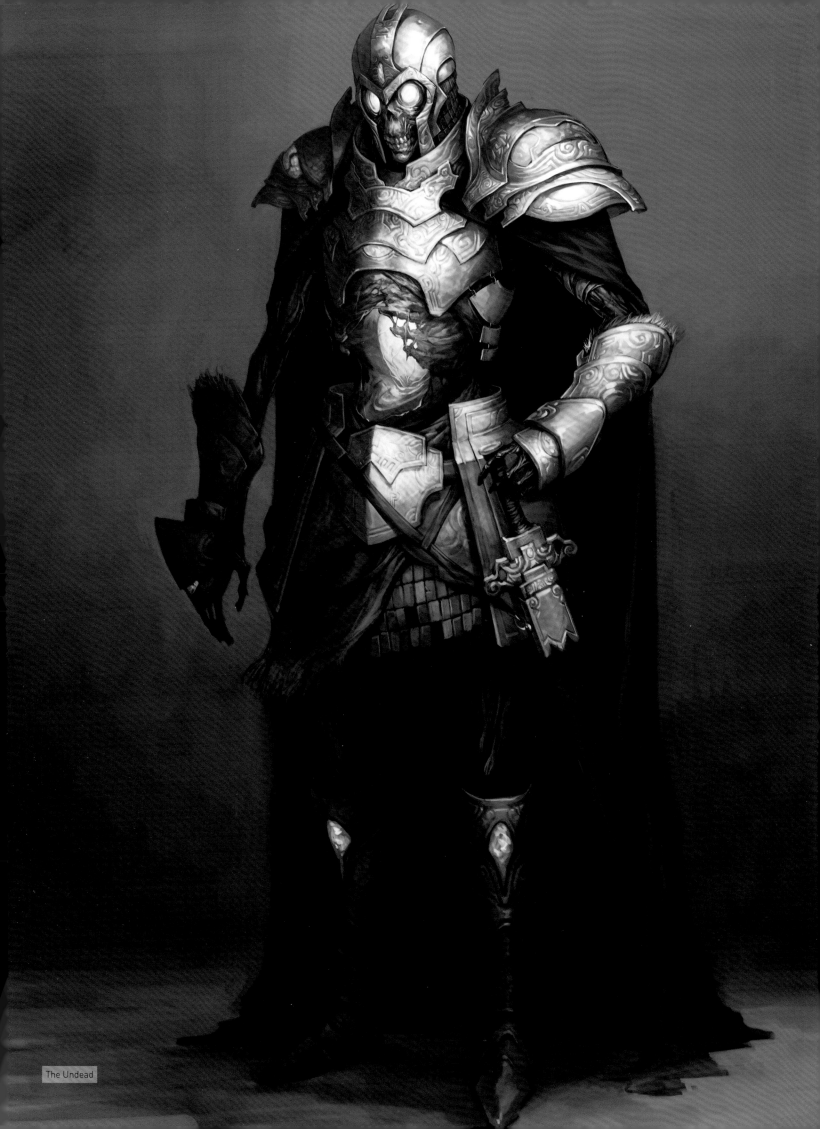

The Undead

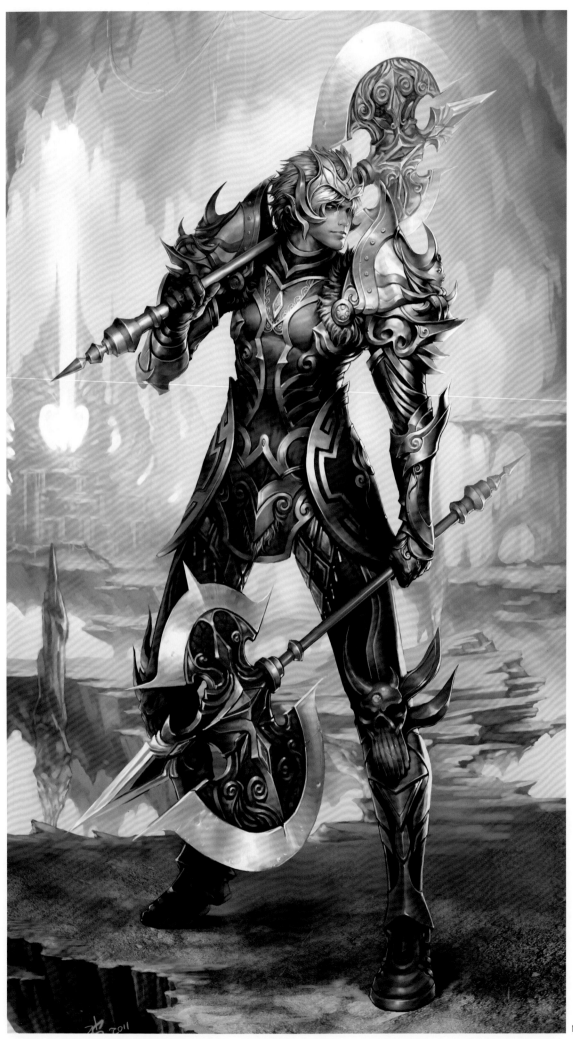

Male Warrior

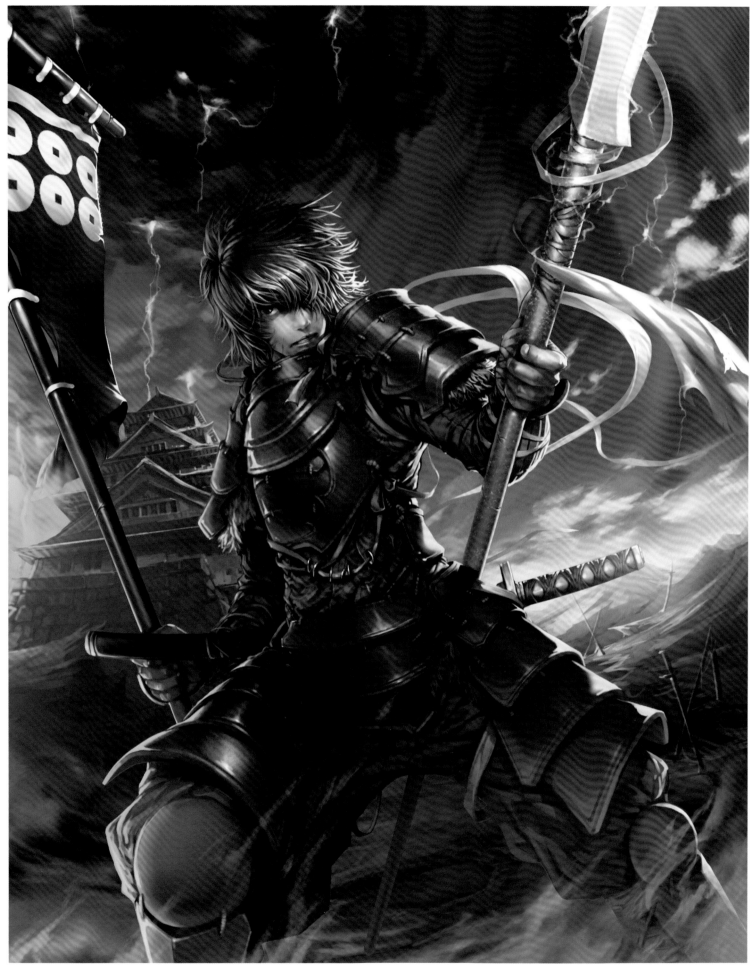

Anayama Kosuke

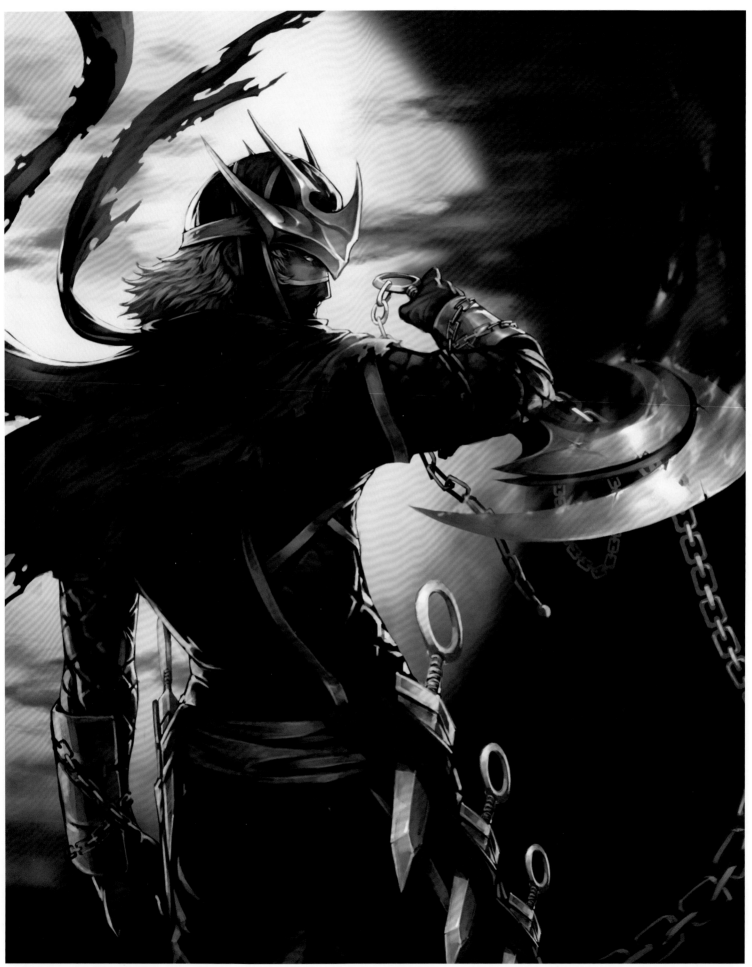

Fuma Kotarou

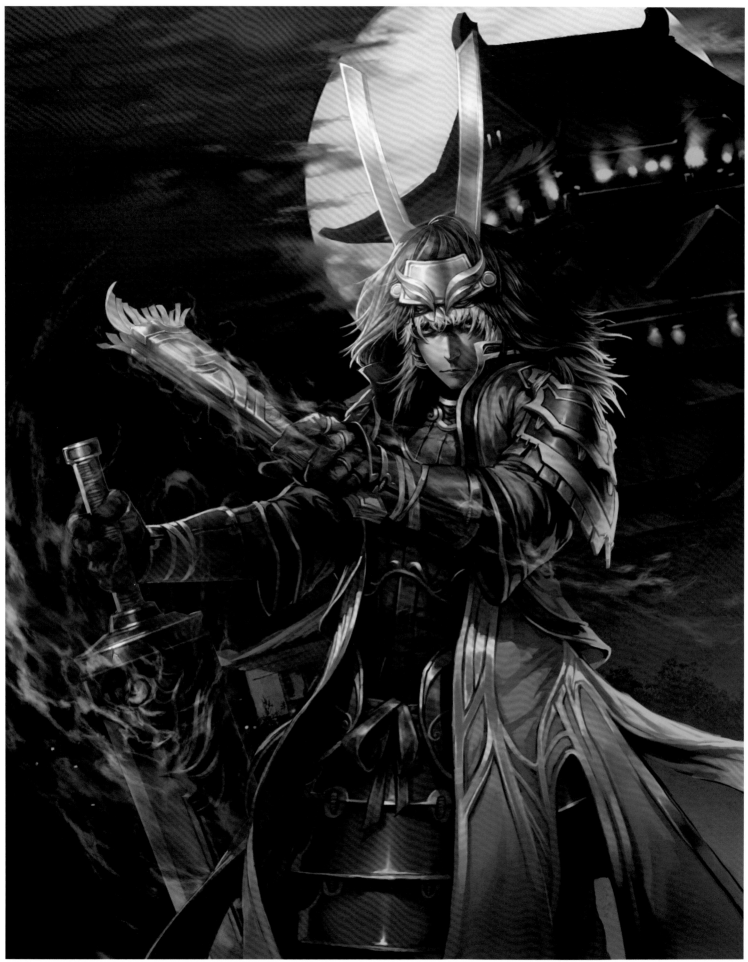

Ishida Mitsunari

Dong Hang

Screen Name: ZOMBIE
Blog: blog.sina.com.cn/crowcg
Profession: Concept designer, illustrator

PROFILE

Dong Hang first entered the CG digital painting industry in 2008, and got involved in the game industry in 2009. He enjoys every step in translating ideas into reality when painting. His favorite subject is monsters.

INTERVIEW

What's your creative plan and subject in future?

The next creative plan is something I have been thinking about for a long time. Due to my personal preference for fantasy-related, apocalyptic subjects, I like depicting what the world would look like after a nuclear war or a plague when humankind is about to go extinct. I have to create a large number of things to populate this world, such as characters, vehicles, houses, weapons and so on. It is a process with a large workload and a lot of challenges.

What do you like to do in your spare time?

I usually choose to do something that relaxes myself and enriches my knowledge base at the same time, such as travelling. The beauty of travelling is that you have a chance to experience different lives and get acquainted with various customs, very meaningful for concept design. Reading and watching movies at home is also a good way of entertaining myself while learning new things, as it requires knowledge of other disciplines in addition to painting, such as history, industrial design, biology, or even philosophy. We need to learn more to meet the requirements from different clients.

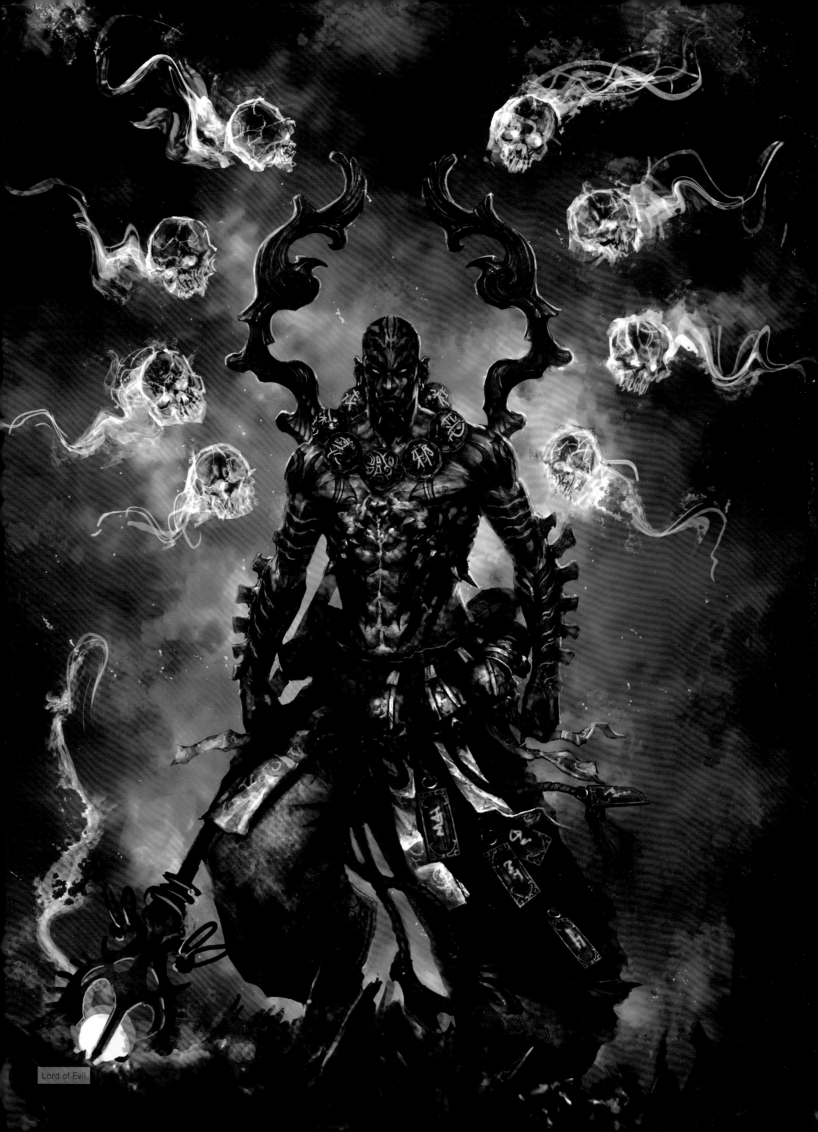

Lord of Evil

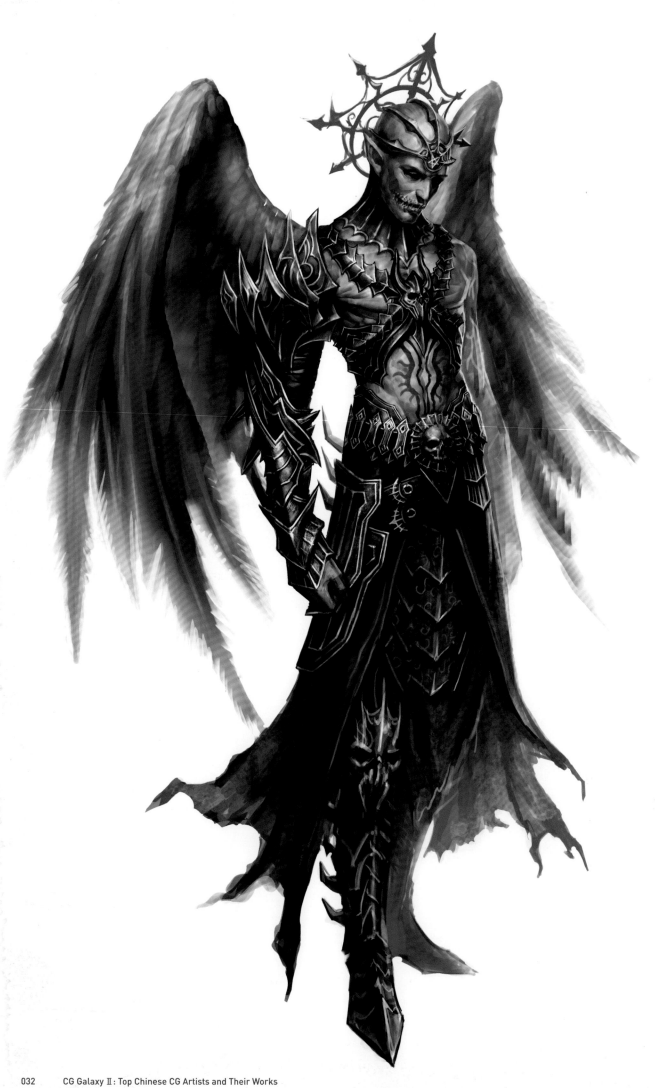

Fallen Angel

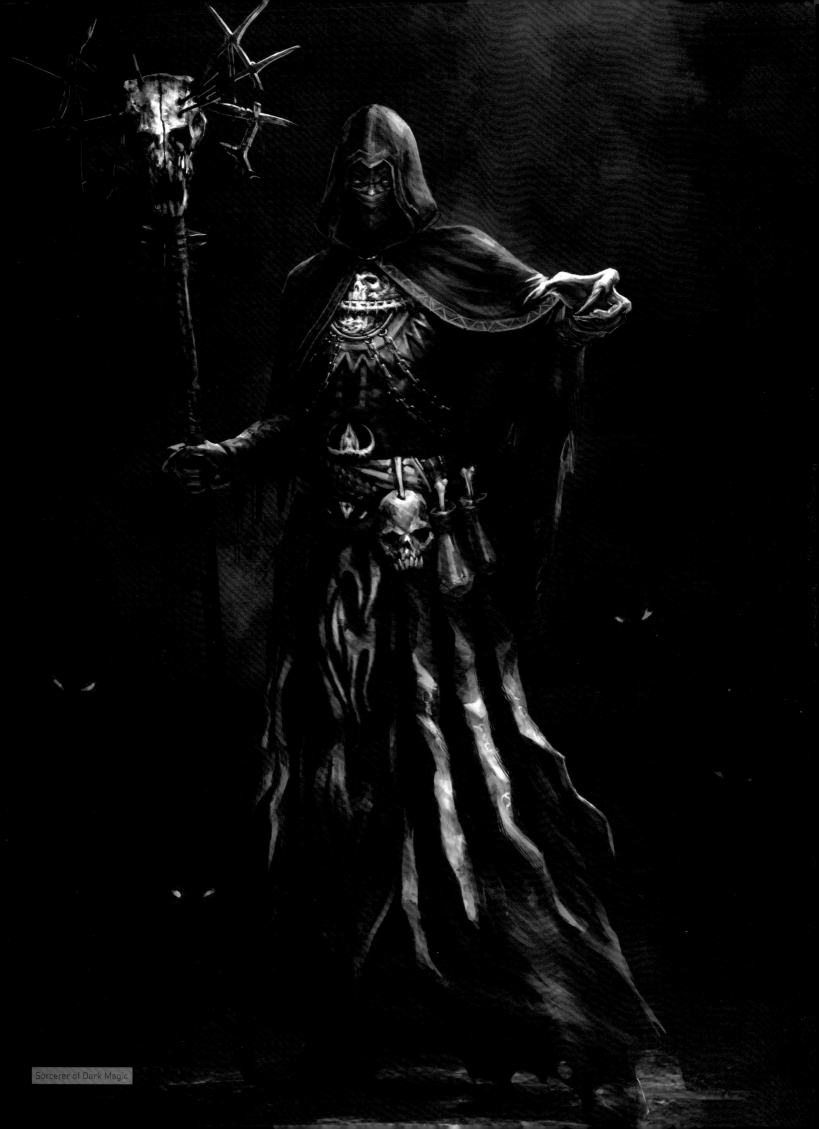

Sorcerer of Dark Magic

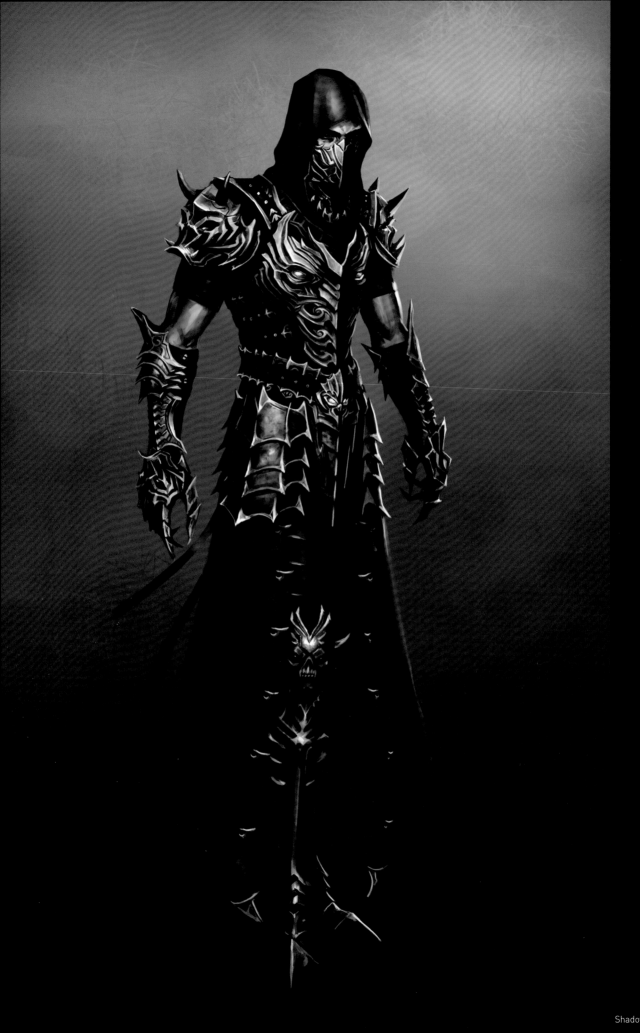

Shadow Assassin

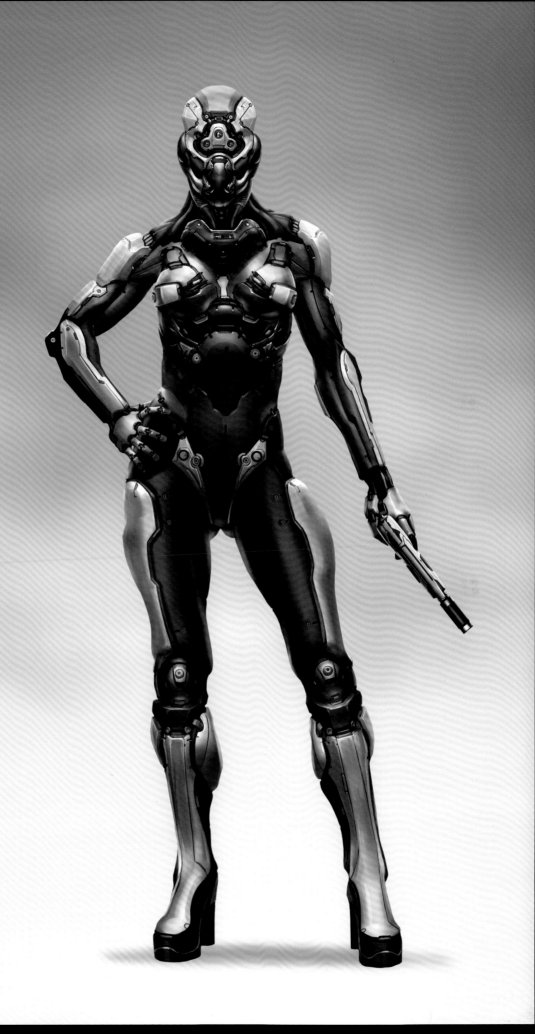

Assassin

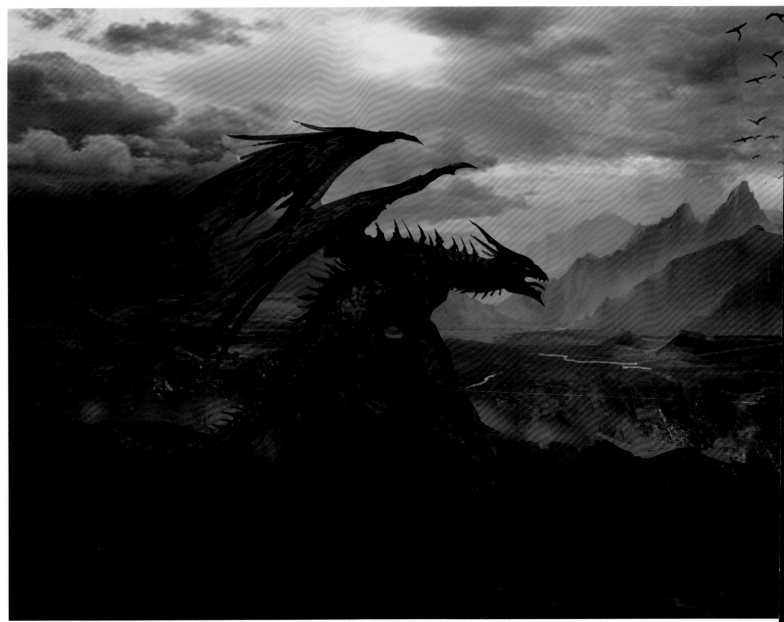

Range of Evil Dragons

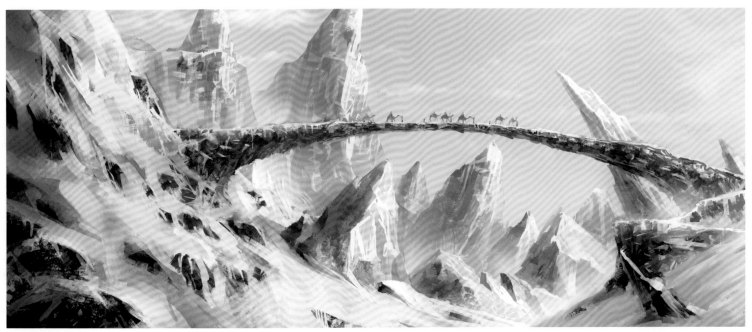

Trade Route

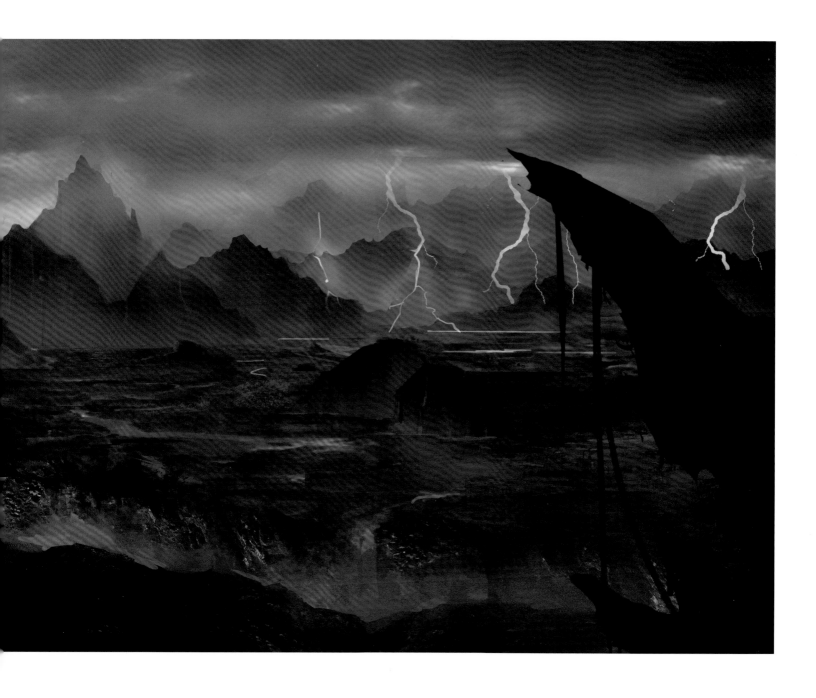

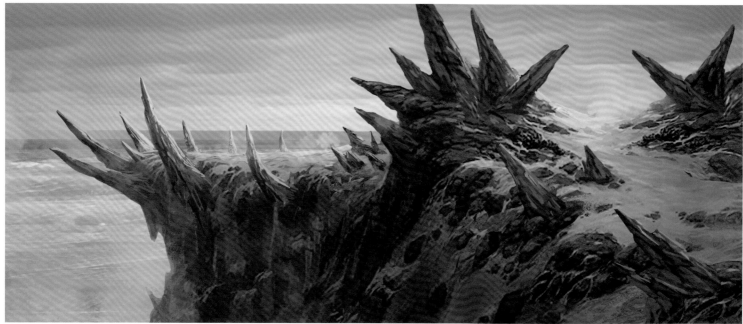

Cliff

李 双 跃 L i
S h u a n g
y u e

Li Shuangyue

Screen Name: Shuangyue
Blog: blog.sina.com.cn/yue22yue
Profession: Concept artist, illustrator

PROFILE

Having entered the game industry in 2009, Li Shuangyue is versed in various painting styles and subjects. He has worked at NetDragon Websoft, Perfect World in Beijing and has taken part in the production as well as research and development of diverse large-scale games. His works, brimming over with intensity, have been included in *EXOTIQUE6*, and won awards such as the 2011 Fantasy Galaxy Best Art Award.

INTERVIEW

It is a prevailing practice to produce creative work in a digital format. Which do you think is better to meet the requirements of commercial projects, digital painting or traditional hand painting? Which one do you prefer?

Personally speaking, I think digital painting is a better choice for commercial projects, at least in China. I often paint with computers, but I prefer traditional hand painting. No matter whether it is oil painting, watercolor, or traditional Chinese painting, I hope I will have more opportunities in the future to work in these formats.

What does traditional painting mean to you? What is your general creative process with traditional hand painting?

Traditional hand painting is nothing but personal expression. It has nothing to do with commercial interest, but it might become the most important thing for me in the future. When I resort to traditional hand painting, the general creative process is to think about creative concepts, produce drafts and elaborate on the canvas later.

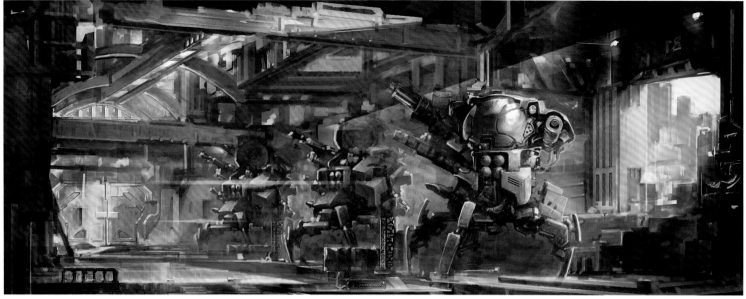

Base

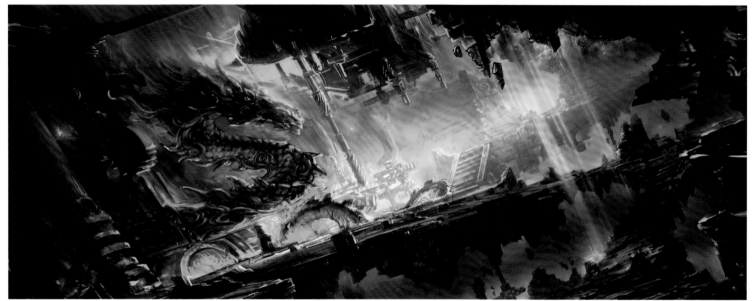

Dragon Cave

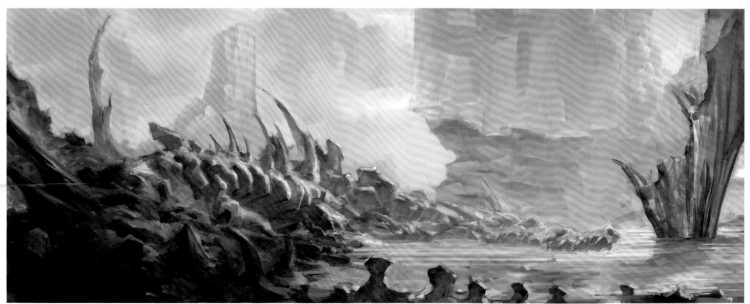

Dragon Spine

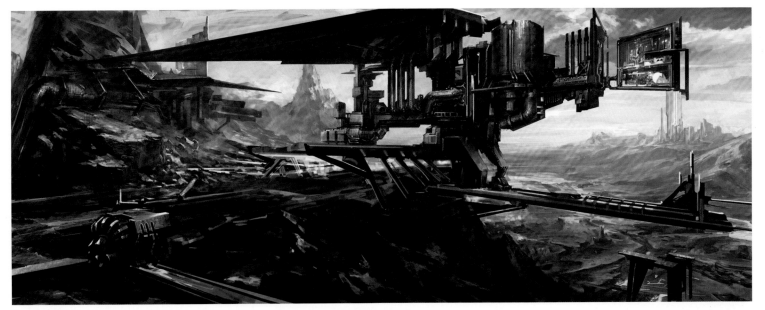

Supply Point

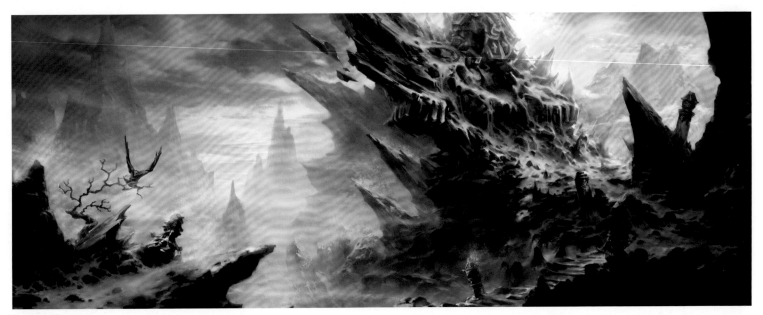

Snow Mountain Statue

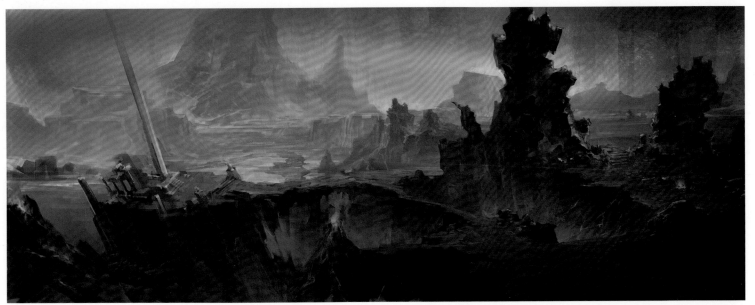

Valleys on the Seafloor

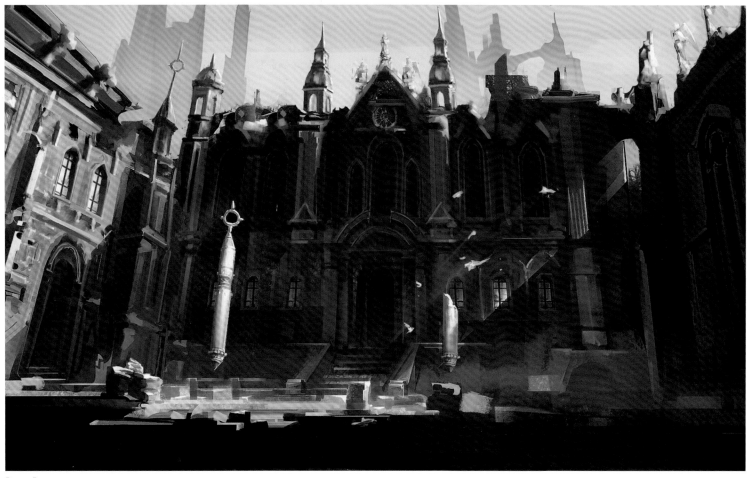

Peace Dove

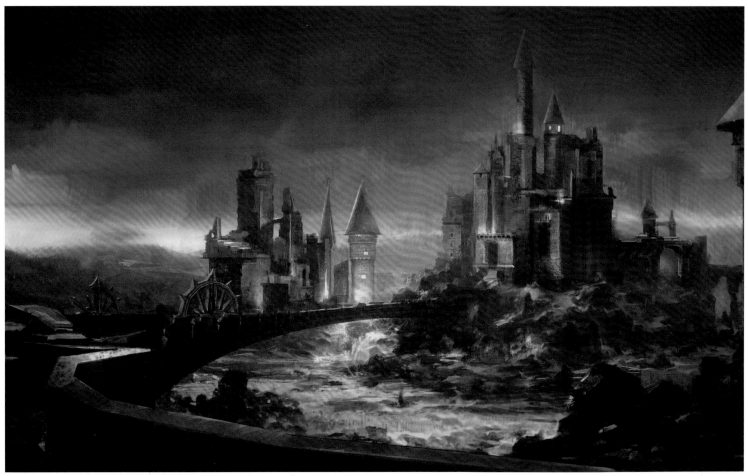

Castle

Liu Tao

Screen Name: Niutao
Blog: blog.sina.com.cn/u/2704114937
Profession: Scene concept artist

刘 涛 Liu Tao

PROFILE

Liu Tao is skilled in scene drawings and character-based promotional illustrations. He has worked as senior art director at Giant Interactive Group in Shanghai and Beijing Perfect World Co.,Ltd.

INTERVIEW

In retrospect, what do you think is your most defining feature? And what has made you who you are today?

Looking back, many people and many things have helped me grow. I have evolved from cute 2D in my early years to 3D in style, and from Chinese to Greek, European and fantasy subjects. Undoubtedly, my career as scene concept artist has been quite smooth and given me access to various subjects, providing me with numerous opportunities. Here I would like to extend my heartfelt gratitude to Zhao Lei and other mentors who have given me great help, as I have little chance to express this in my daily work. Their sophisticated and established painting styles and artistic approaches have influenced and inspired me. With a long journey ahead, I hope I can make further breakthroughs and progress in the future.

Could you share with us your techniques for using colors and brushes?

Due to character and scene design requirements, and also as a result of my personal preference, I tend to use rich colors and texture variations in personal and commercial work. For this reason, I choose colors of the same value but different in hue to achieve a special effect which features color variation but consistency in style. I also like to use high saturation to put stress on themes in key areas. As for brushes, I prefer to use brushes with angular and rounded edges in combination to create a strong contrast. Then, I select brushes specifically intended for certain textures and effects to match the dominant brushes.

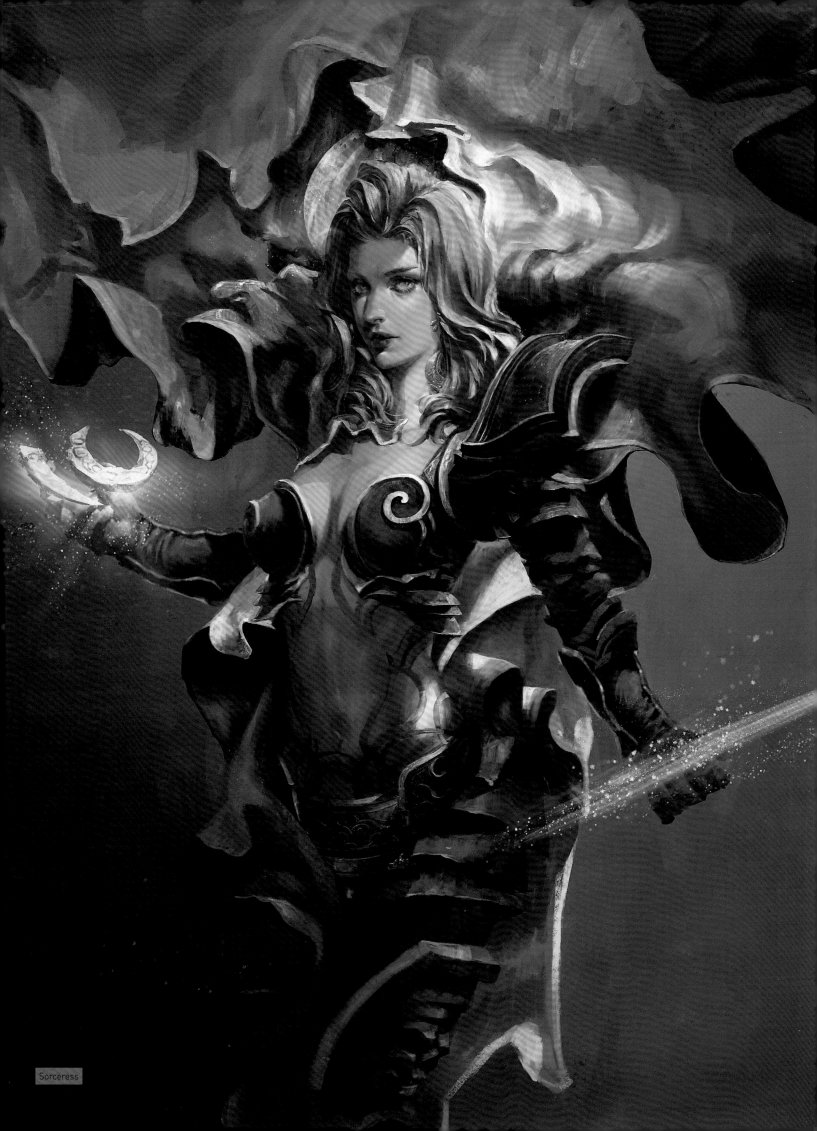

Sorceress

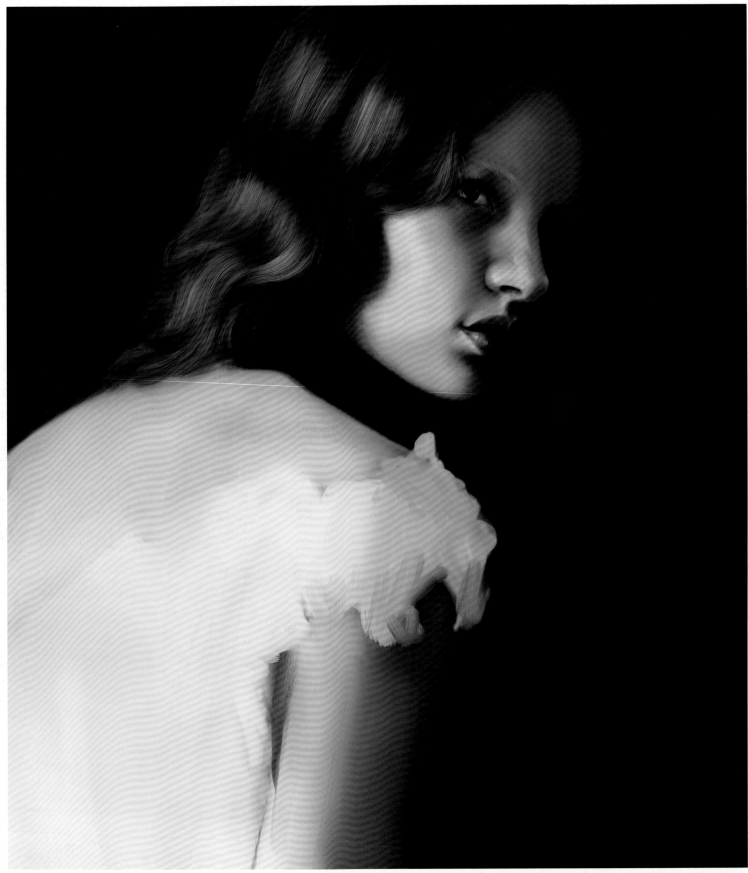

Portrait

Male Head Portrait

Female Head Portrait

Song Qijin

Screen Name: Xiao Dupi
Blog: blog.sina.com.cn/sqj226
Profession: Freelance artist

PROFILE

A graffiti lover in childhood, Song Qijin started learning fundamental art in 2003. He entered the game concept art industry in 2009 and served as concept artist at Shanghai Winking Entertainment Ltd., and project art director at Elements of Power Studio. He currently works in his own studio.

INTERVIEW

How many years have you been in this industry? What has impressed you most?

I have been in this industry for a decade, during which I was most impressed by the realization that a professional should be down to earth, modest and learn to source inspiration from life to enhance his own painting skills.

When did you first become interested in art? Why did you decide to become a professional artist?

I have had a strong interest in painting as long as I can remember. I still keep a series of dark art works I drew at the age of five or six. Even in childhood, I already had great passion for monsters and spirits of the deceased, which surprised me a little in retrospect, as I had little access to such subjects back then. I seemed to have an inherent interest for such subjects. I don't know what else I would do if I were not a painter. Therefore, I have followed my heart and make my living as a painter.

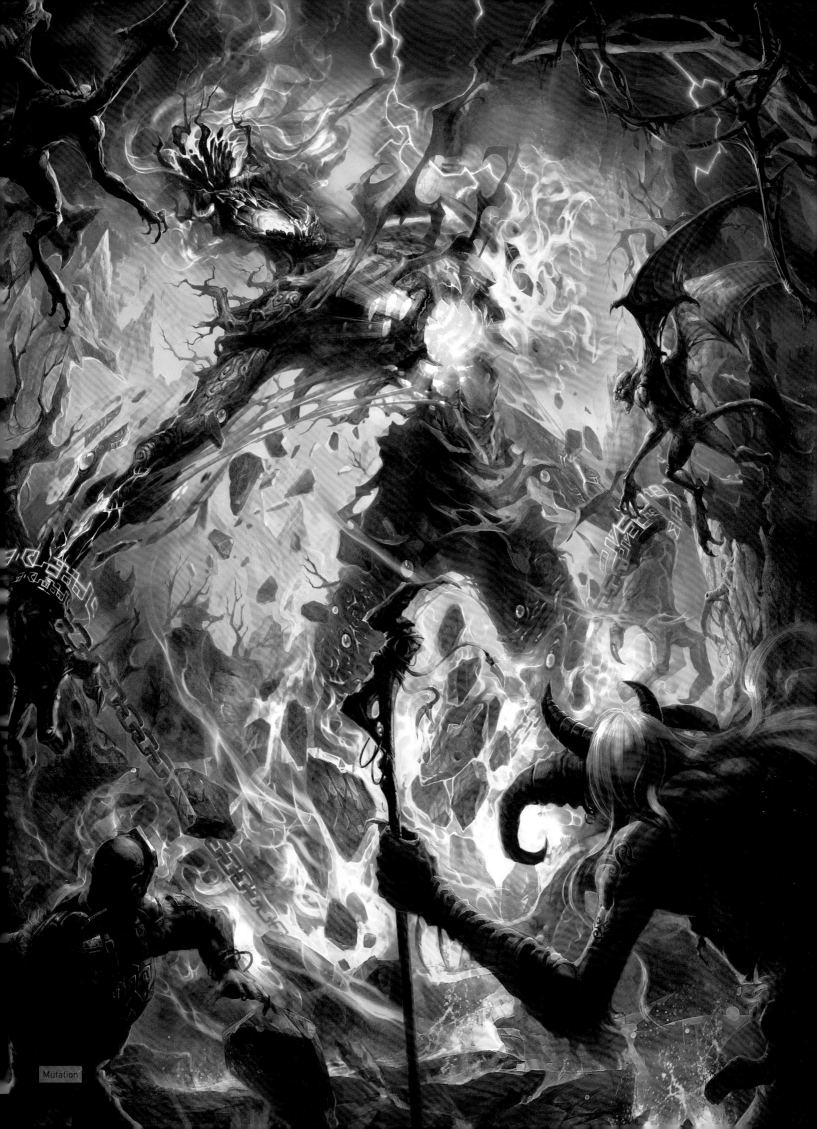

Mutation

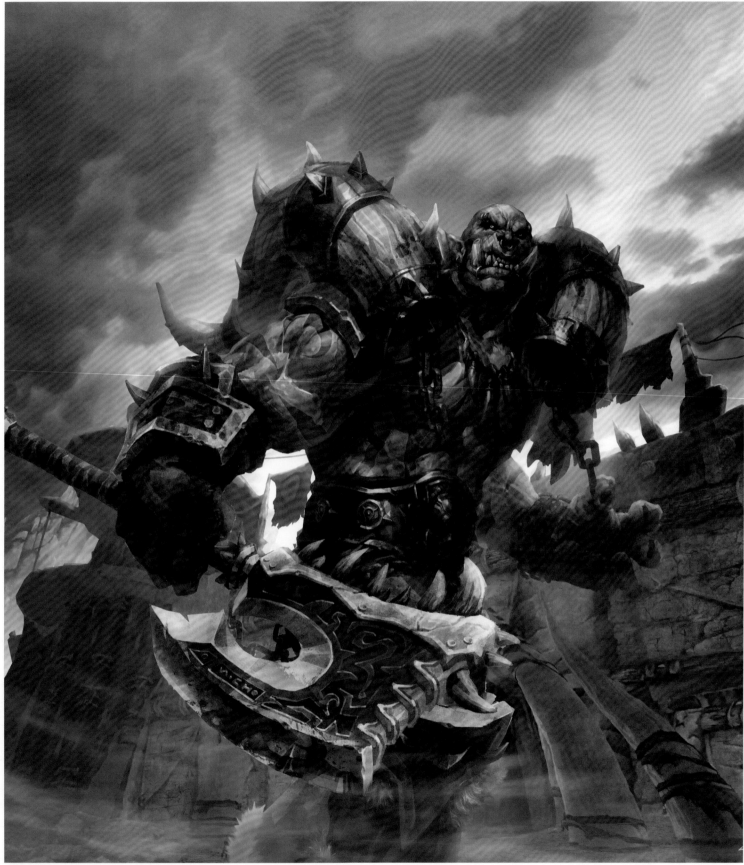

Hellscream

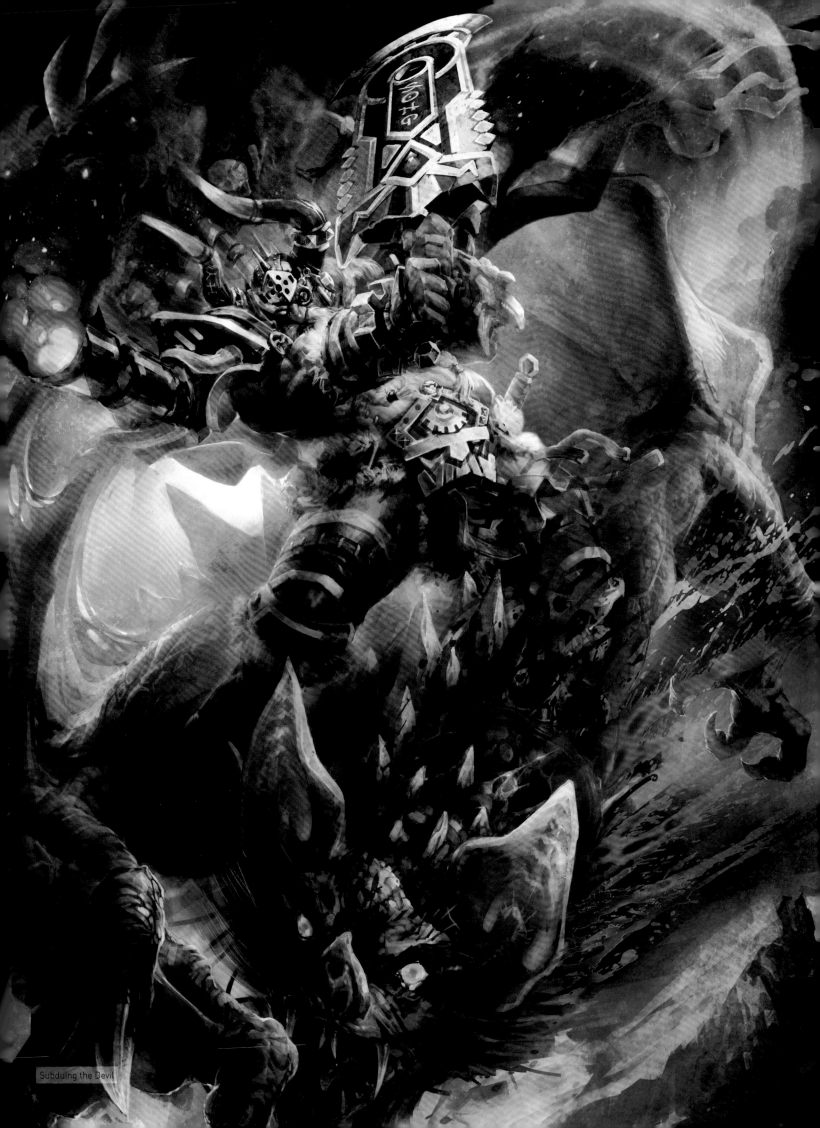

Subduing the Devil

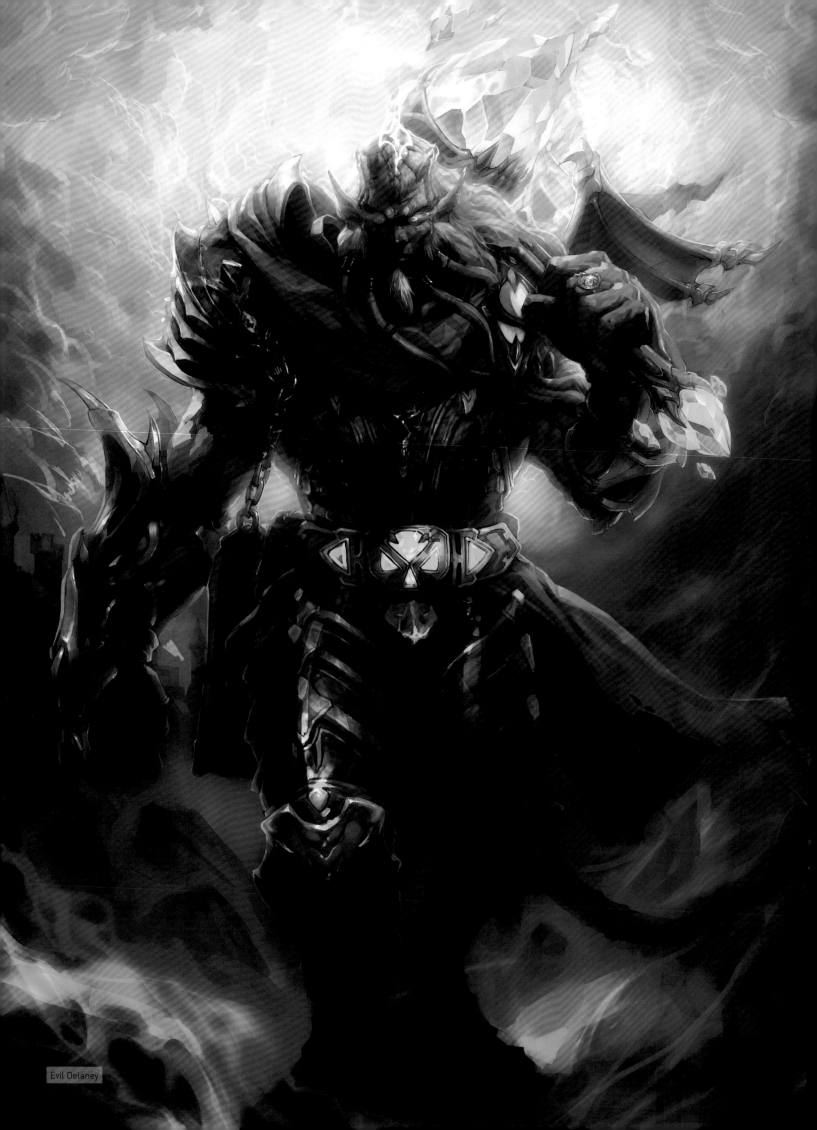

Evil Delaney

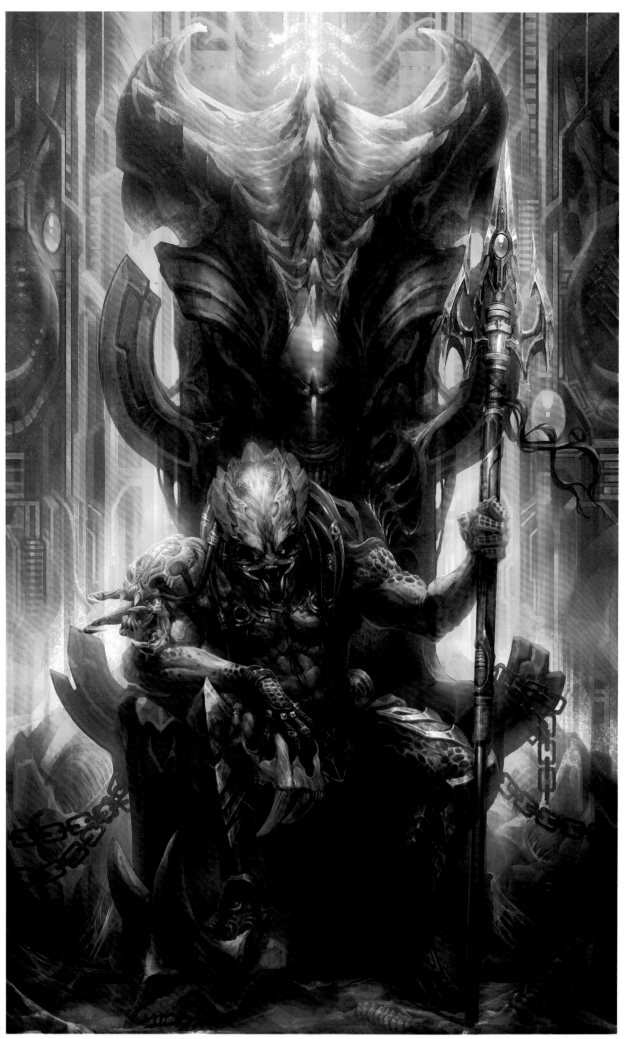

The Predator

Mano Models

Screen Name: Mano Models
Blog: www.manogk.com
Profession: GK artist

末 那 M a N °

PROFILE

Mano Models is primarily focused on development and production of original garage kits which mostly revolve around oriental legends. Today, the garage kit industry is thriving in Europe, America and Japan. Mano Models sources subjects from the vast reservoir of time-honored oriental legendary literature and produces works defined by their unique tastes. Domestic and foreign fans can appreciate their work while gaining a better understanding of the cultural elements underlying these garage kits.

INTERVIEW

What's your opinion of the prospects for the garage kit industry?

At present, the domestic garage kit industry is underdeveloped, and doesn't really have support from other sophisticated industries such as game, movie and animation. Most professionals randomly design things or have no consciousness of copyright issues, which restrains development of the industry to some extent. However, some industries have recently started to recognize the significance of developing derivative products, which promises great opportunities for both fans and professionals.

Does Chinese garage kit industry differ from its foreign counterparts? If so, in what way?

We think the dominant difference is the environment. Many foreign fans tend to get involved, such as making changes to, re-painting or re-assembling ready-made products. Therefore, the overall environment is encouraging, even if their competence varies. We hope that more and more people in China will start using their hands.

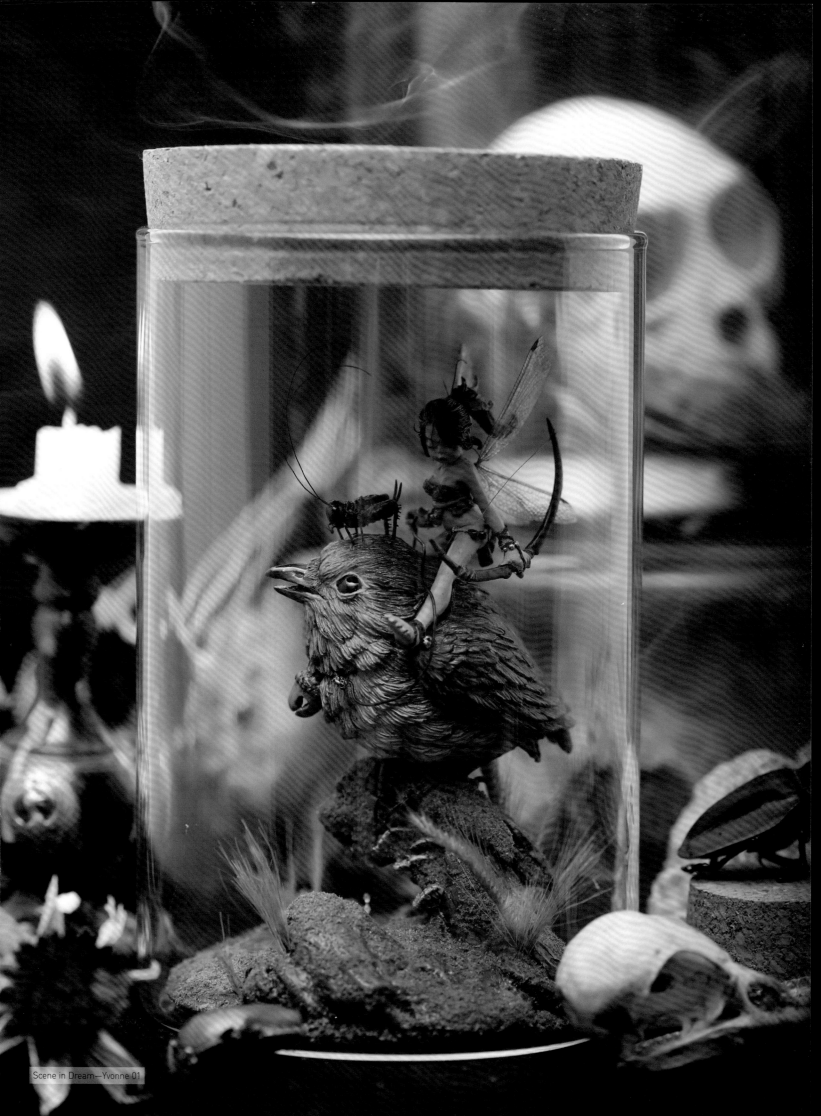

Scene in Dream—Yvonne 01

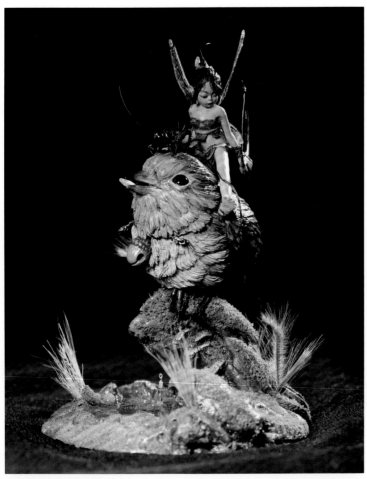

Scene in Dream—Yvonne 02

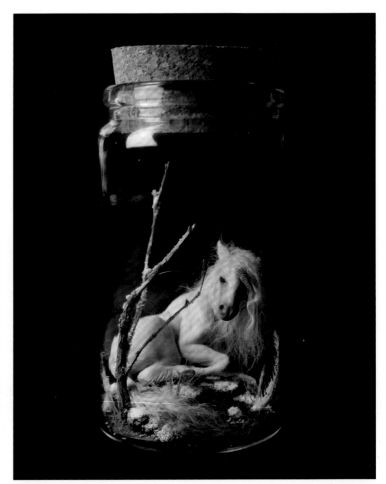

Blue 01

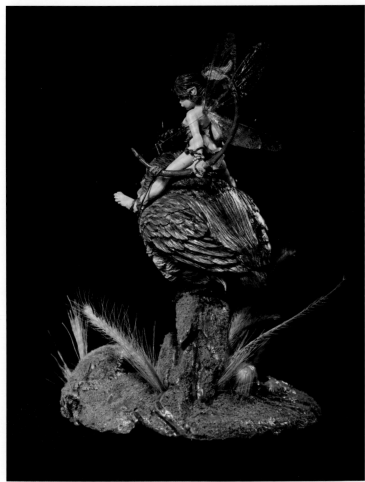

Scene in Dream—Yvonne 03

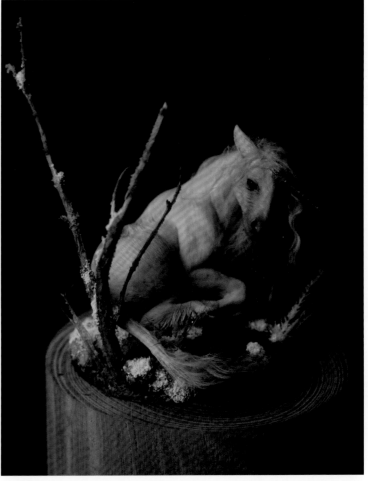

Blue 02

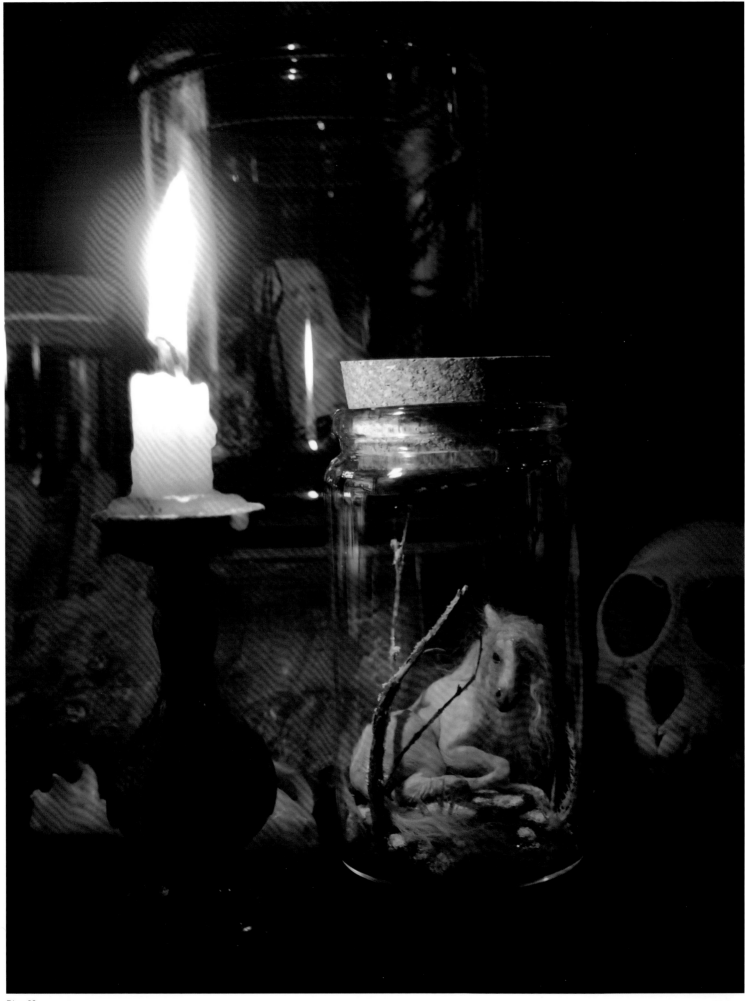

Blue 03

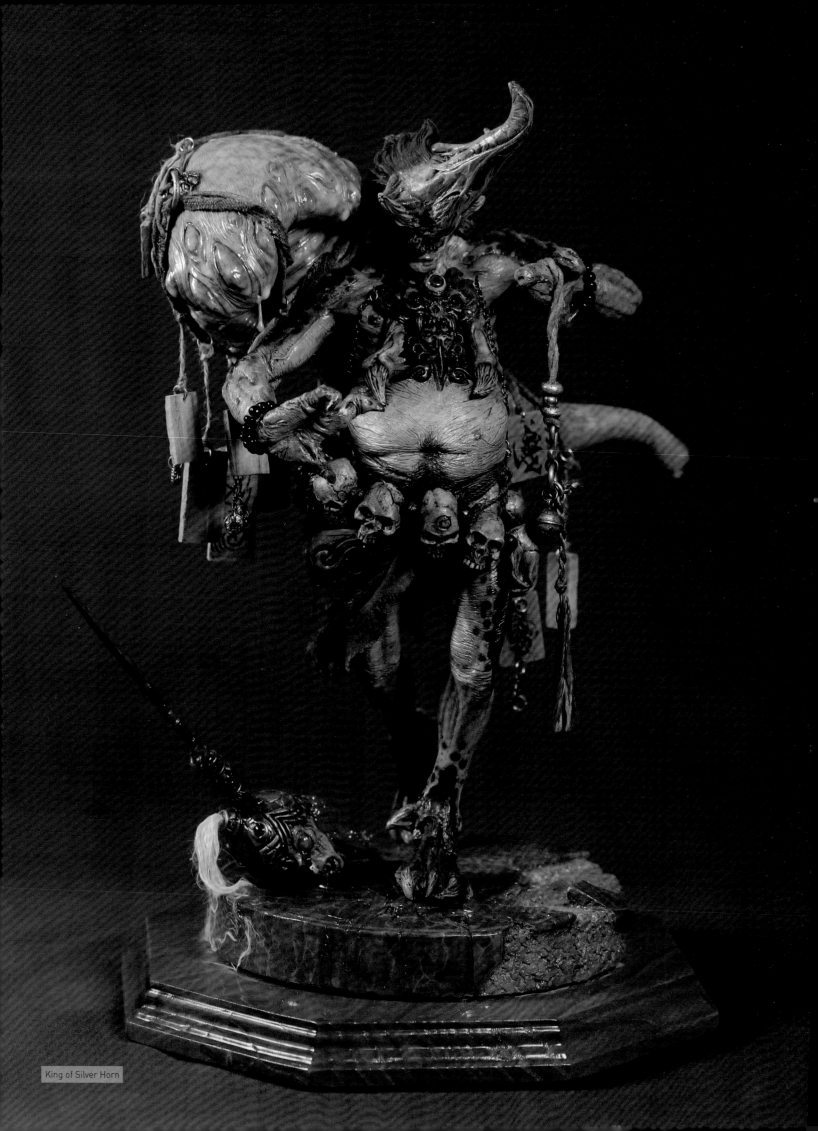

King of Silver Horn

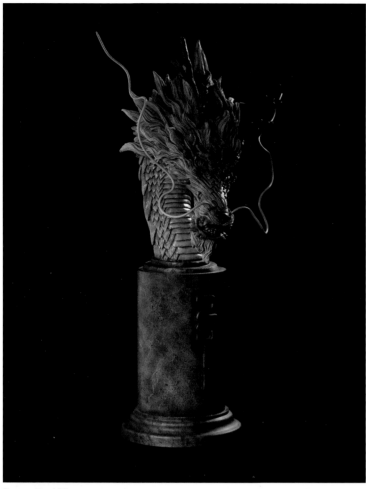

Dragon Head 01

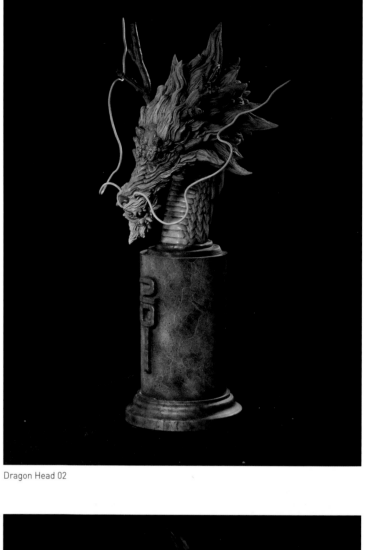

Dragon Head 02

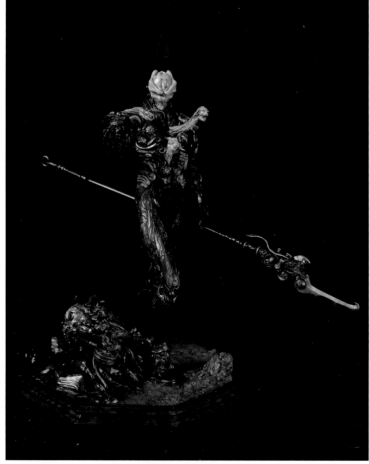

Jerran Z 01

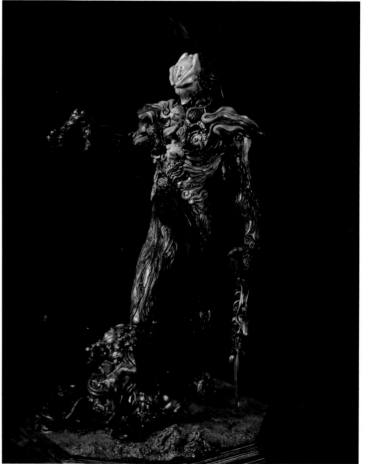

Jerran Z 02

Wang Ning

Screen Name: Snake
Blog: weibo.com/u/1547658021
Profession: Freelance artist, concept artist, illustrator

王 宁
W
g a
n n
i N g

PROFILE

After graduation from Shandong University of Art & Design in 2009, Wang Ning entered the game industry in the same year. Versed in realistic style, he has worked as 2D team leader at Beijing Object Software, and is currently a freelance illustrator. He has participated in the R&D of many game projects, and has accumulated extensive production experience.

INTERVIEW

Digital painting is becoming a dominant trend. Which do you think is better for commercial projects, digital painting or traditional hand painting? Which one do you prefer?

Personally speaking, digital painting better suits my commercial projects. In today's CG industry, digital painting is dominant because compared with traditional painting digital painting is less time-consuming and more convenient. However, in the field of pure art, traditional hand painting is associated with values that cannot be achieved through digital painting. Nevertheless, no matter whether it is digital painting or traditional hand painting, the artist must rely on his own artistic accomplishment and fundamental skill. I personally prefer to apply theories and methodologies from traditional painting to digital painting.

For artists like you, which is more important, artistic sensitivity or creative technique?

The "artist" title is too much for me. As a CG designer engaged in the art industry, I see artistic sensitivity as top priority, while techniques only play an auxiliary role. I never overestimate the value of a certain brush or technique when working on a painting. I rely on my instincts as obsession with techniques would end up with monotony in the work.

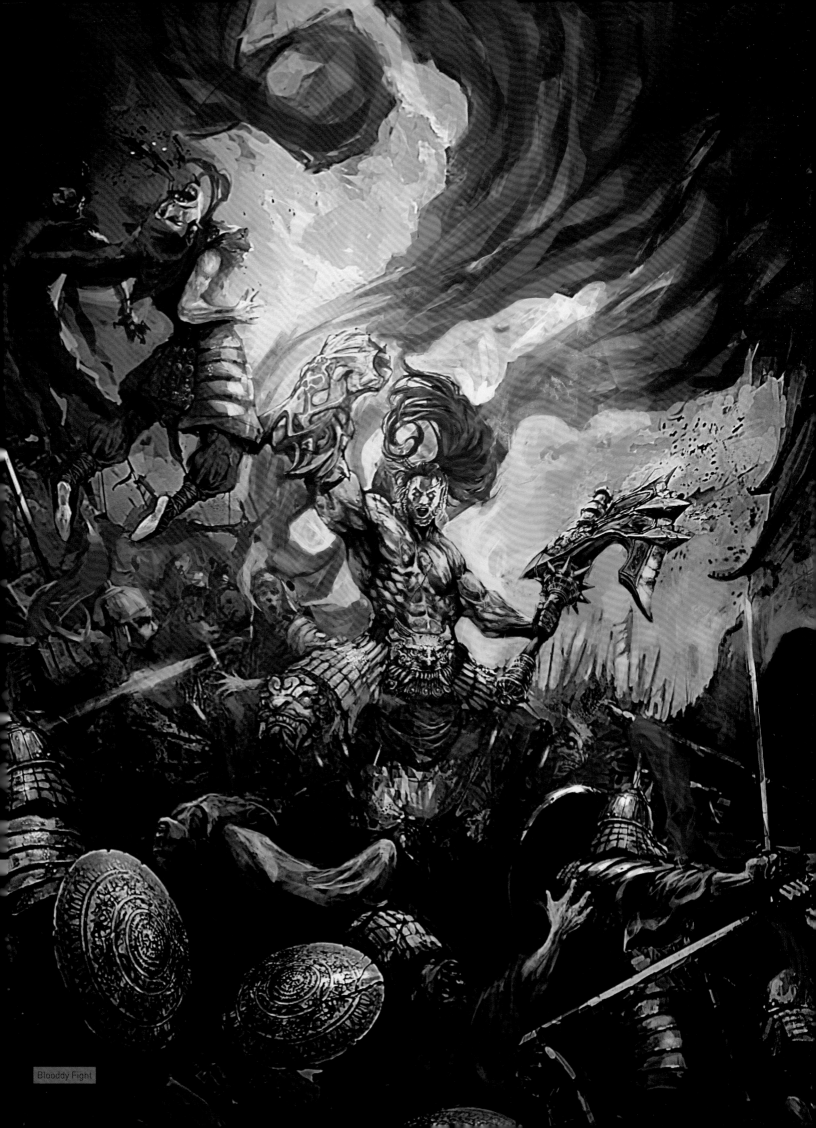
Blooddy Fight

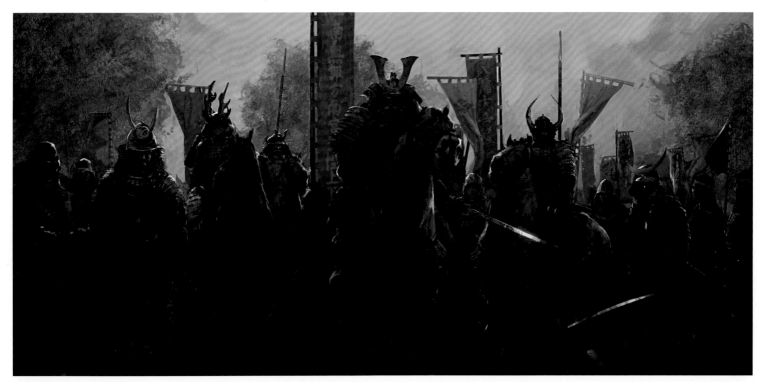

Warriors

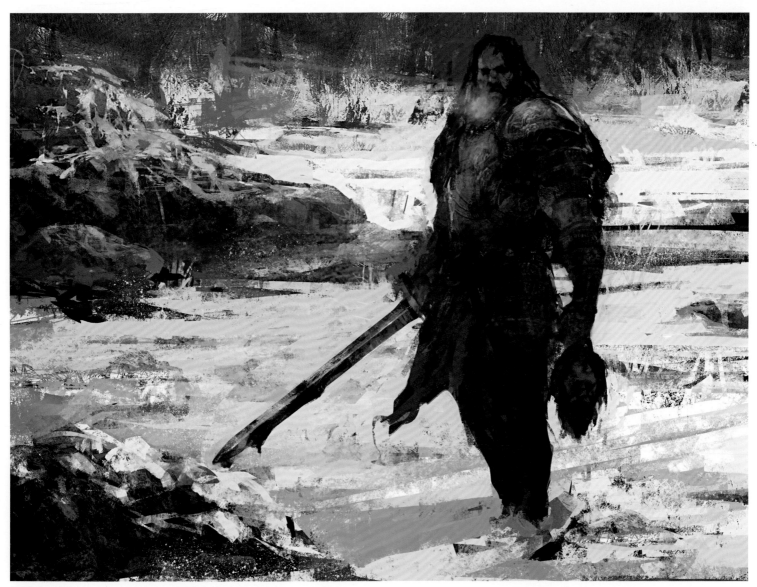

Barbarian King

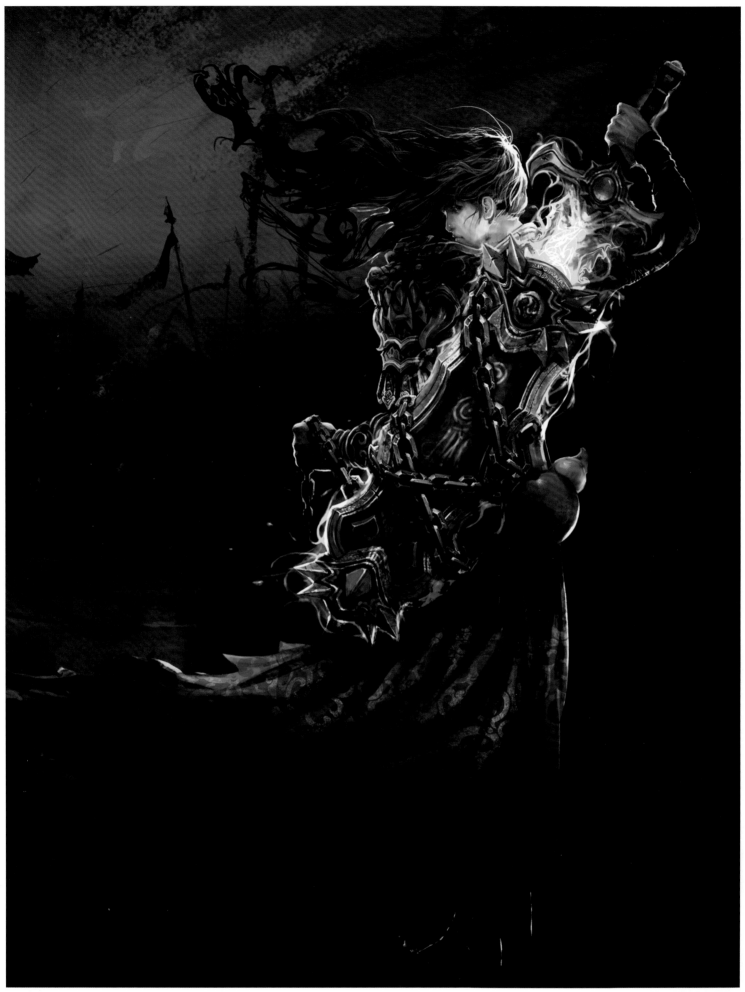

Swordsman

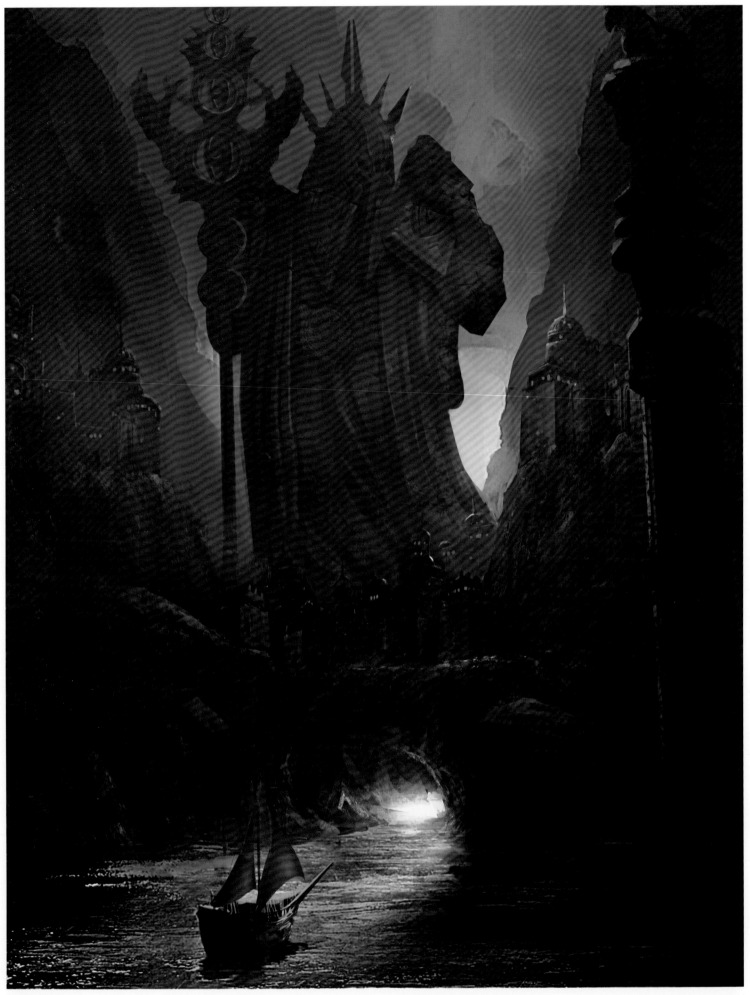

Twilight

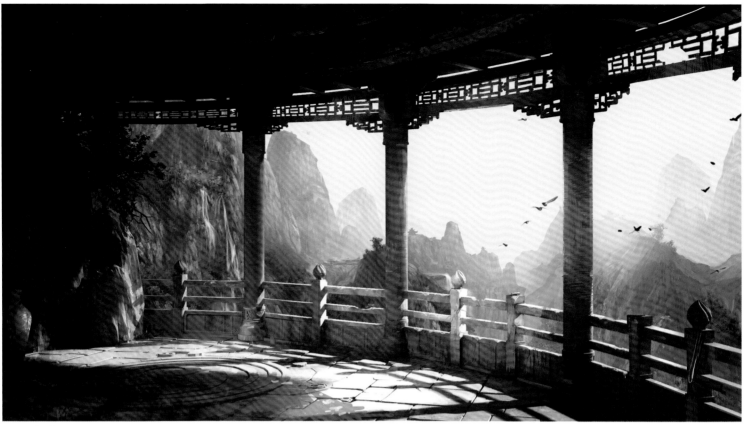

Ancient Pavilion

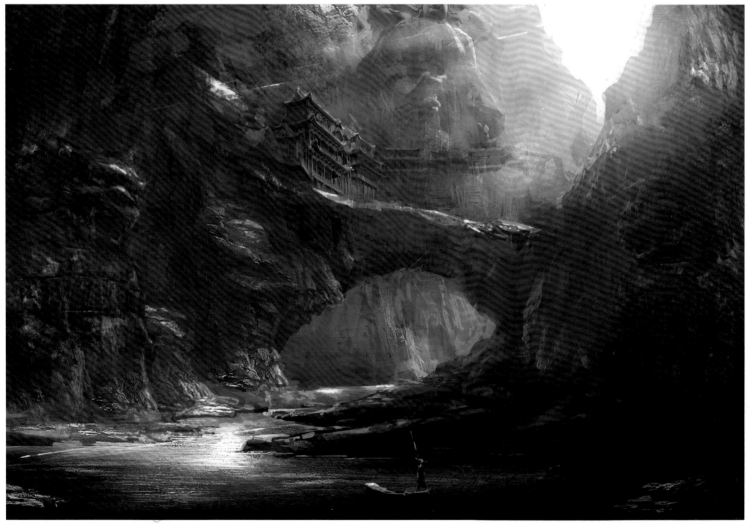

Valley Pass

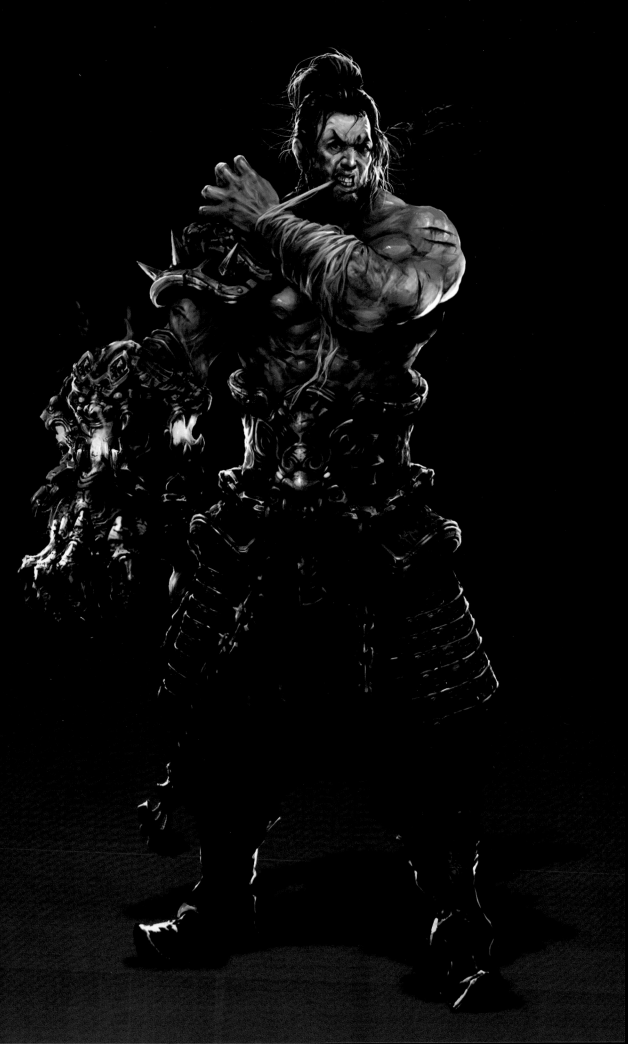
Strong Man

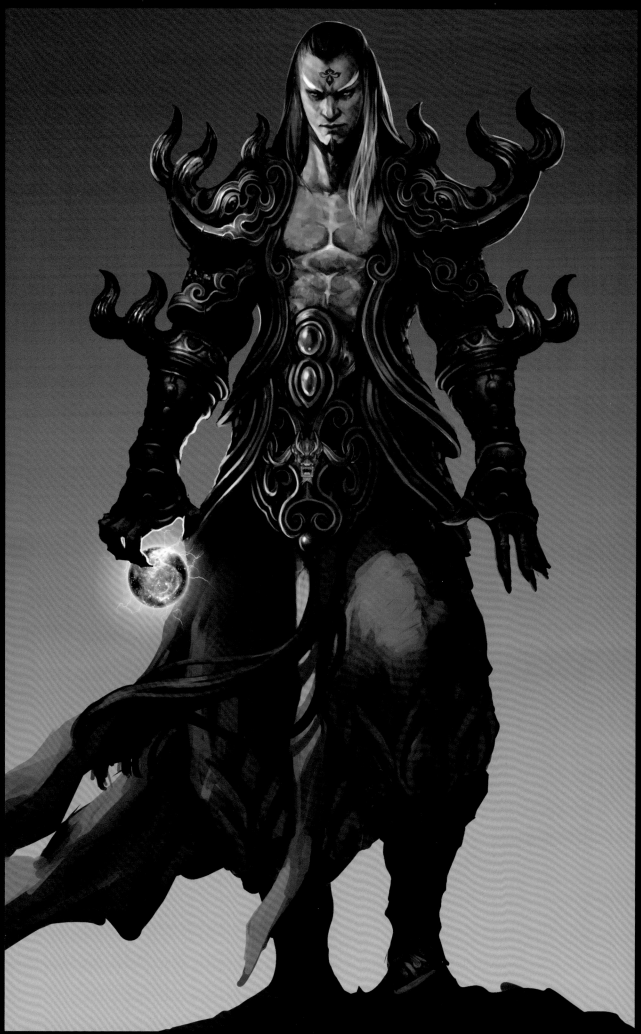

Sorcerer

Zhang Ji

Screen Name: Xiao Hehe (Smiley)
Blog: blog.sina.com.cn/zhangji1984
Profession: Illustrator, concept designer

张

季

Z

h

a

n

g

J

i

PROFILE

After graduation in 2007, Zhang Ji started working for Shanghai Wemade where he served as concept designer for projects such as "Legend" and "Chang Chun". In April 2008 he joined EA China, as concept designer for the "Warhammer online" project. He left EA in December 2009 to work for Perfect World Shanghai and took part in painting the promotional illustrations for "Zhu Xian 2," "Mummy," "Forsaken World," "Dragon Excalibur," "DOTA 2" and other projects as illustrator.

INTERVIEW

When did you first become interested in art? What made you become a professional artist?

My father is a professional in the art industry, and both my grandfathers are well-versed painters. Due to their influence, I used walls as a canvas for my graffiti from an early age. In primary school, I was introduced to manga, and immediately became a huge fan and made up my mind to become a manga artist. In high school, I received formal art training and decided to make a living as an artist.

What do you like to do in your spare time?

I love many things. I spend my free time watching movies, reading comics, playing games, making garage kits like many other game lovers. I also have a strong interest in magic, and have read many books and bought a great deal of paraphernalia. Unfortunately, I am too busy to master it.

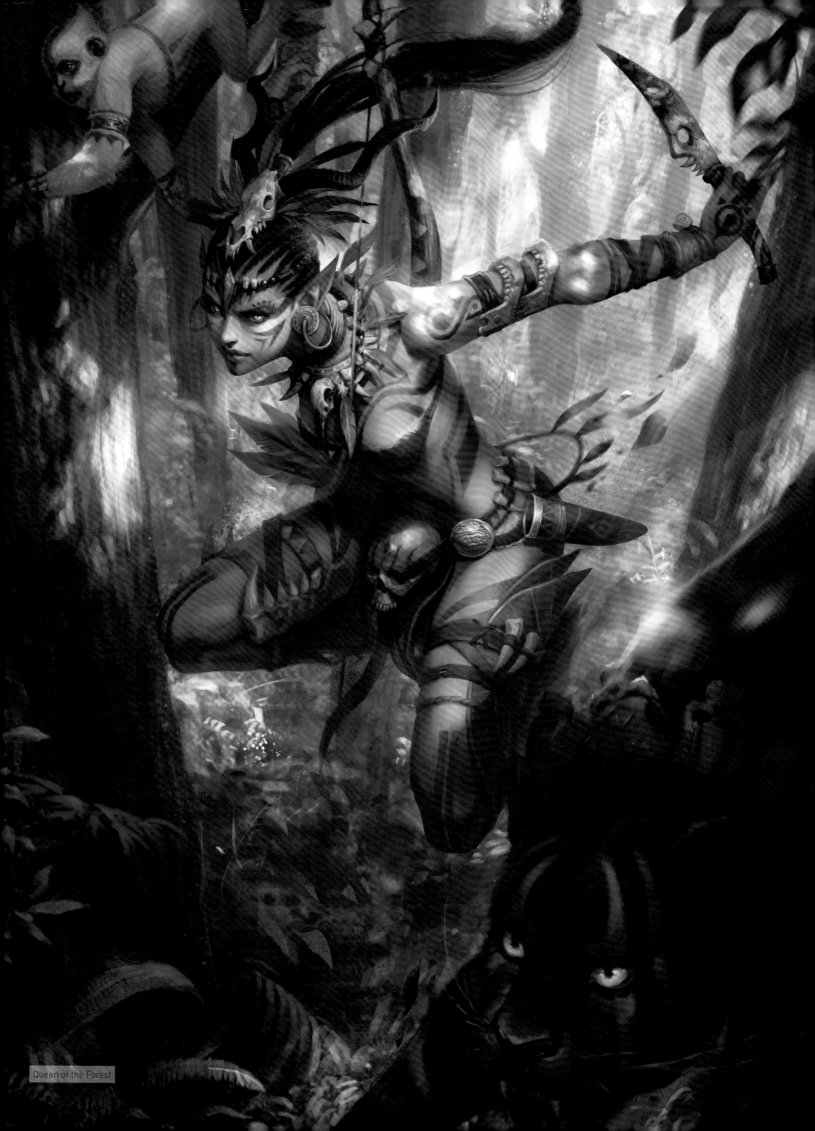

Queen of the Forest

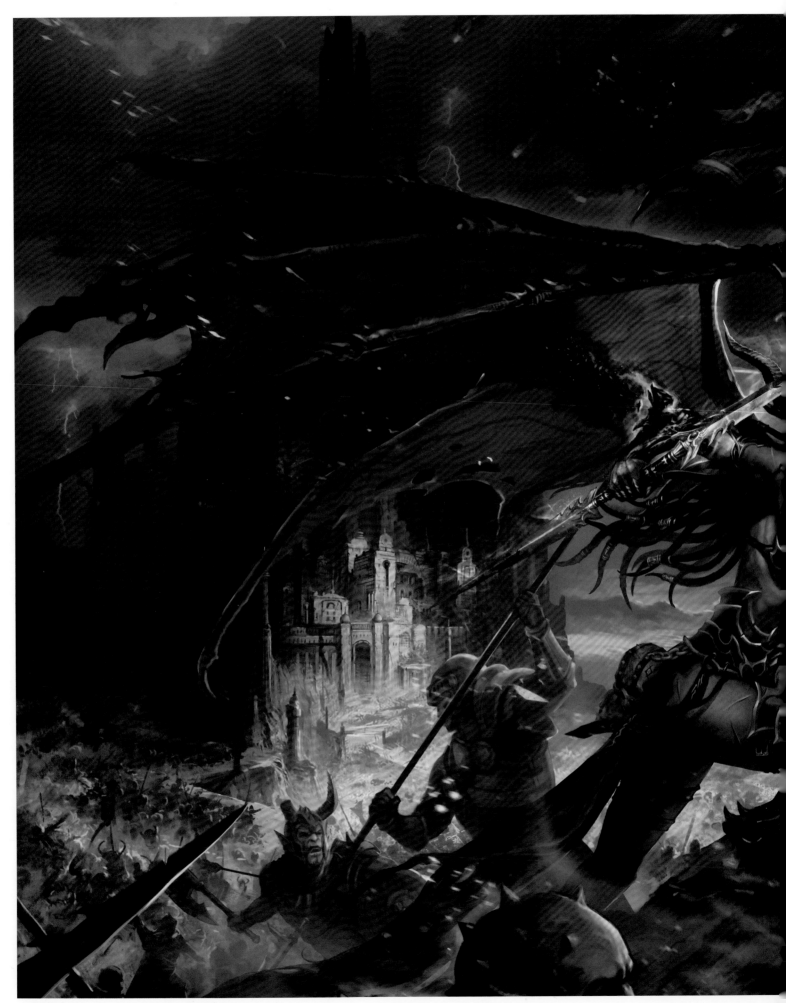

Empire of the Immortals—A Hero on the Battlefield

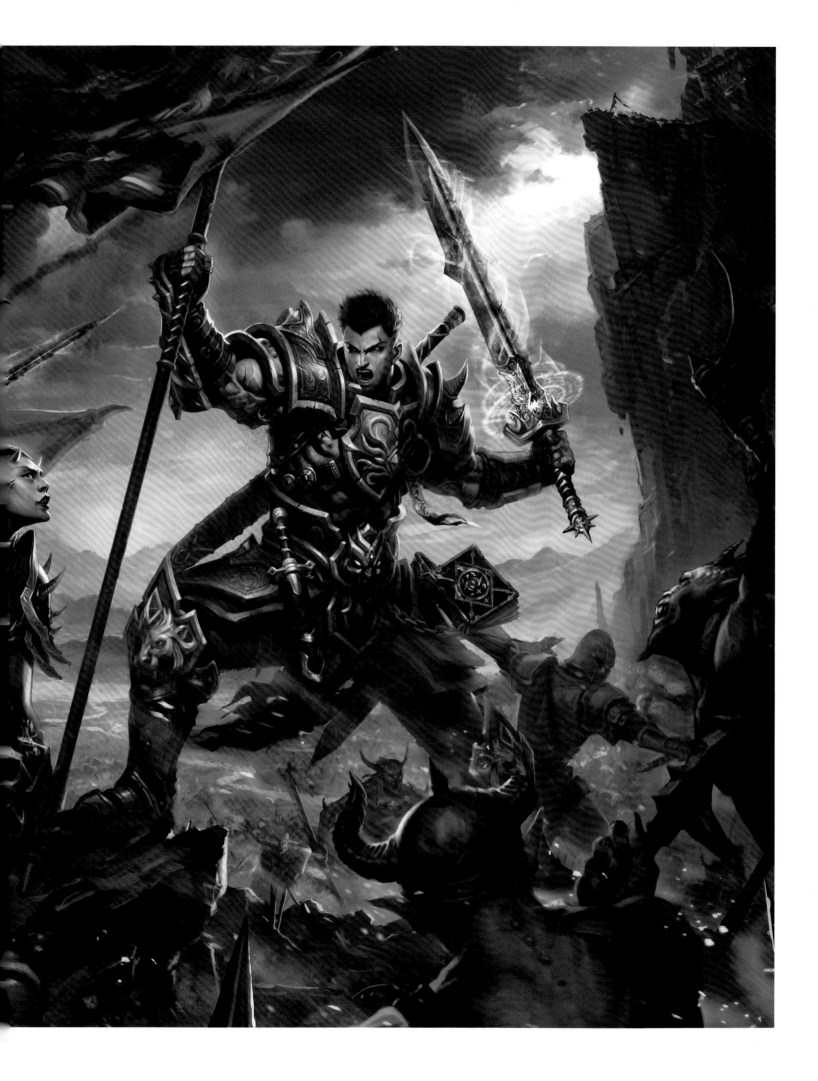

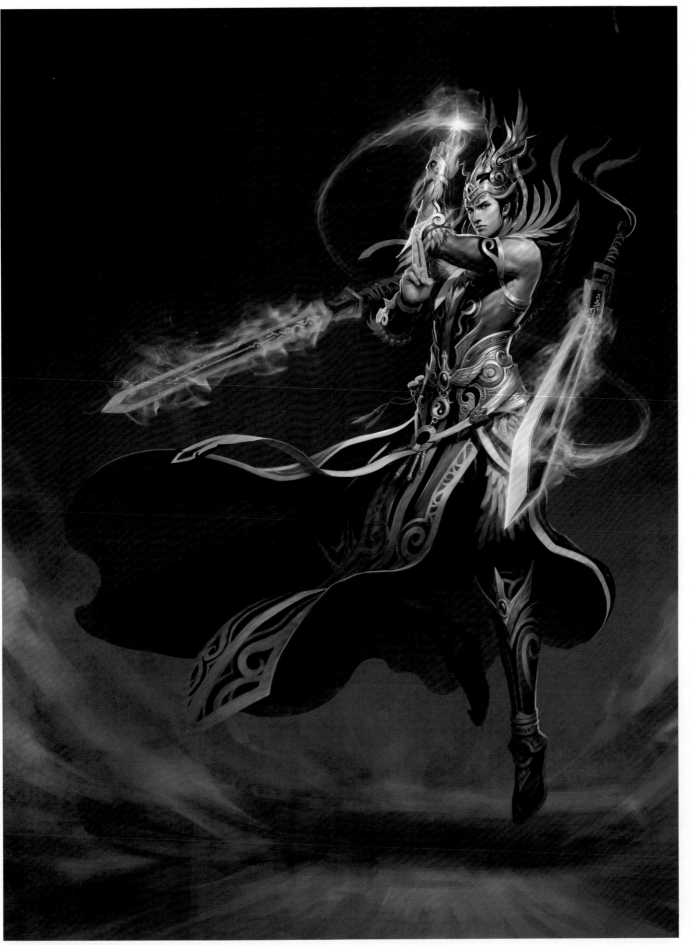

Swordsman from Mount Shu

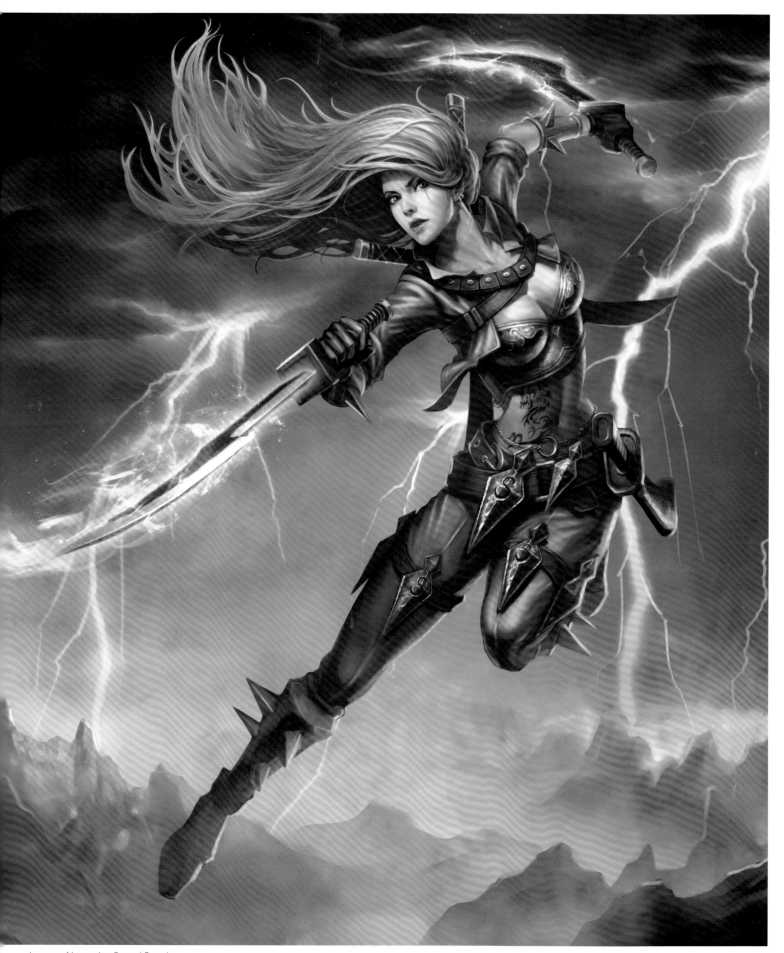

League of Legends—Cursed Sword

Zhang Luye

Screen Name: Luye Concept Painter
Blog: weibo.com/luyegainianxinhua
 blog.sina.com.cn/luyegainianxinhua
Profession: Concept designer, concept artist for games

PROFILE

Zhang Luye graduated from the Animation Design Department of the School of Arts and Sciences, Sichuan Normal University. He entered the game industry in 2008, and currently works at Gameloft.

INTERVIEW

What was the most important project for you last year?
 Two were very important: one was "Heroes of Order & Chaos" for Gameloft, and the other was "The Amazing Spiderman 2" for the same company.

When did you first develop an interest in art?
 Both my parents are engaged in painting. For that reason I had an intense interest in painting from childhood.

How do you spend your free time?
 I'm a B-boy and like to dance with others when I'm free. I'm also a sports person. Street dance, mountain bike downhill, rock climbing and other extreme sports are all my passions.

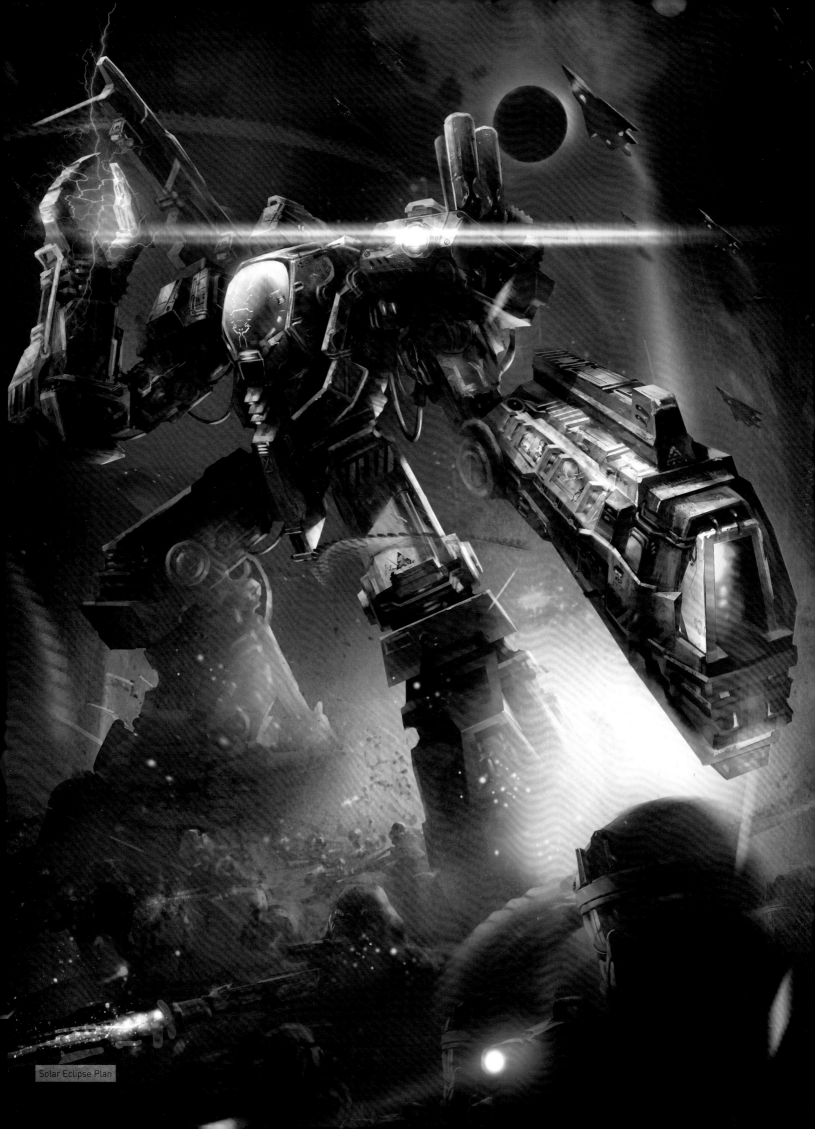

Solar Eclipse Plan

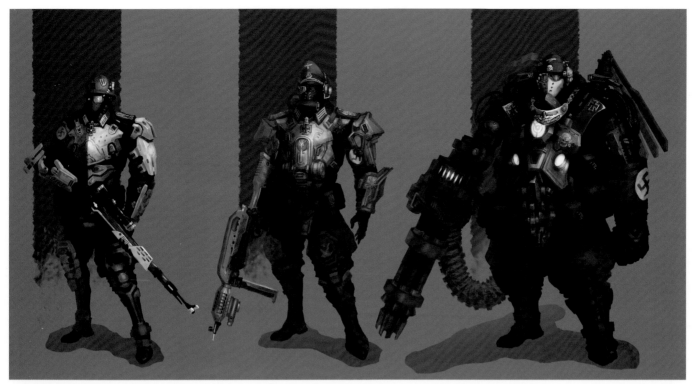

German Soldiers

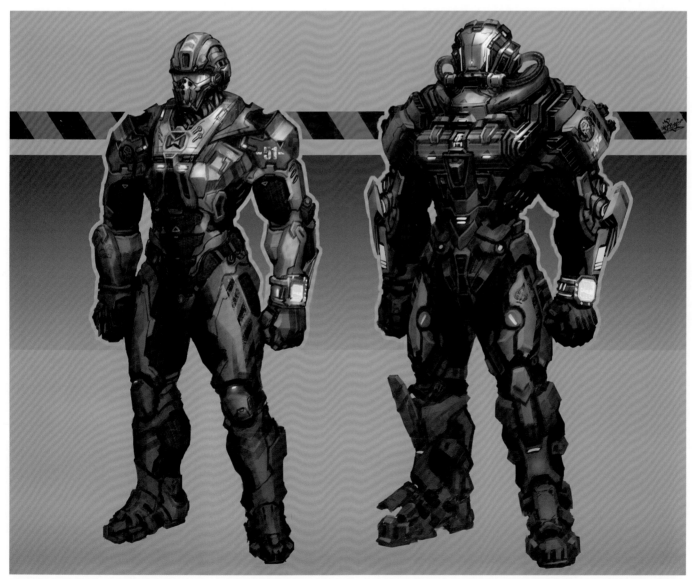

Final Sketch for Armor

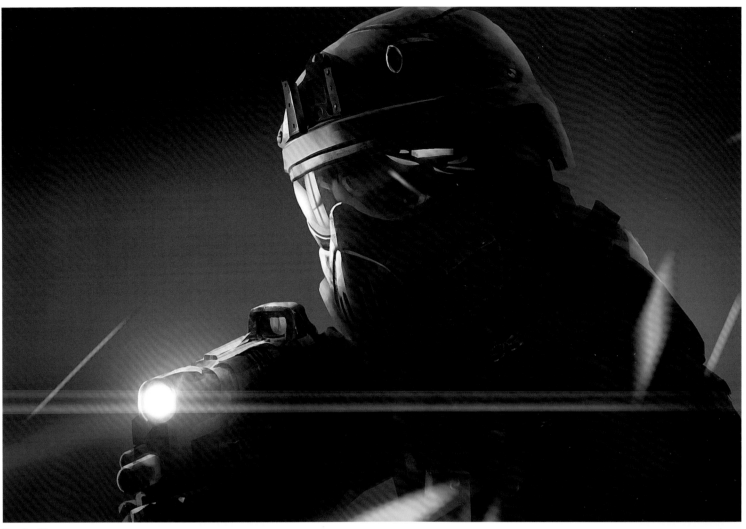
Practice 01

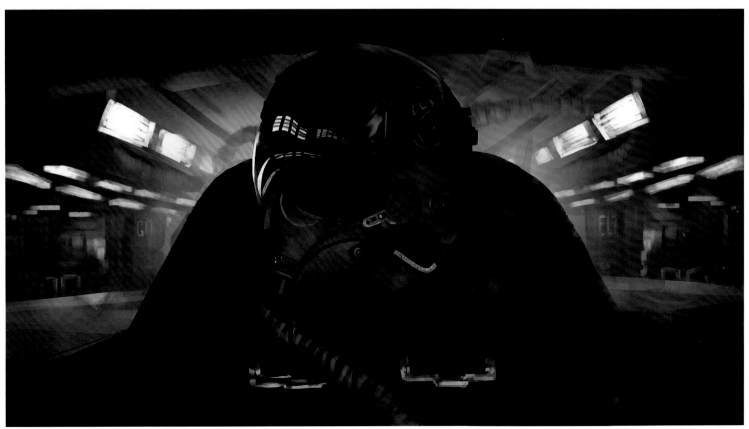
Practice 02

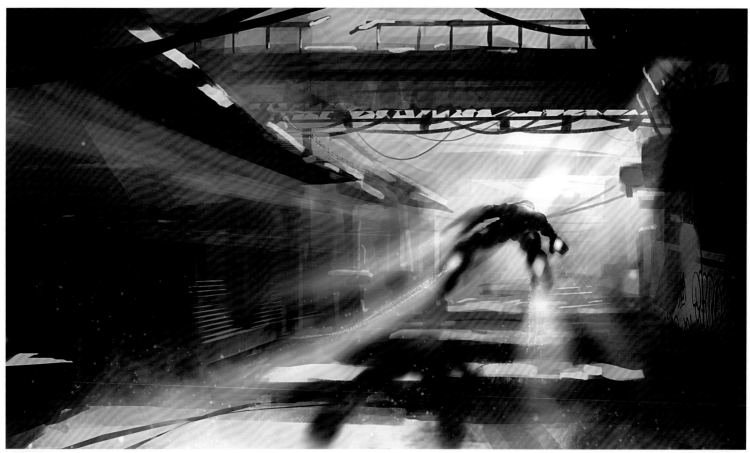
Taking off

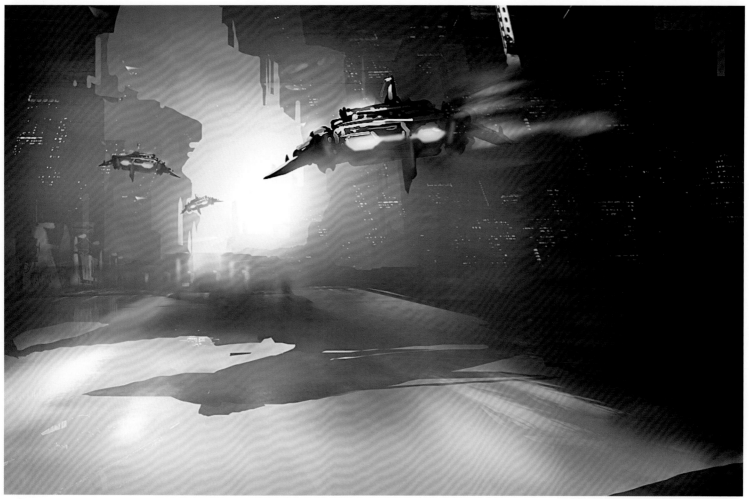
Departure

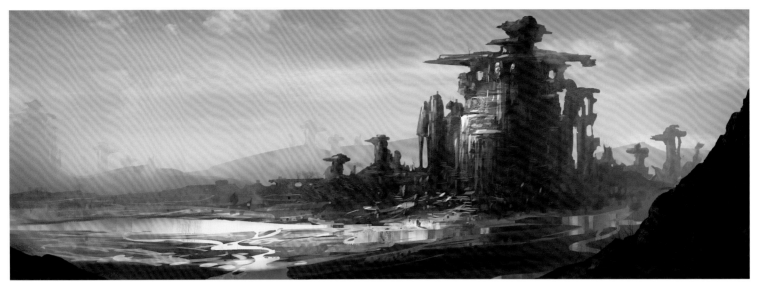

Atmosphere 01

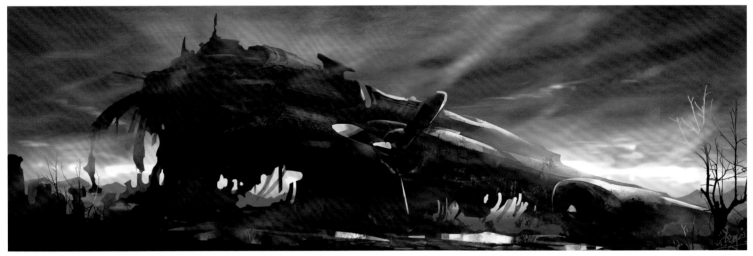

Atmosphere 02

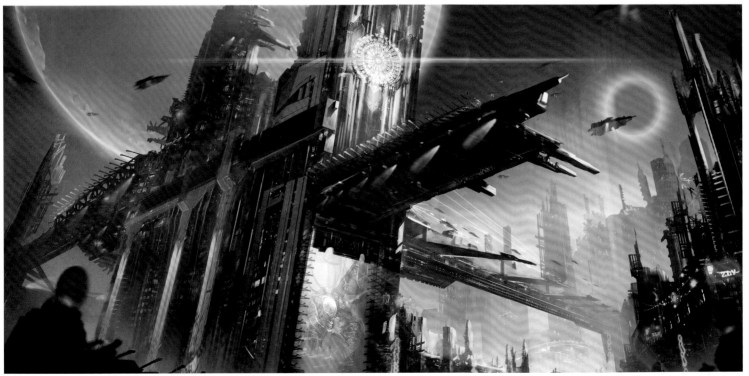

2099-V38

Dong Shaohua

Screen Name: *Jackstraw Reloaded*
Blog: blog.sina.com.cn/fantasydong
Profession: Freelance illustrator

PROFILE

With years of experience in the illustration industry, Dong Shaohua has produced a large amount of cover images and illustrations for many fantasy literature titles as well as renowned domestic and foreign magazines. He is also responsible for many poster and character designs for online games. His styles are diverse, featuring fantasy, swordsman, and comics. Recognized for his realistic touch and distinctive aesthetics, his work has been showcased in collections such as *The Best Works of China's Top 100 Illustrators* and the *Master Yearbook* among others.

INTERVIEW

As one of the most senior designers in game concept art, what, in retrospect, do you think is your defining feature? What makes you who you are today?

I am indeed senior in age, but whether I'm senior in terms of skills is a different question. Over the years, one of my trademarks has been my increasing focus on Chinese subjects. In the larger context of Chinese online games, such subjects have been quite favored. I must express my heartfelt thanks to my mentor Weng Ziyang. Though I have never put my gratitude into words, I have always felt it at the bottom of my heart. Weng's Chinese style has always influenced and inspired me. I still have a long way to go, and I hope for new achievements.

Digital painting is becoming a dominant trend. Which do you think is better for commercial projects, digital painting or traditional hand painting? Which one do you prefer?

Actually, I personally prefer hand painting. However, digital tools are indeed more convenient and less time-consuming to use. They are incomparable when it comes to commercial projects, but hand painting still maintains a dominant position in the artistic and creative domain. Hand painting produces a unique texture, which cannot be achieved through CG techniques. However, many digital artists incorporate both hand painting and CG techniques in their creative activity. Illustrators have to adjust themselves in a timely way with the advance of technological development. At first, I first finished line drawings in pencil by hand, and then scanned them to paint with computer. Later, I got rid of the pencils and relied completely on computer. Of course, I still practice painting by hand occasionally. After all, hand skills are important. Computers are nothing more than a tool.

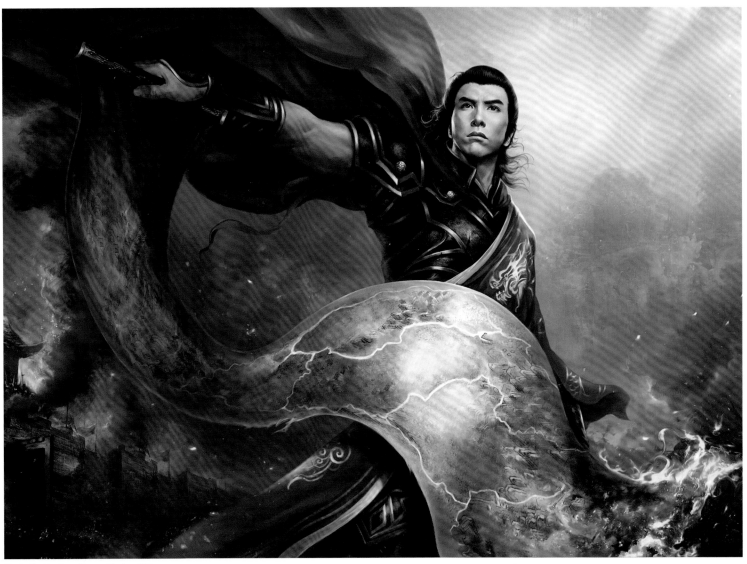

Unrivalled in Great Tang—National War

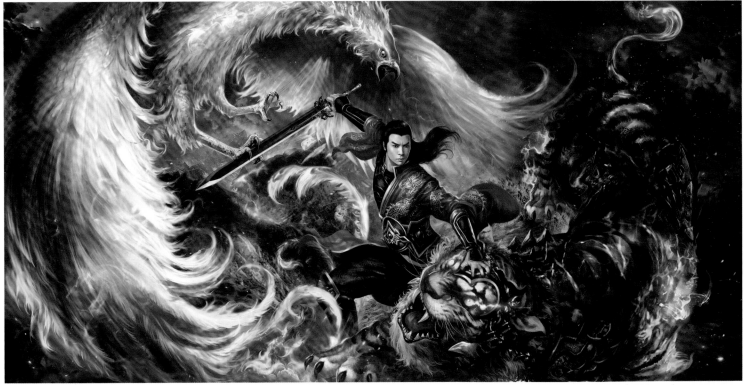

Unrivalled in Great Tang—Divine Beast

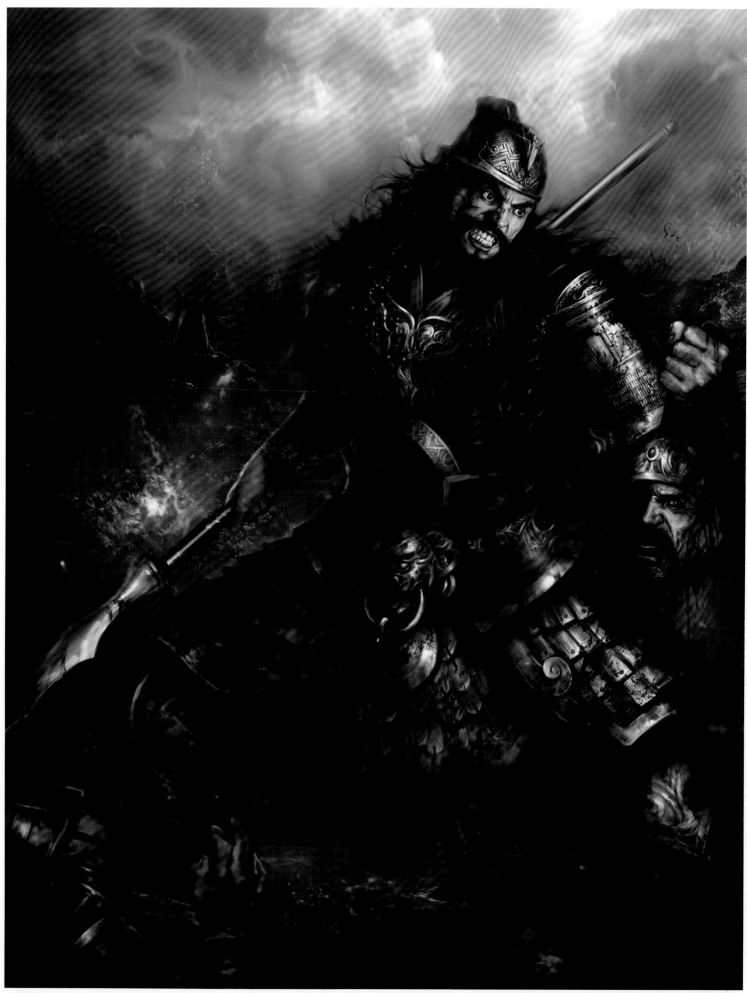

Ferocious Zhang Fei

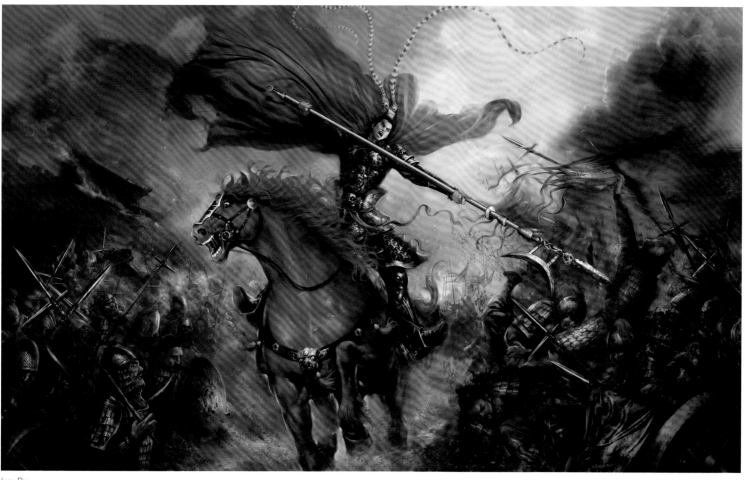

Lyu Bu

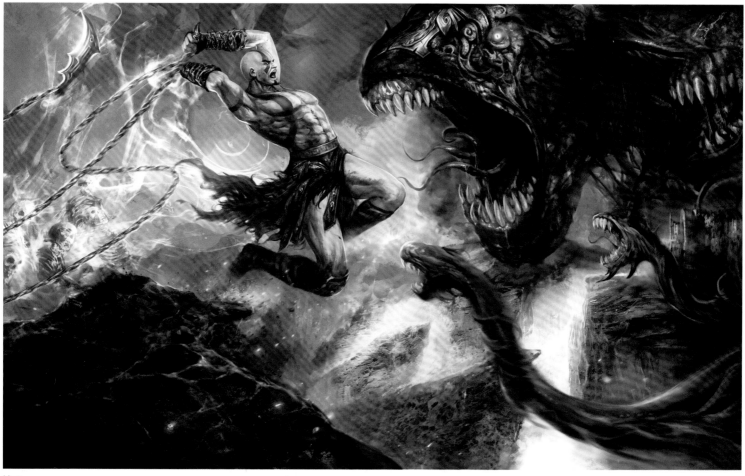

Mars

Wang Xun

Screen Name: Boar Wangxun
Blog: blog.sina.com.cn/wangxun3145
Profession: Concept artist

王
勋
W
a
n
g
X
u
n

PROFILE

Wang Xun graduated from
the Department of Animation,
Communication University of
China. He serves SNDA as senior
concept designer and director
of the 2D Art and Entertainment
Department.

INTERVIEW

As a professional who has been in this
industry for many years, you must have much
experience to share with young painters. What
do you want to share most?

There is no shortcut. Observation and
practice are the most immediate and efficient
ways to make improvements. Painters are
always haunted by two challenges, one of
which is concerned with inspiration, while
the other is about skill. The latter can be
addressed through practice, while the
former requires observation, thinking and
accumulation. To observe, think, and then
accumulate, so that fresh materials can be
reorganized and integrated, and turned into
inspiration. Observation has to be followed
by thinking, because just seeing something
will not be of great help. Only things that have
been observed and dwelled upon take root in
our mind. The other solution is practice, which
is the only efficient way to acquire sound skills.

Digital painting is becoming a dominant trend.
Which do you think better fits commercial
projects, digital painting or traditional hand
painting? Which one do you personally prefer?

Digital painting is second to none as an
efficient and powerful effect processing and
editing instrument and is thus obviously
better positioned for commercial use.
However, traditional hand painting is the base.
Personally speaking, I find it challenging to
give full play to my ideas and skills when
doing commercial projects. Therefore, I
prefer to exploit my potential via traditional
hand painting. Besides, staying away from
electronic devices can relax both my body and
soul, and free me from uncomfortable feelings
as a result of long-term exposure to electronic
radiation.

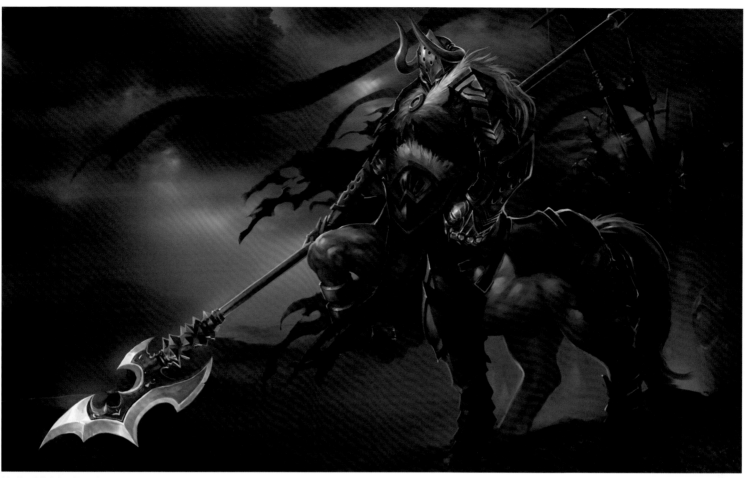

Medieval Knight—Hecarim

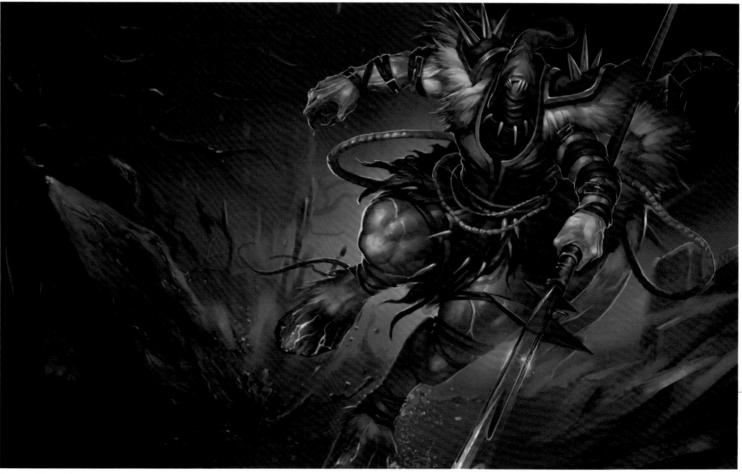

League of Legends

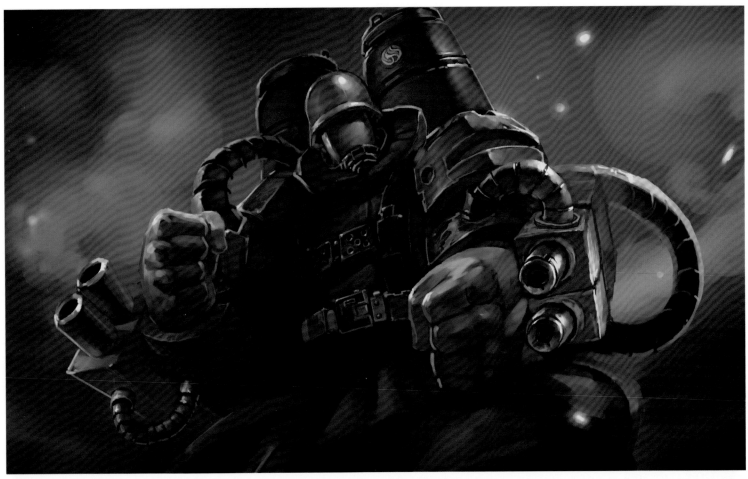

Soldier on a Flaming Lizard

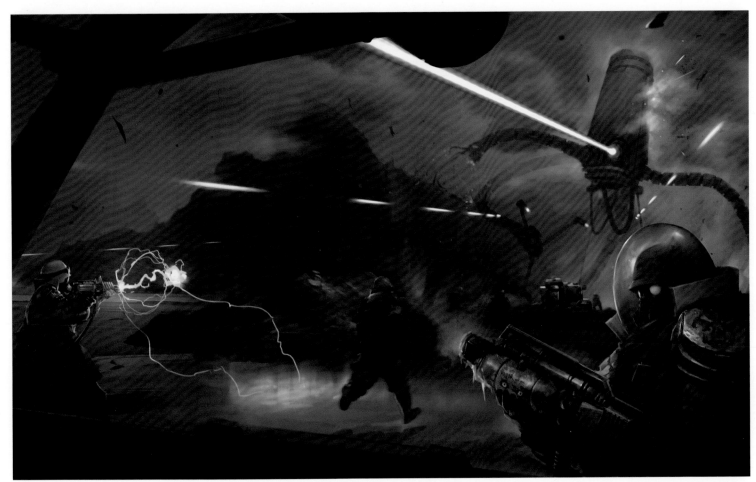

The Land of Dragons

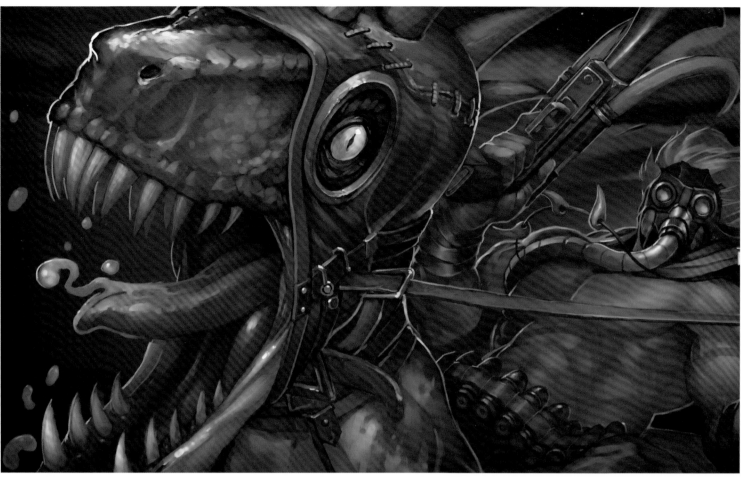

Captain of Dragon Calvary

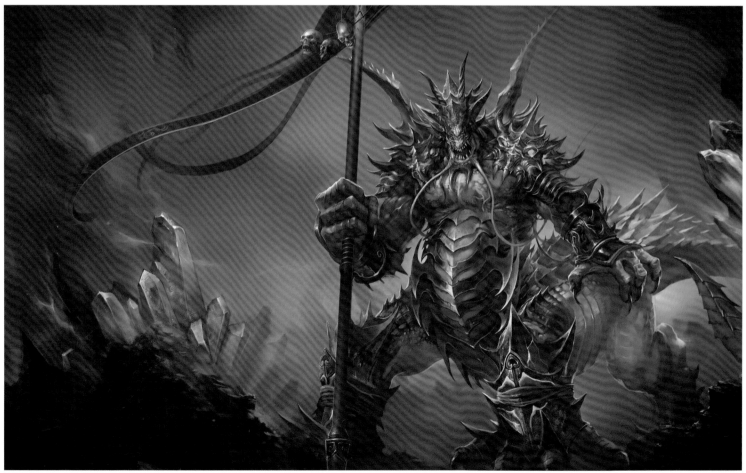

Giant Monster in the Valley

Du Zijun

Screen Name: Zijun_zinna
Blog: blog.sina.com.cn/zinnadu
Profession: Concept designer, illustrator

PROFILE

Du Zijun graduated from Tongji University in 2008 and entered the game industry in the same year. She previously served the Shanghai Office of Shenzhen Baza, Shanghai Heimang and Shanghai Moliyo. In 2013, she was signed to APPLIBOT in Japan as professional painter.

INTERVIEW

When did your interest in art begin? What made you become a professional artist?

Even before primary school, I had already started painting and playing the piano. This childhood experience has exerted a strong influence on me. However, I did not choose art as my major for higher education, but studied science instead. After graduation from the computer department, I had no career plan at all. During this period, I never give up my passion for art. I took part in various art festivals, read many books on the subject and watched many movies and animations. I spent numerous weekends in the gallery. In college, I took design-related part-time jobs. With intensified interest in art, I started to seriously think about becoming a professional painter.

How do you spend your free time?

I attend live concerts by rock bands or other live music performances. I also like to take trips to expand my vision and change my understanding of the world. I'm also a passionate reader. Recently, I've been trying planting flowers and playing the guitar.

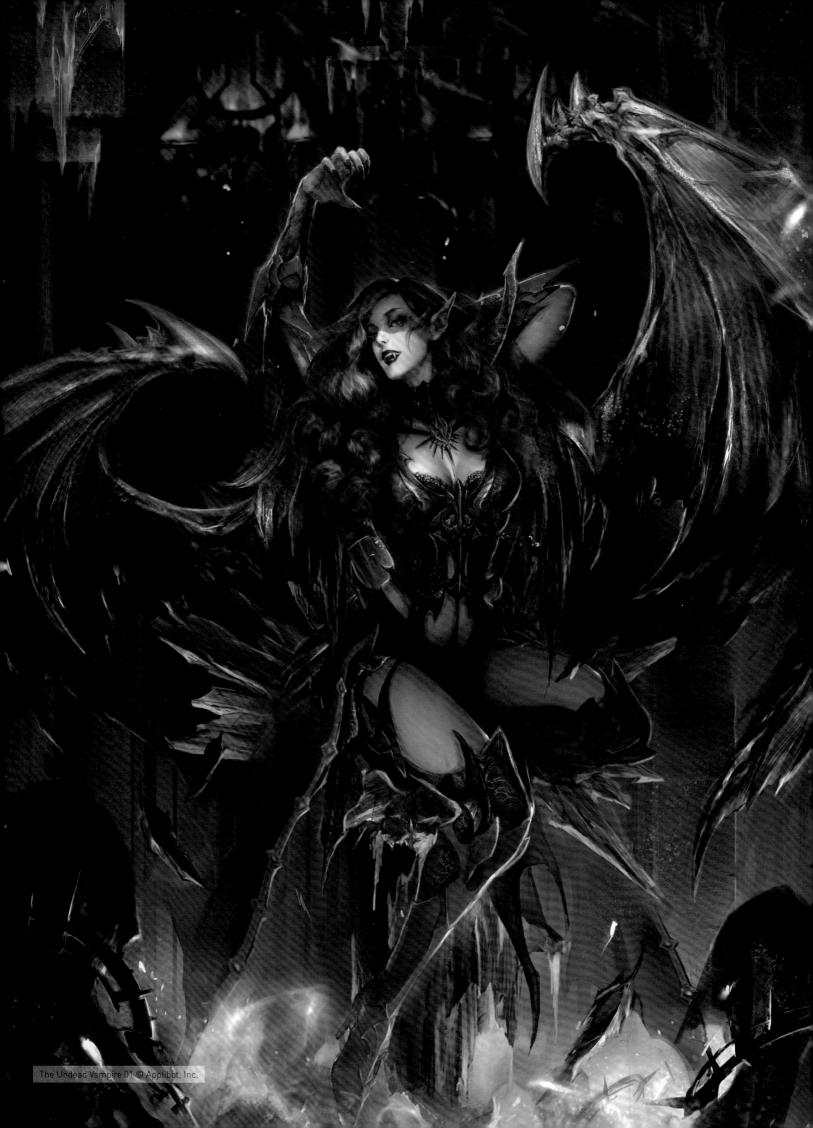

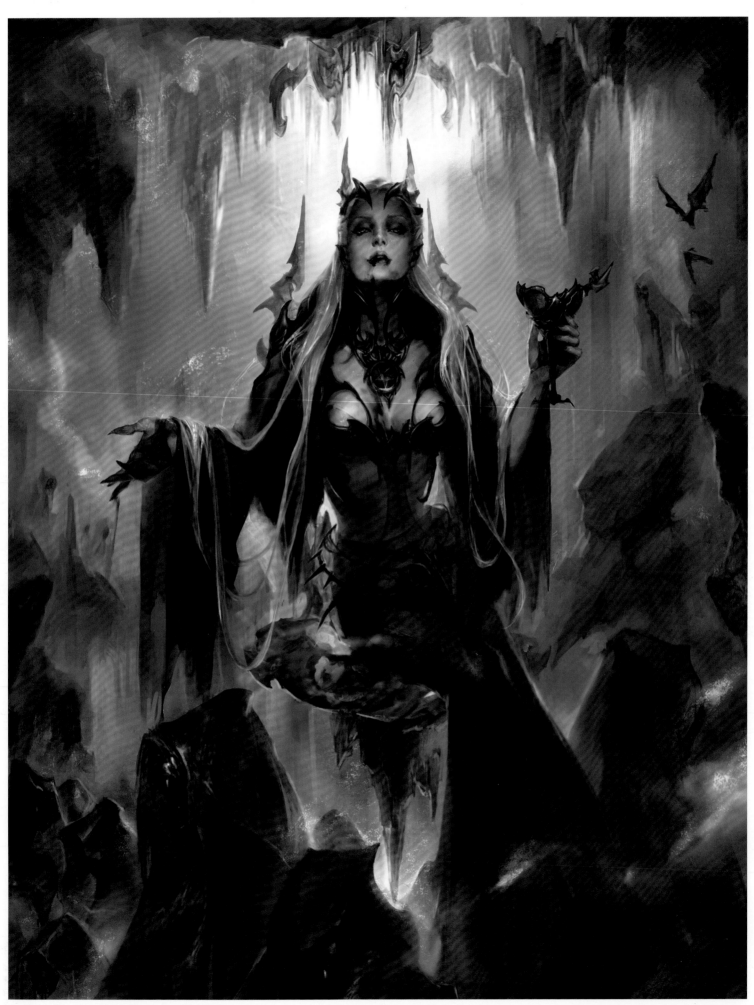

The Undead Vampire 02 © Applibot, Inc.

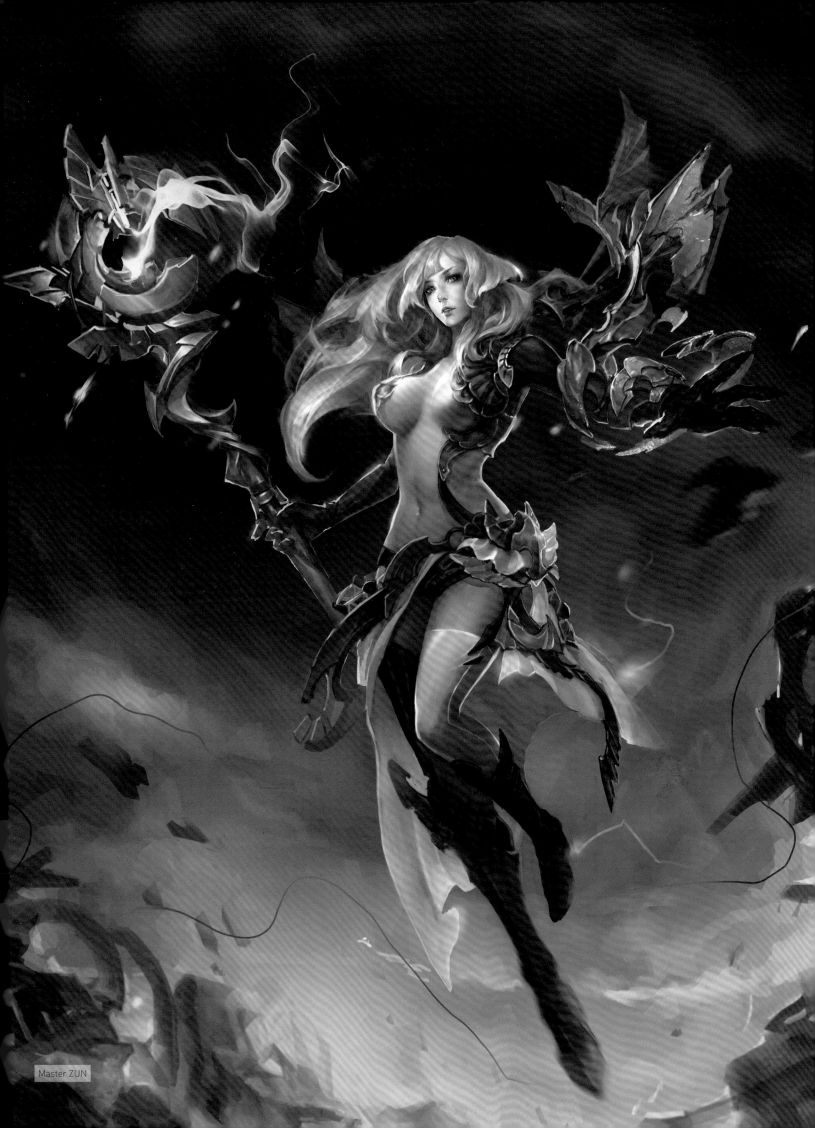
Master ZUN

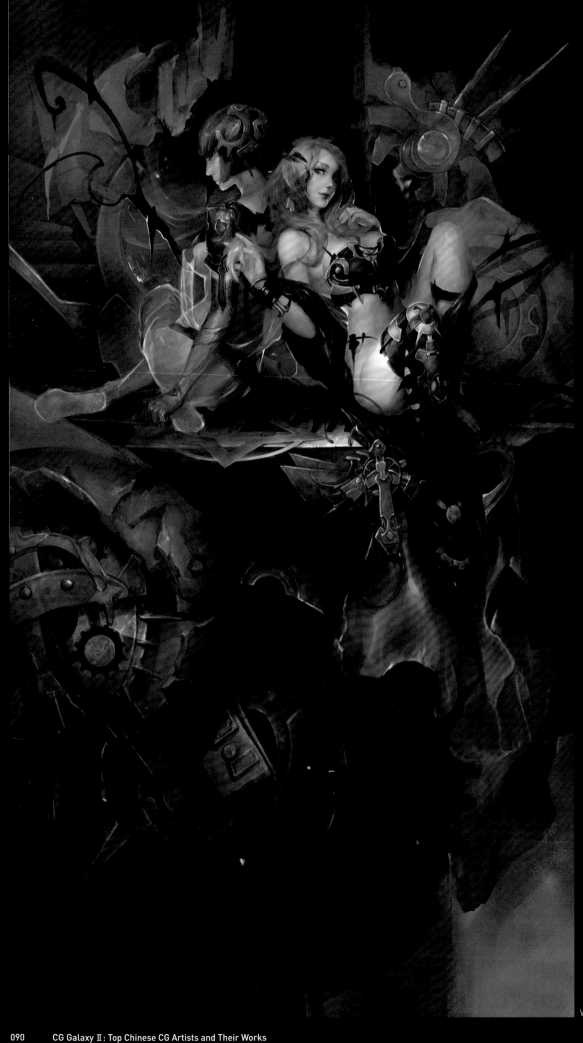

Which is she?

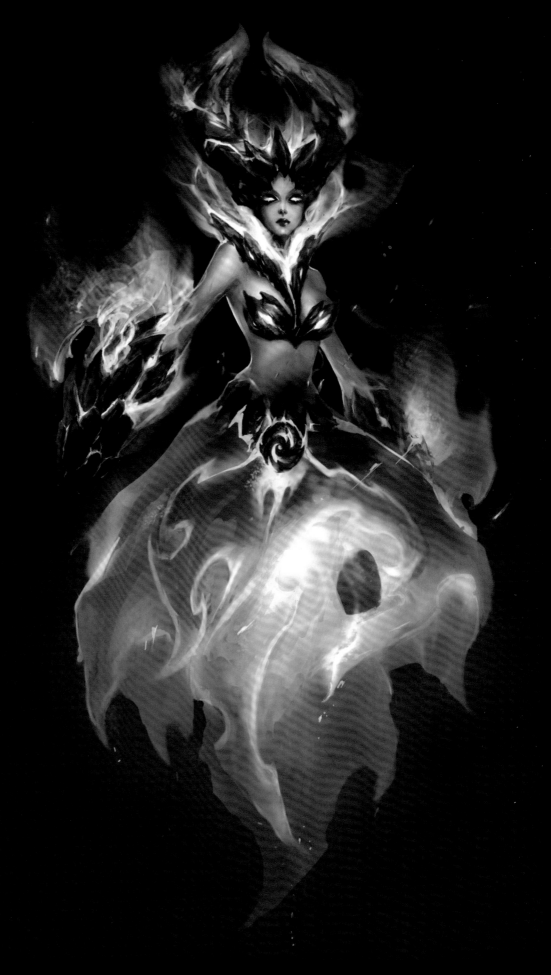

Elemental Monster

Wang Xin

Screen Name: Peach of Iron Skin
Blog: blog.sina.com.cn/tiepitaozi
Profession: Game concept artist

王
鑫

W
a
n
g
X
i
n

PROFILE

At college, Wang Xin published a short comic entitled *Sunny Mind* in *Beijing Cartoon* and joined Yanyu Vision as assistant to the chief comic writer. Wang first became engaged in CG painting in 2005 and later entered the game industry. During the past seven years, he first served Dynamic Space as game conpept designer and then at the academic department of Beijing Game College as researcher. Since 2008, he has worked at Renren Games as art director.

INTERVIEW

Now you must have a lot to share with young painters. What do you want to share most?

I would like to share what I have learnt over the years. A beginner or young painter should pay attention to fundamental skill training. After all, fundamental skills are your backbone, while fancy strokes and flashy post effects are gimmicks. Beginners are usually obsessed with these visually appealing elements and focus on them even when appreciating masterpieces. They often neglect the most important elements such as solid fundamental skills or composition approaches, methods to control light and shade as well as atmosphere. Also, you have to be persevering, and never stop painting. Finally, you should maintain a positive psyche. It is a long journey. If you feel you have arrived, you will stop making progress.

What subjects have you chosen in the past few years?

I enjoy finding creative subjects in original works to entertain myself. Recently, I have done a lot of work on characters from "Dragon Ball." This manga phenomenon has greatly influenced me. When depicting characters, I prefer to display characters and story scenes based on my own understanding and expressive approaches . Of course, some finished characters differ so much from the original that others cannot tell they are actually the same characters.

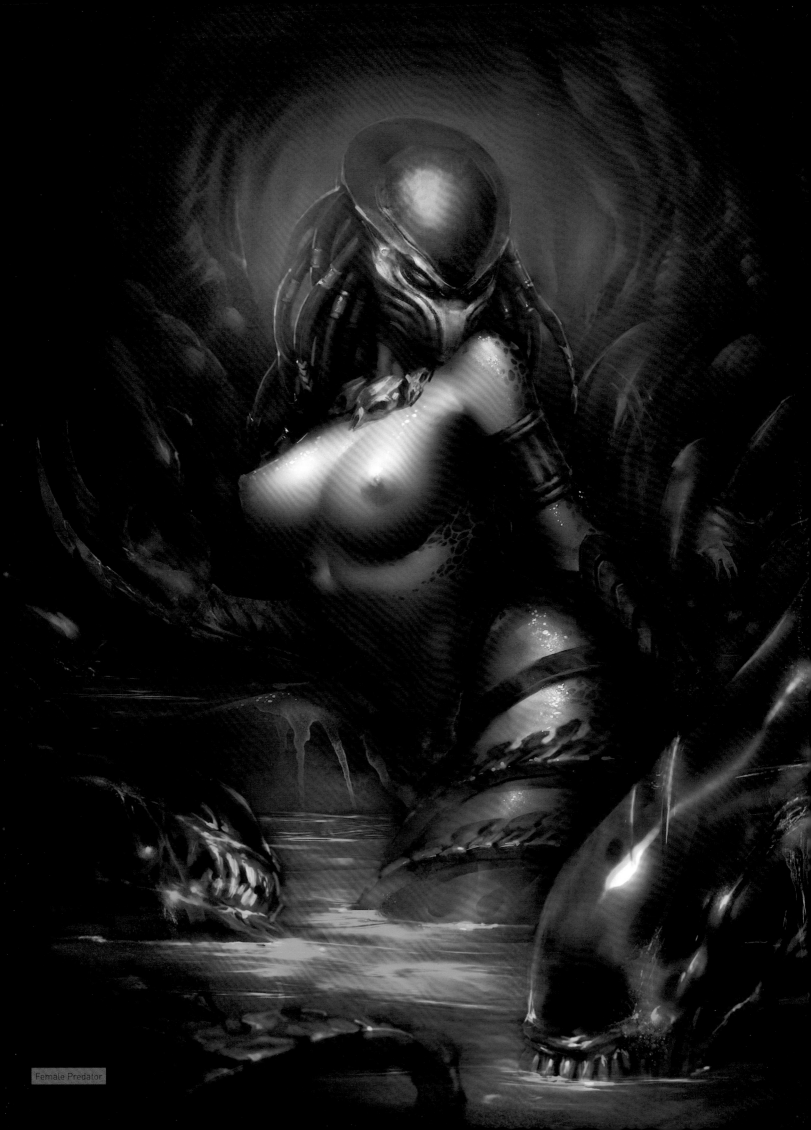

Female Predator

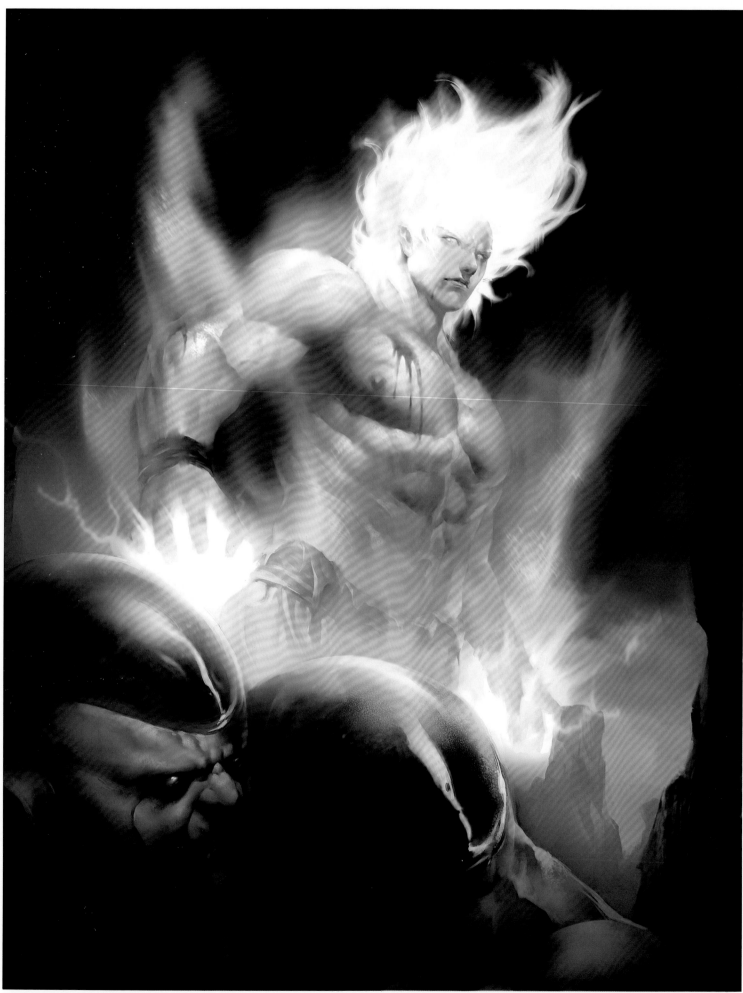

The Battle of Namek

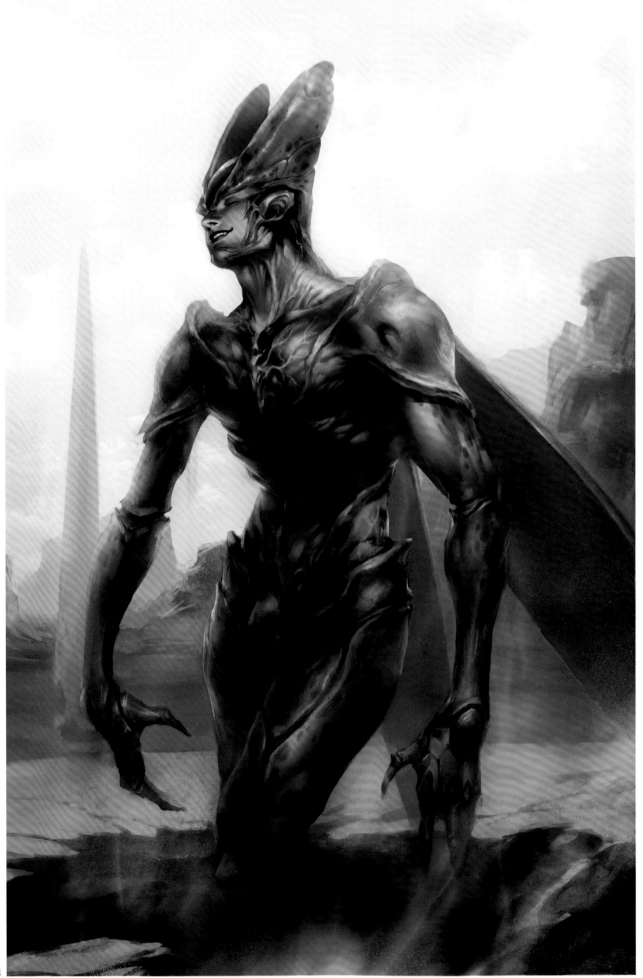

Cell

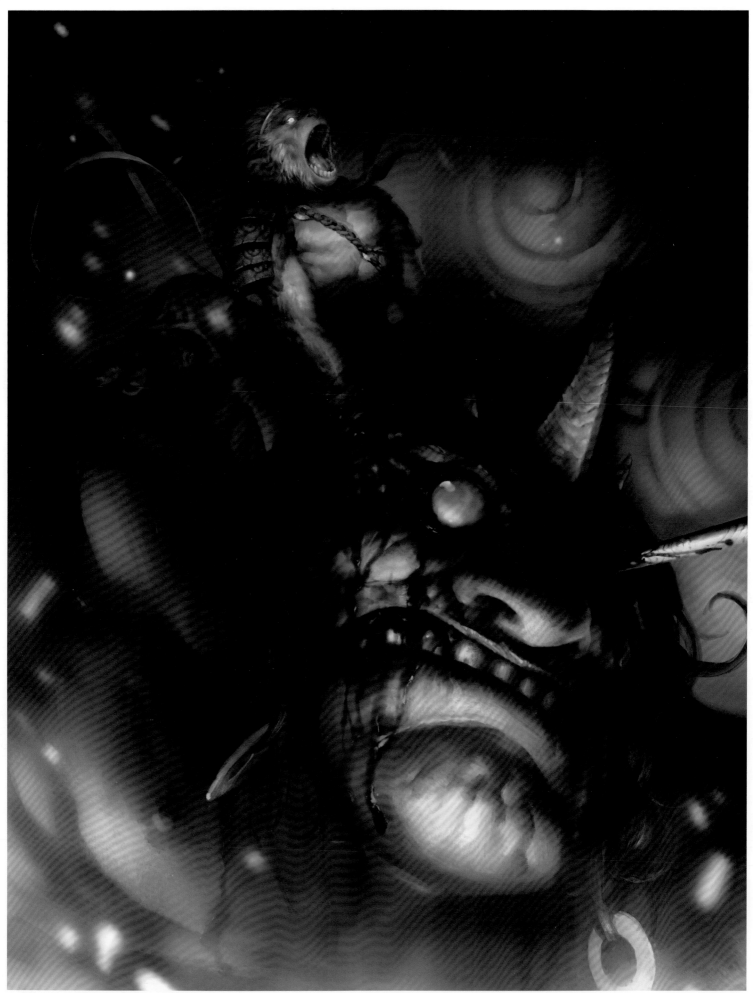

Battling with the King of Silver Horn

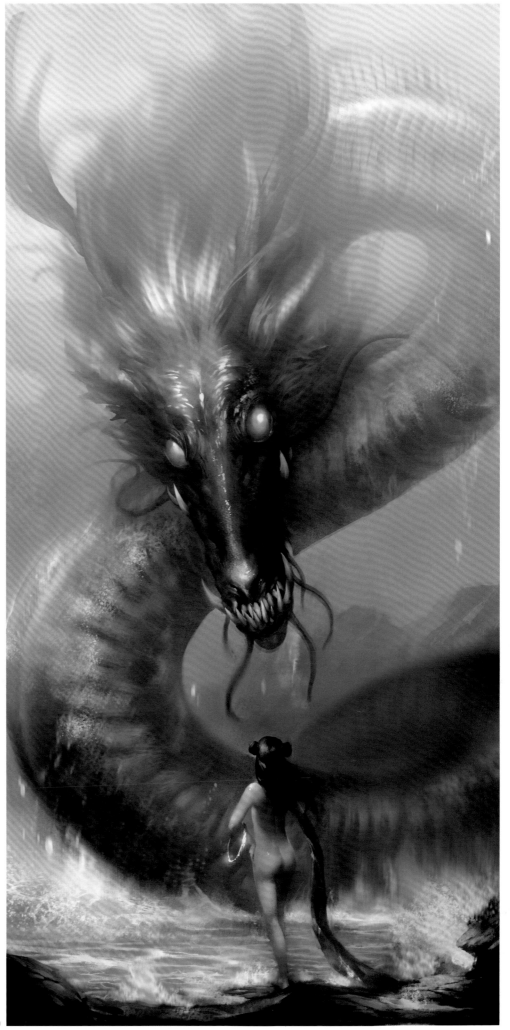

Nezha

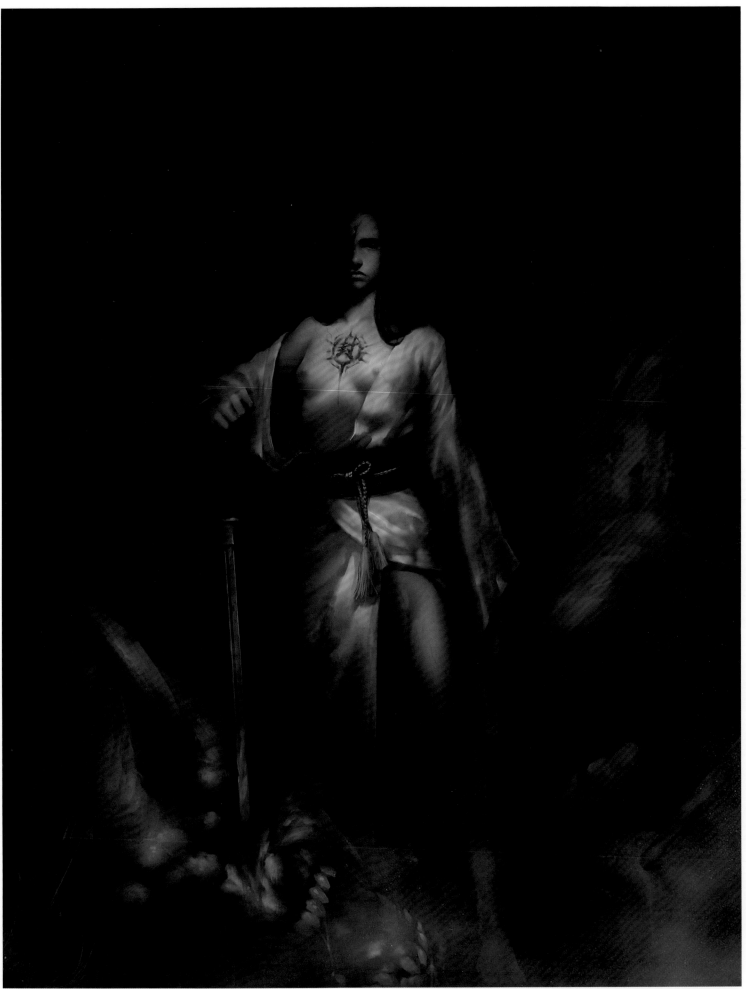

Slaughter

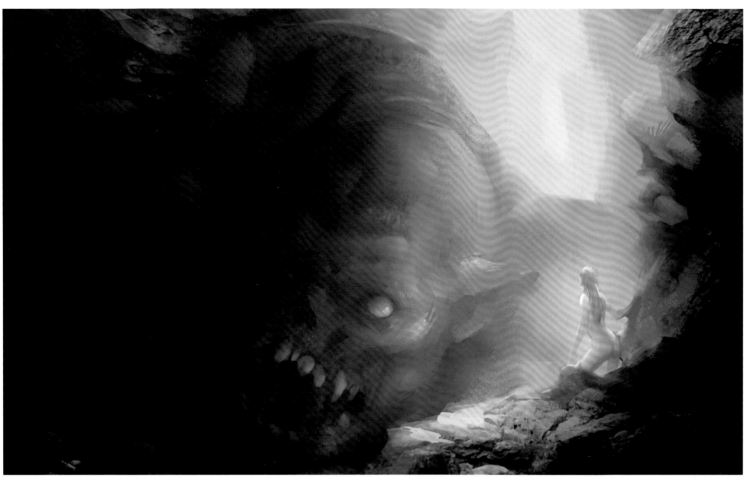

Encounter

Giant Monster

Guan Jian

Screen Name: Masterkey
Blog: www.guanjianart.com/
Profession: Freelance artist, concept artist,
illustrator, model maker, and independent
game producer

G
 u
 a
 n
 J
 i
 a
 n　关　健

PROFILE

Guan Jian first became engaged
in the game industry since 2004.
Proficient in various painting
styles and 2D and 3D techniques,
he has worked as project art
director at Beijing Kingsoft,
Youxigu International Software
among other companies. His
work was nominated for the
China Computer Graphics Festival
(CCGF), and ranked 9th in the 3D
team category for "Dominance
War 4" and 3rd in the 2D category
for "Dominance War 5."

INTERVIEW

**How long have you been engaged in this
industry? How do you feel about this industry?**

 I have been in this industry for nine years,
and am impressed by a number of things.
Like most people, I first entered this industry
out of love and the necessity to make a living.
With increasing experience and enhanced
understanding, I have mixed feelings for my
job. Fewer and fewer friends of mine are still
engaged in painting or creative work. Some of
them have switched to administrative work,
and only a few still adhered to their original
choice. However, there are still a few who
still keep their dreams and aspirations in
this industry, and those are the true lovers
of painting and games. I only hope my work
would help others to improve and grow, and
continue to bring joy to people.

**What do you think is the most important
element in the creative process? What is
of overriding significance for enhancing
creativity?**

 I believe that the concept and meaning
of your creative work is the most important
element in the process. Techniques are not
the answer, as they are simply tools to give
expression to your ideas. I'm not denying the
significance of techniques, just prioritizing
content over form. Form without content is
meaningless. Technically speaking, it requires
active observation to enrich your idea bank.
We cannot create work without foundations,
or make something out of nothing. I think

amateur designers rely on inspiration, which
cannot really be depended upon. Inspiration
comes and goes as it wishes, and can slip
through your fingers easily. It can often
leave you completely. Professional designers
depend on reflection. They reflect on their
own creation by looking at different things to
adjust to the heavy workload and high speed of
professional life. This requires rich experience,
and also extensive observation, which breeds
creative energy.

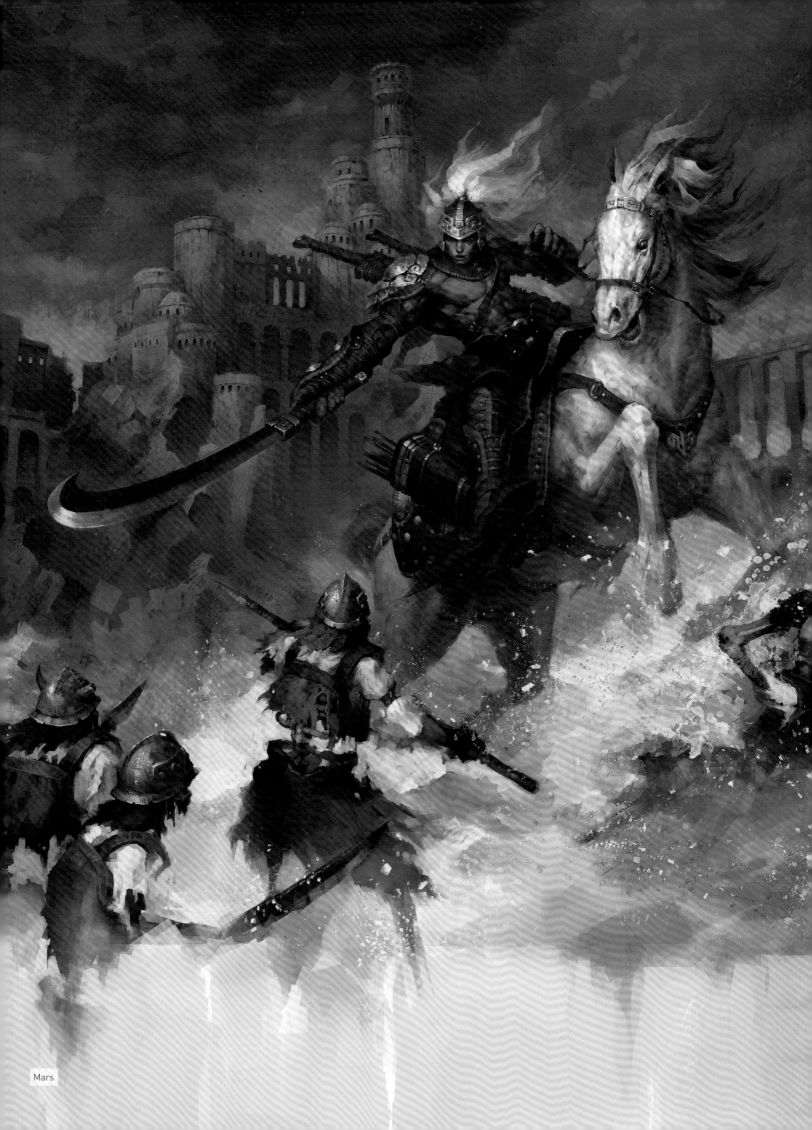

Mars

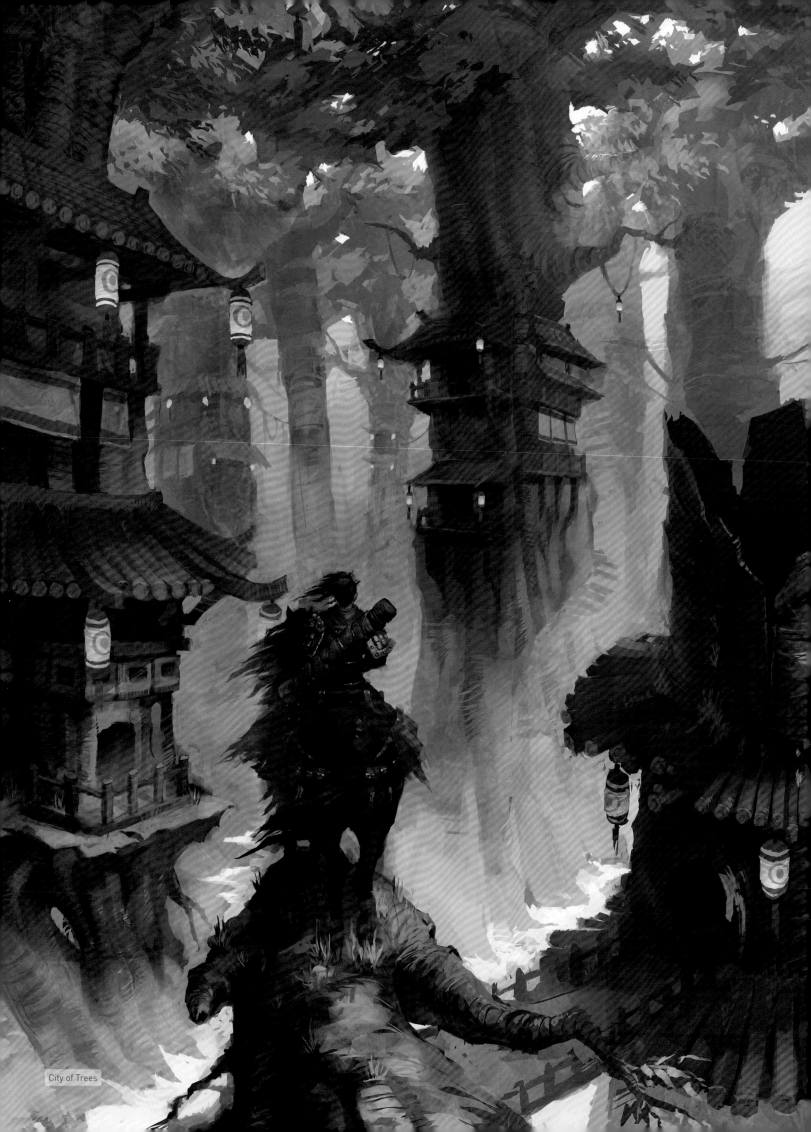

City of Trees

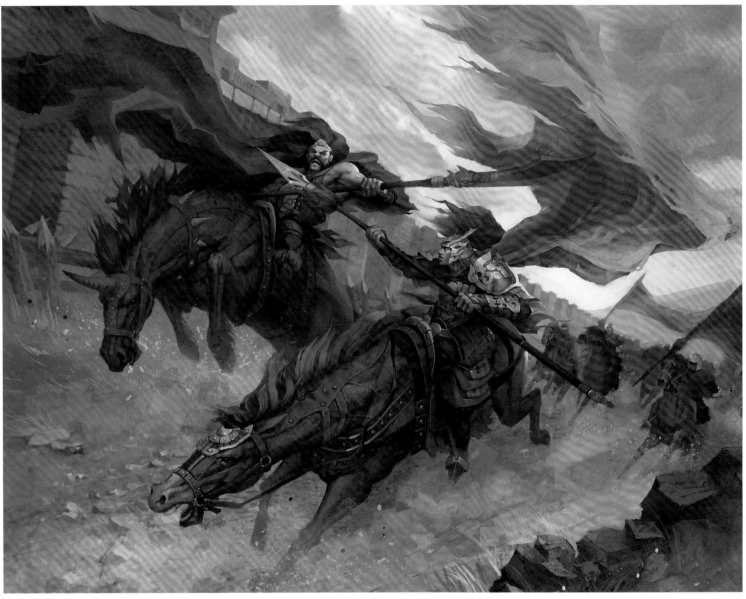

Duel

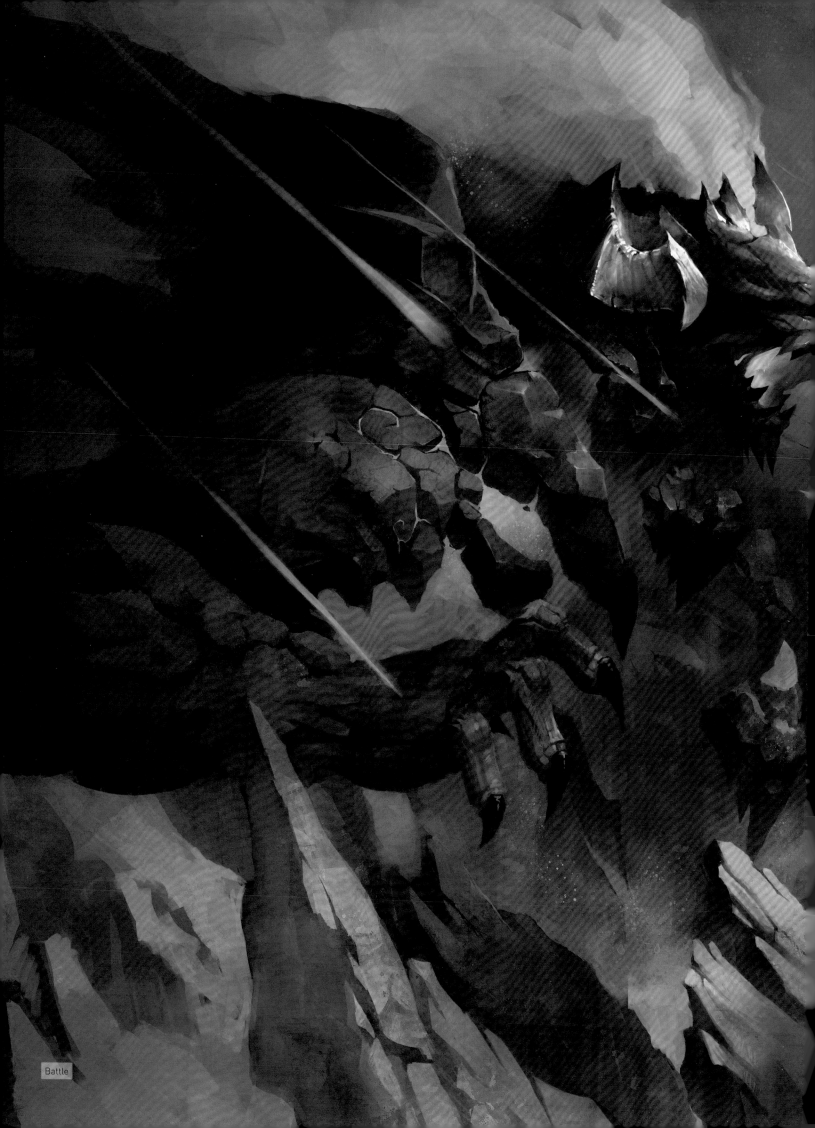

Battle

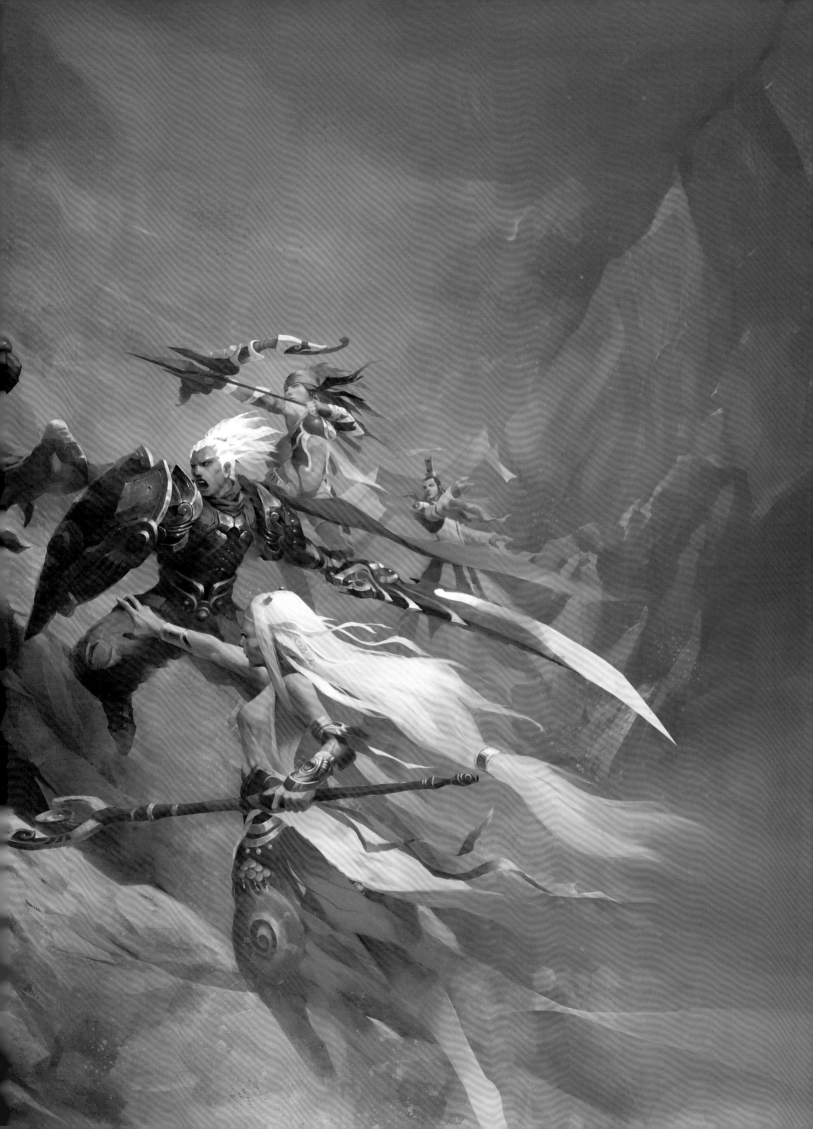

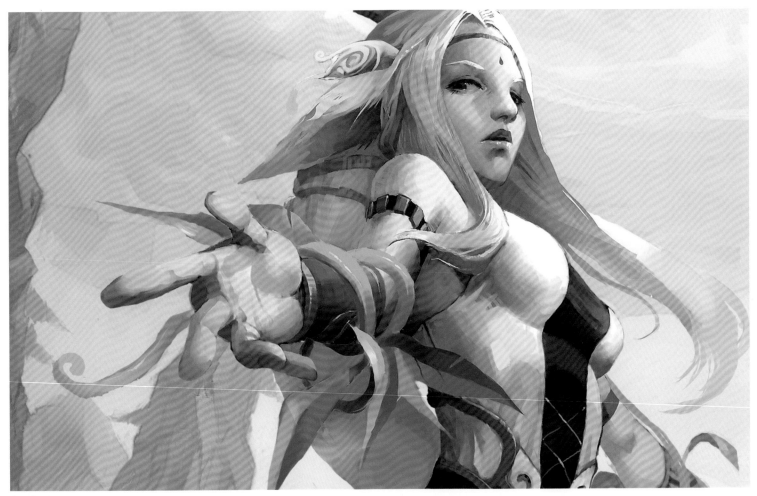

Fairy Deer

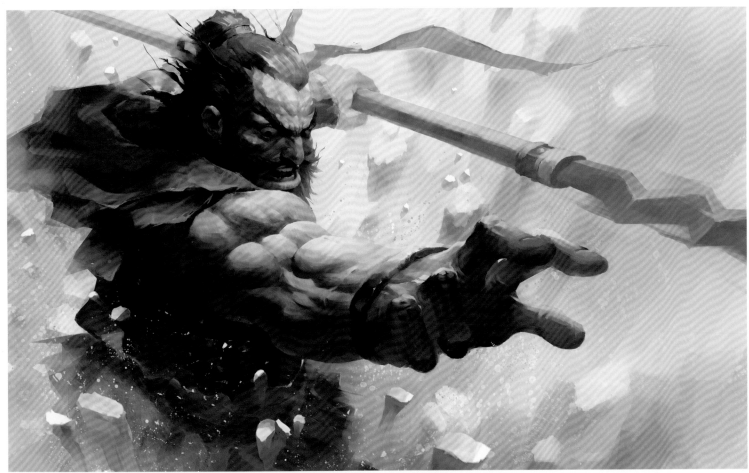

Zhang Fei

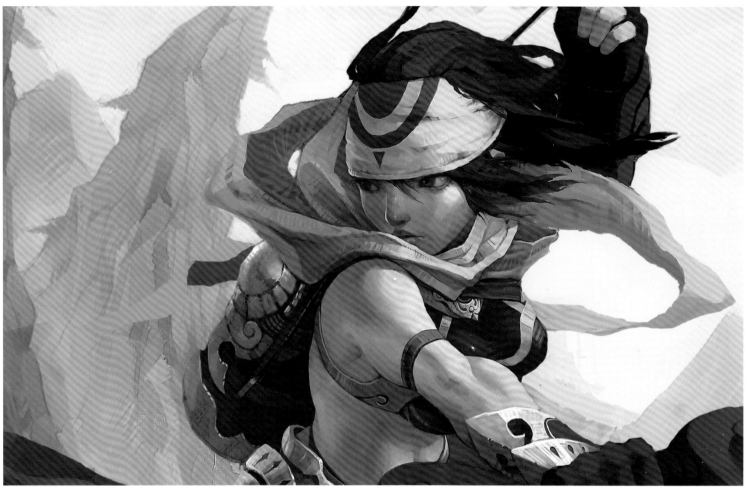

Archer

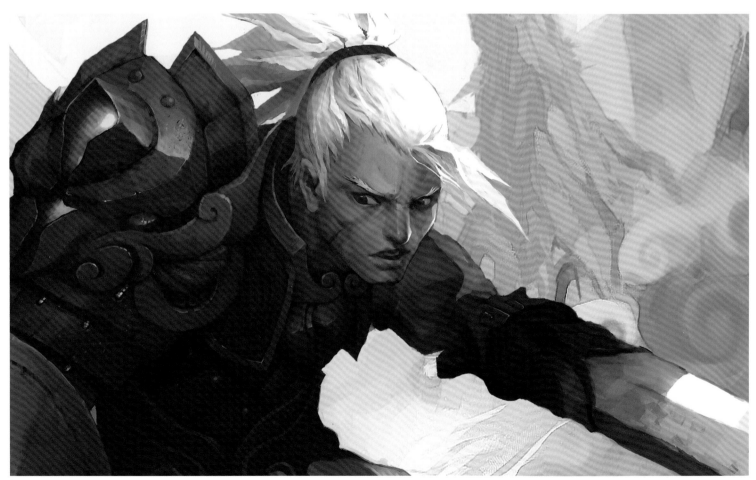

Sergeant

Cai Zhichao

Screen Name: TRYLEA
Blog: www.zcool.com.cn/u/260209
Profession: Illustrator

C a i Z h i c h a o
超
智
蔡

PROFILE

Cai Zhichao graduated from the China Academy of Art and is currently an illustrator. His representative works include "The Story of Cloud" and "Revolution of Skystrategy." He currently works as art director at GAMECOX and has participated in the core development of games such as *Zombie Evil* and *Heroic Land*. In addition, he is also a contributing illustrator to magazines such as *Novoland*, *Super Nice*, *Vista*, and *Black Pupils*.

INTERVIEW

What does traditional hand painting mean to you? If you use traditional hand painting for creative work, what's your general process? How long does it take to complete a work?

Traditional hand painting is another way to complete artwork. I'm used to sketching drafts by hand in the beginning of the creative process and I like using watercolor. Different from drafting by extensively laying color blocks and determining volume, I tend to start with line drawing when painting in watercolors. When time permits, it generally takes a whole week to complete a work.

What is more important to you, artistic sensitivity or creative techniques?

Both artistic sensitivity and creative techniques are important to craftsmen and artists, irrespective of their personal priorities. Craftsmen are keen to perfect their techniques, and art is only a byproduct; in contrast, artists try to improve their techniques in pursuit of art. Personally speaking, creative techniques can be honed during daily work, while enhancement of artistic sensitivity requires observation and perception of life.

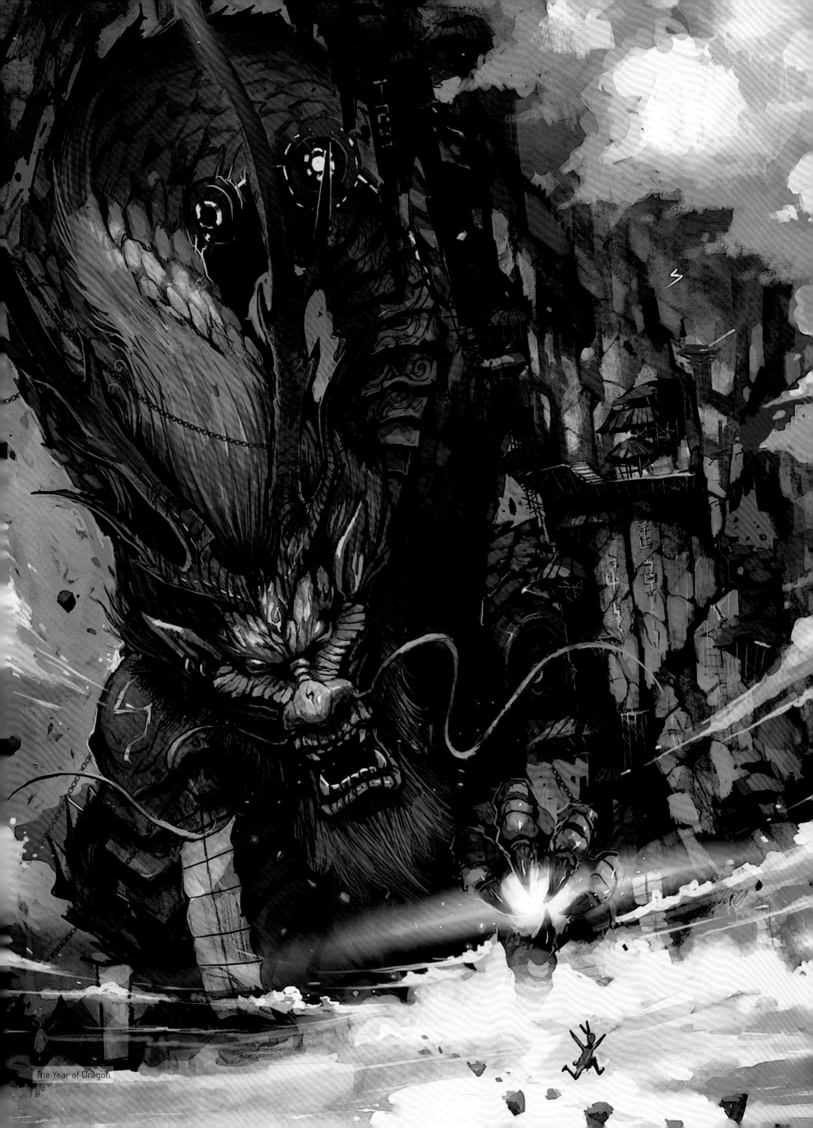

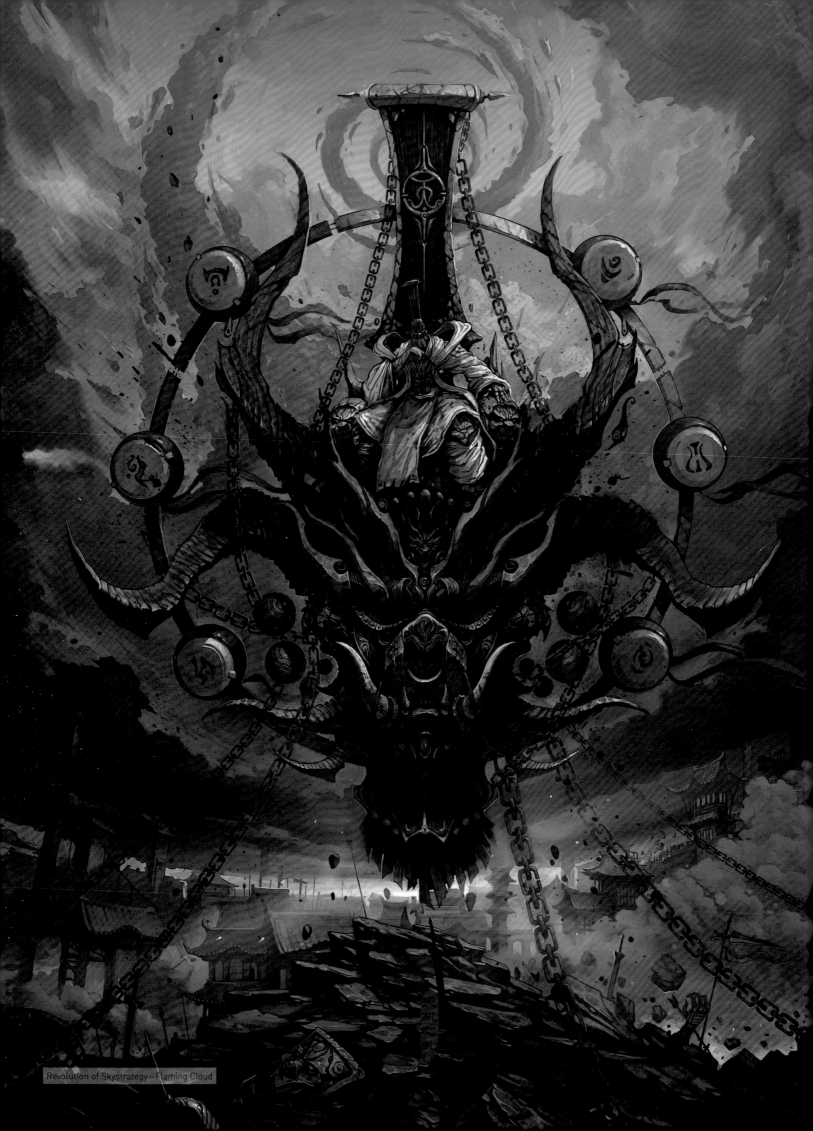

Revolution of Skystrategy—Flaming Cloud

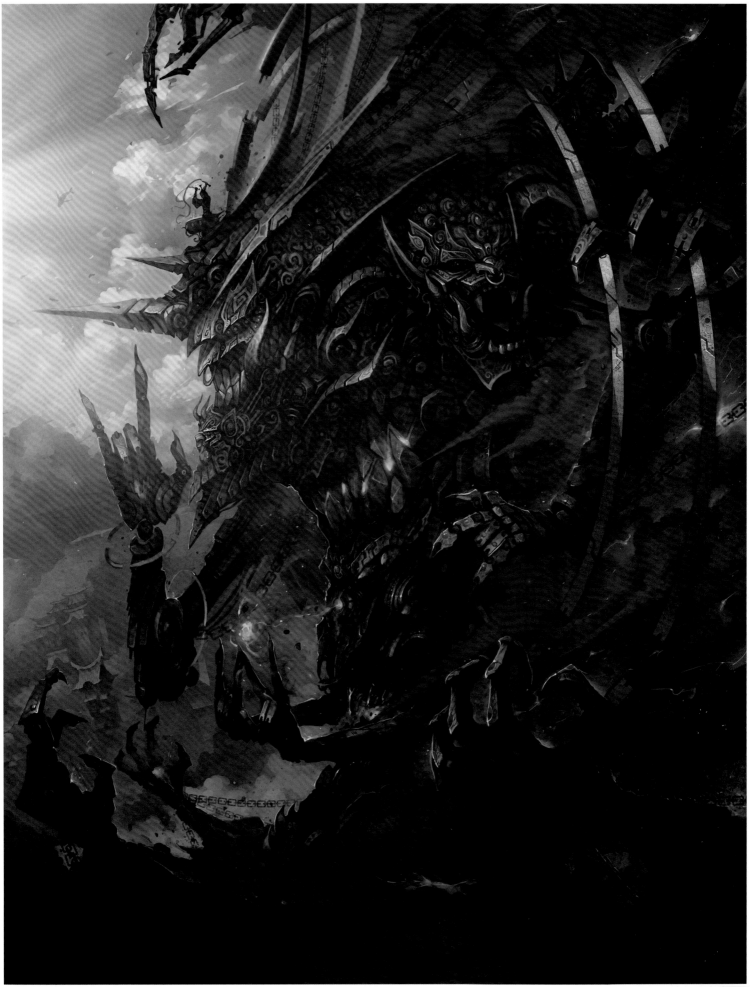

Calamity Devourer

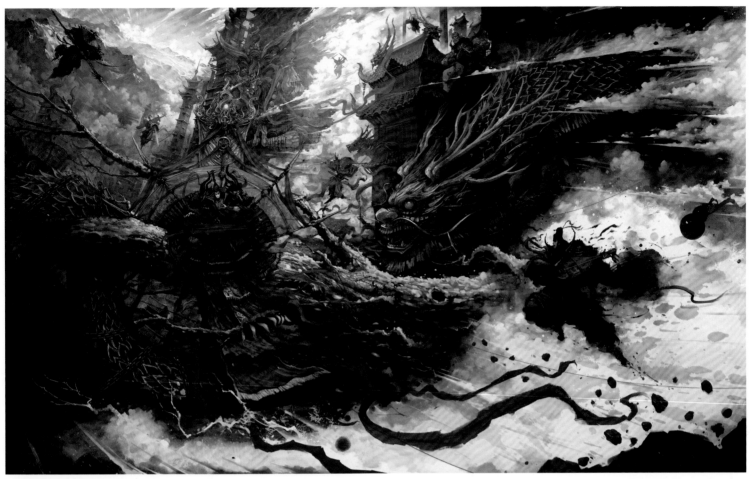

Empress of Heaven

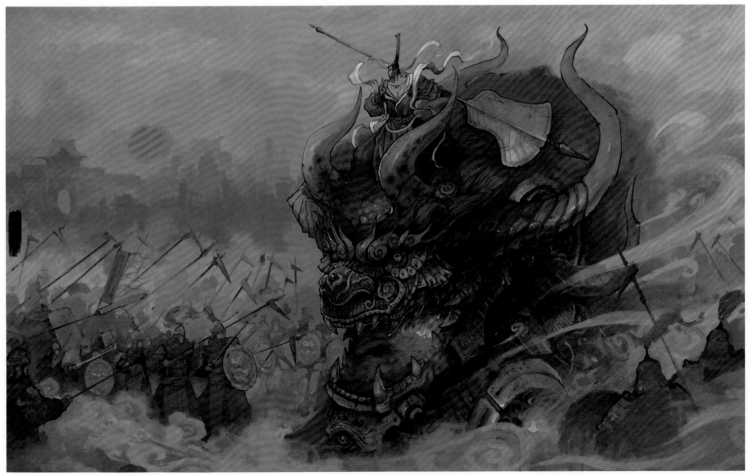

Revolution of Skystrategy—Wind and Thunder

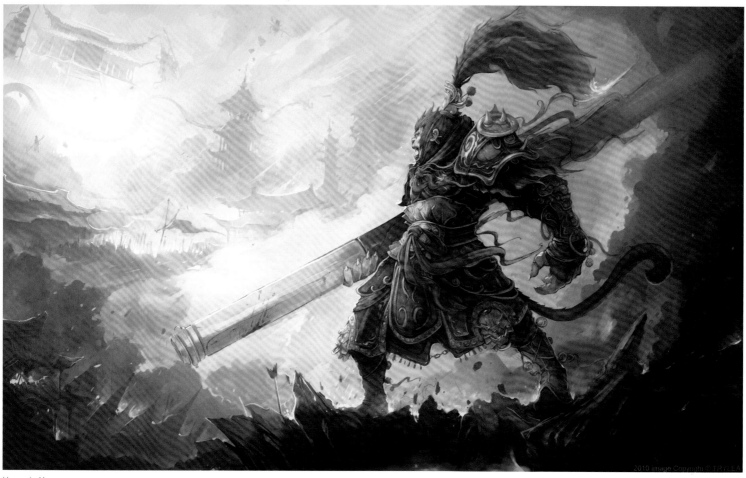

Havoc in Heaven

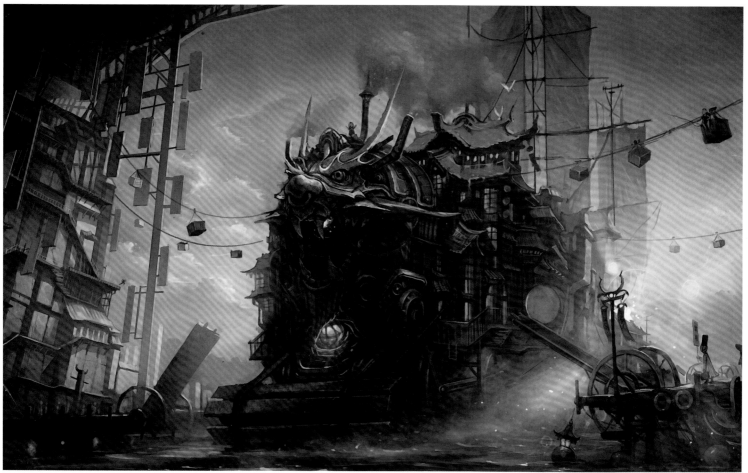

In the Cloud—Terminal

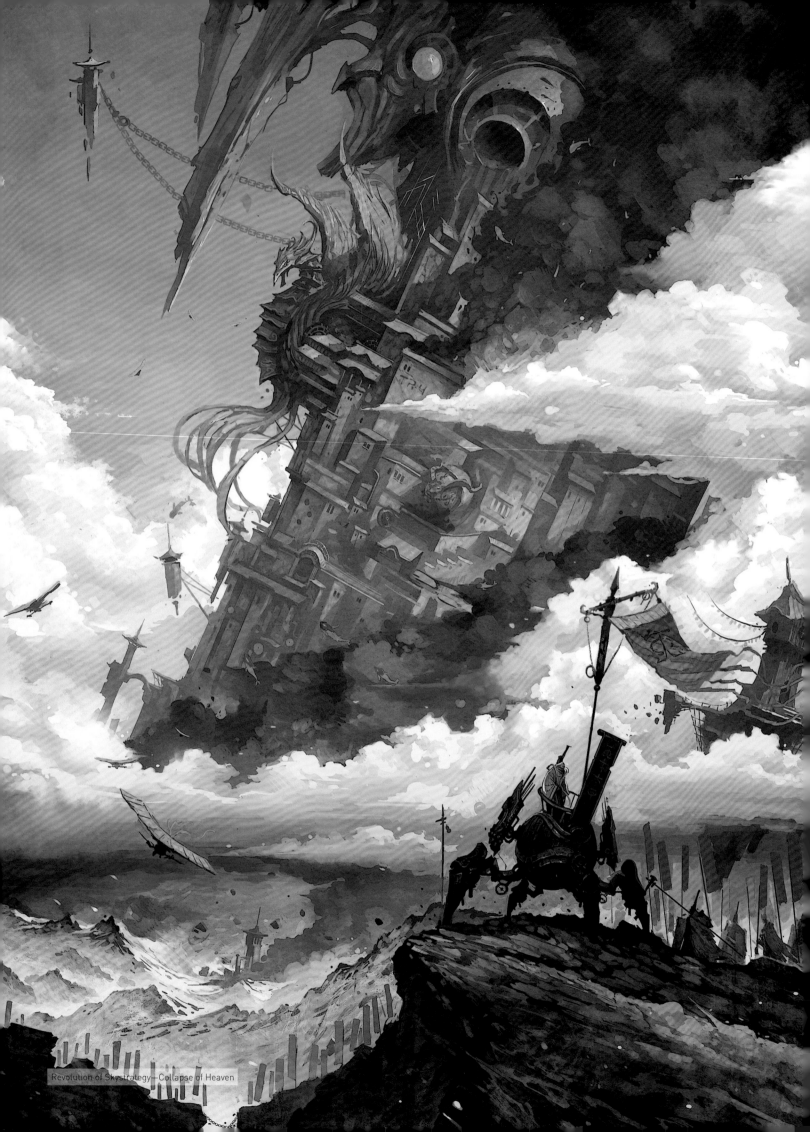

Revolution of Skystrategy—Collapse of Heaven

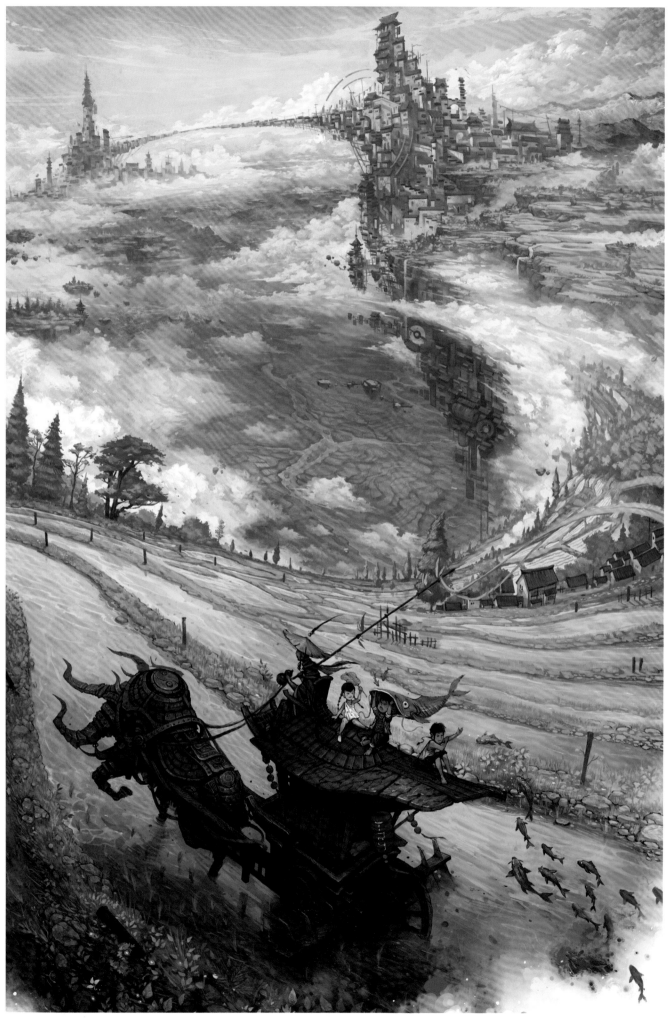

Range—Cloud

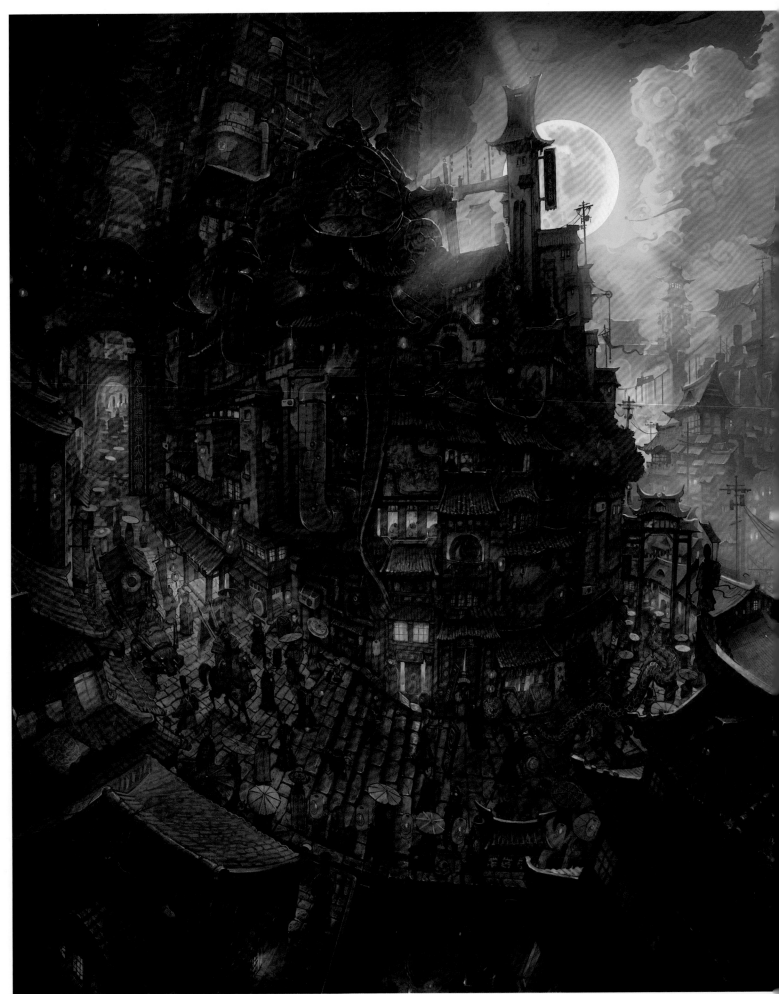

Moonlit Street and Palace

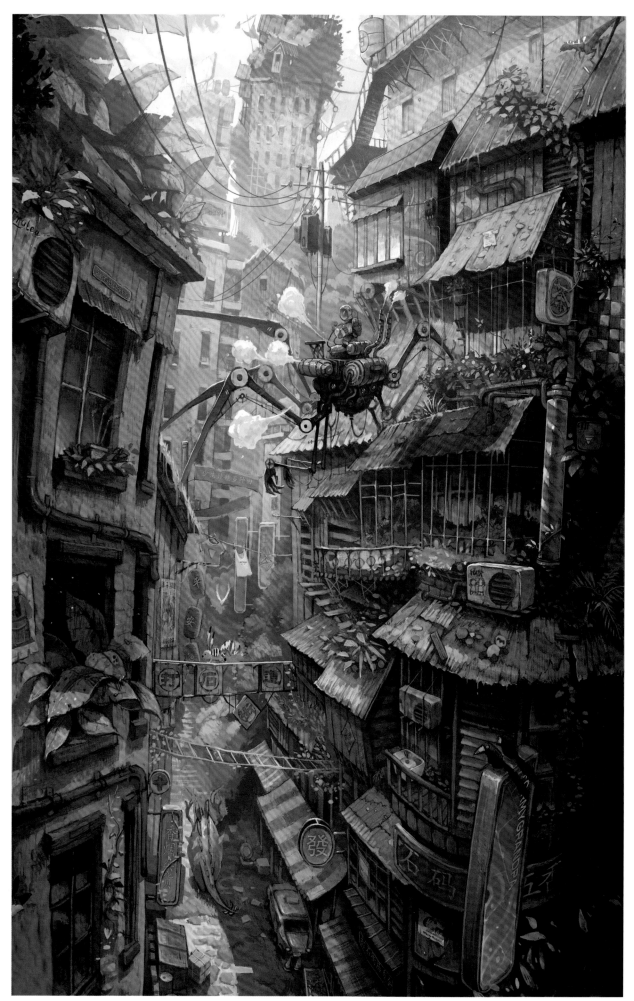

Range 02—Memory

Huang Chaogui

Screen Name: Gui the Painting Beggar
Blog: blog.sina.com.cn/hcgsss
Profession: College teacher, illustrator

PROFILE

Huang Chaogui teaches decorative illustration at the Integrated Modeling Department of Guangxi Arts Institute. He hosted a solo exhibition in 2009, and has authored various design-related books, such as *Computer Illustration Tutorial*, *CG-Creative and Commercial Application*.

INTERVIEW

What subjects have you chosen in the past few years?

Firstly, my creative subjects are not commercially related. Therefore, I value the underlying content and ideas in the painting process, while techniques and materials come second. I prefer to reflect social problems in current society such as environmental degradation, rampant crime and corruption in a humorous or metaphorical way. Secondly, after determining the overall subject, I give full play to my will. During the painting process, I will return to the composition to add, remove or revise details, even to the extent of making it completely a different picture. However, despite these changes, its central idea remains unchanged, i.e., it revolves around current issues.

When did you become interested in art? What made you become a professional artist?

I began painting for fun, rather than for making a living, and that is still the case today. I was a rebellious child and discovered that the painting brush was one of the most effective tools to express myself, or even to indirectly change others' views. From that point on, I have embarked on the artistic journey. I chose to be an artist simply to express my ideas.

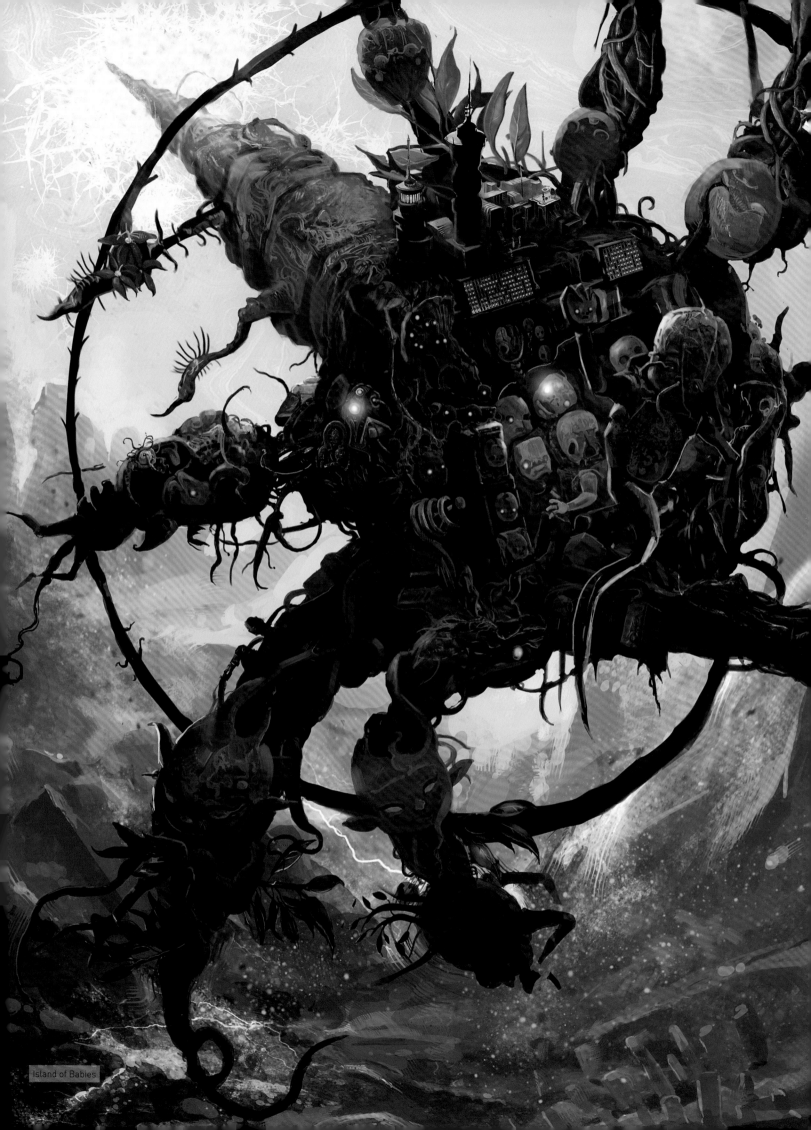

Island of Babies

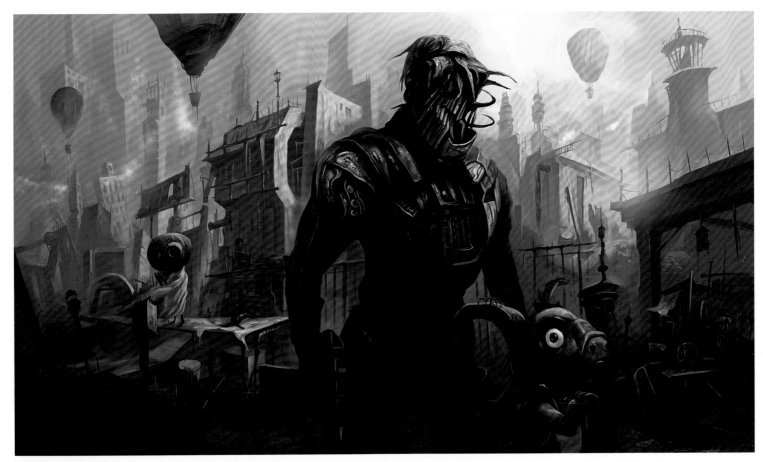

Capital Punishment

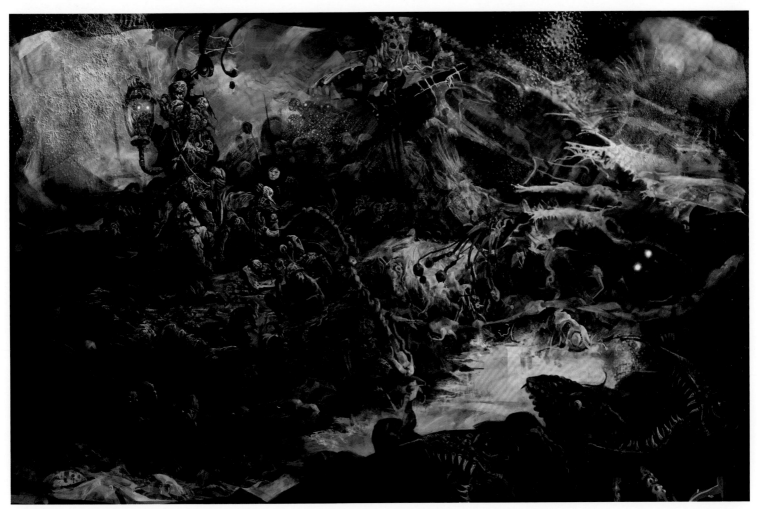

Siege of the Dead

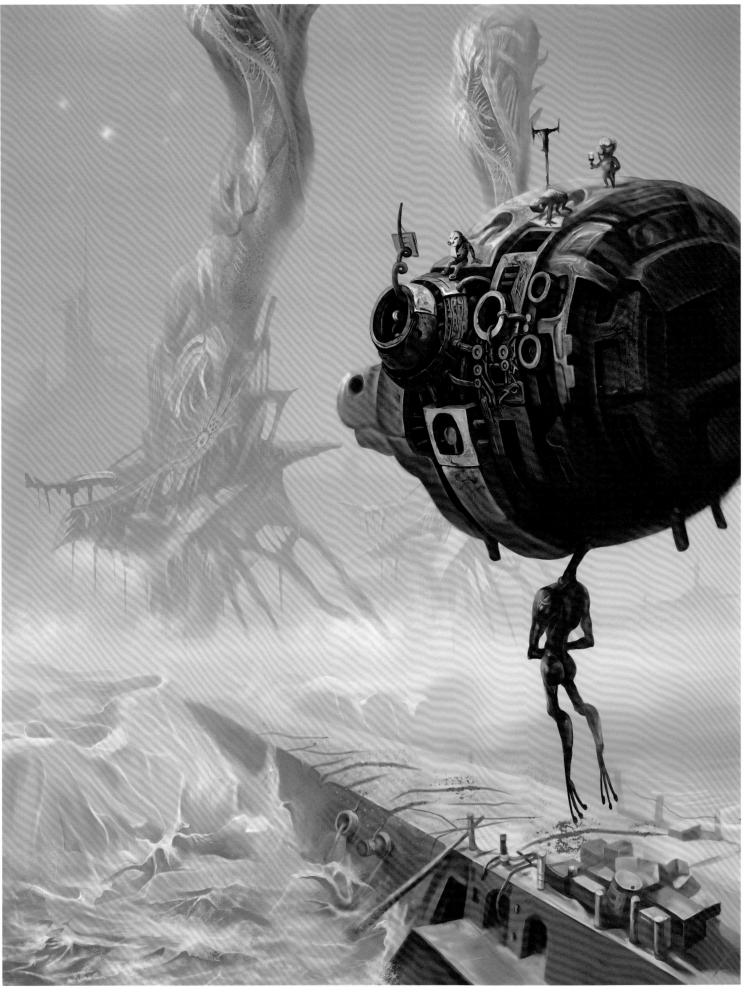

Fallout 01

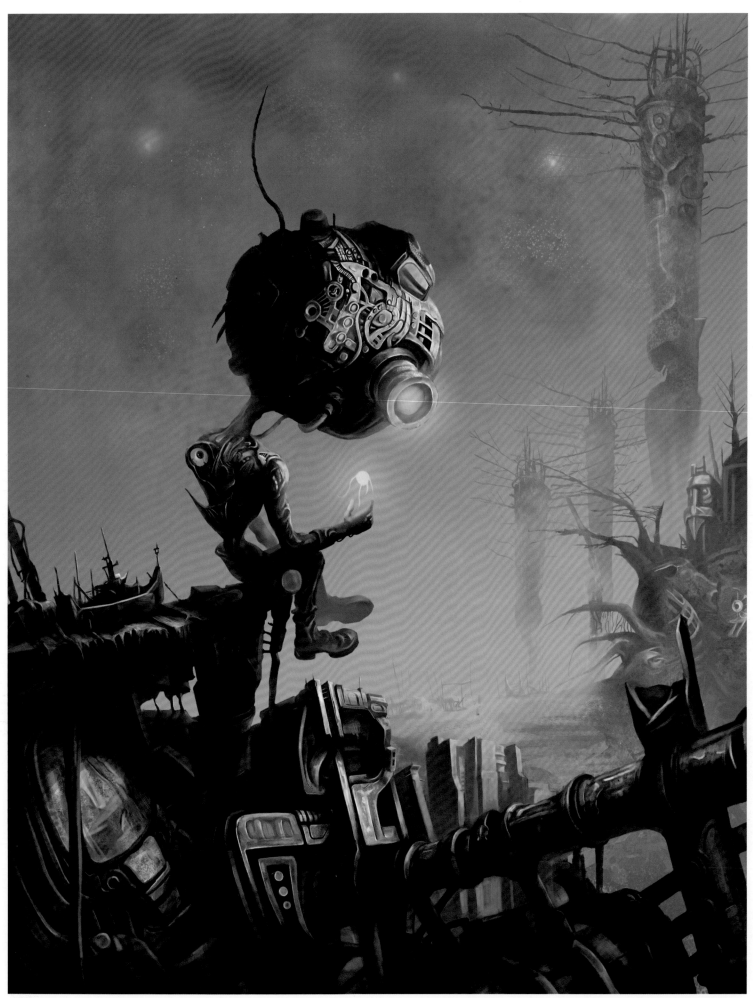

Fallout 02

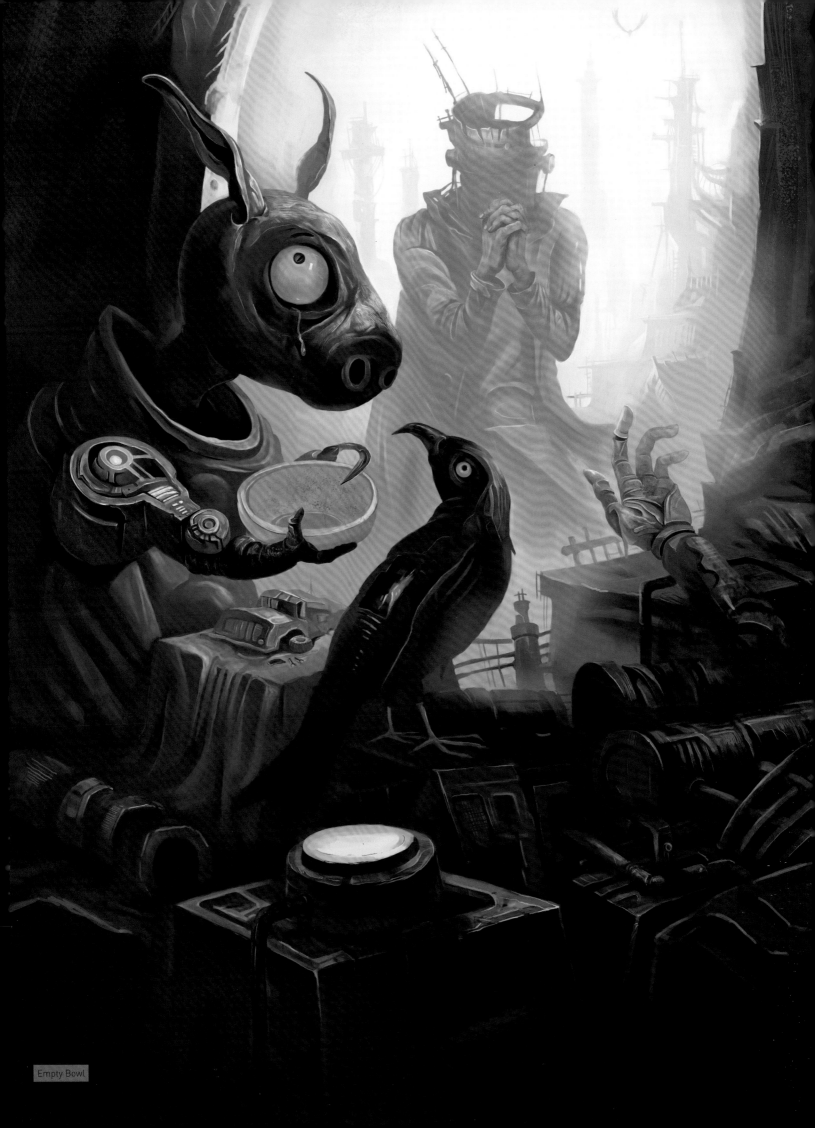

Empty Bowl

Deng Jie

Screen Name: Deviljack-99
Blog: blog.sina.com.cn/deviljack99
Profession: Game concept designer

PROFILE

Deng Jie entered the CG industry in 2008, and is versed in painting various game styles. He previously served as project art director at Beijing Ourpalm Co.,Ltd. and Mobile APP Network. He won Best Creative award at the Second "Hanwang" Digital Creation Contest, and has been invited to various universities to host lectures on games.

INTERVIEW

Would you please share with us what you did last year?

Since 2012 to date, I have largely committed myself to the development of two games on WWⅡ: one of them is a mobile game, and the other is an online game. Staff in the game development department mostly live a dull life, with our jobs mainly concerned with formulating art design plans, repetitively revising them, and improving the visual and artistic effects of games based on proposals.

When did you first become interested in art? What made you become a professional artist?

I have been interested in art since childhood. My college life exposed me to new elements in art which made me determined to become a professional artist and pursue an art-related career. After graduation, I was engaged in design, animation and the game industry. I entered the game industry as an ordinary concept artist and now have been promoted to project art director. However, I still find fault with my work in the creative process and feel there is room for further improvement.

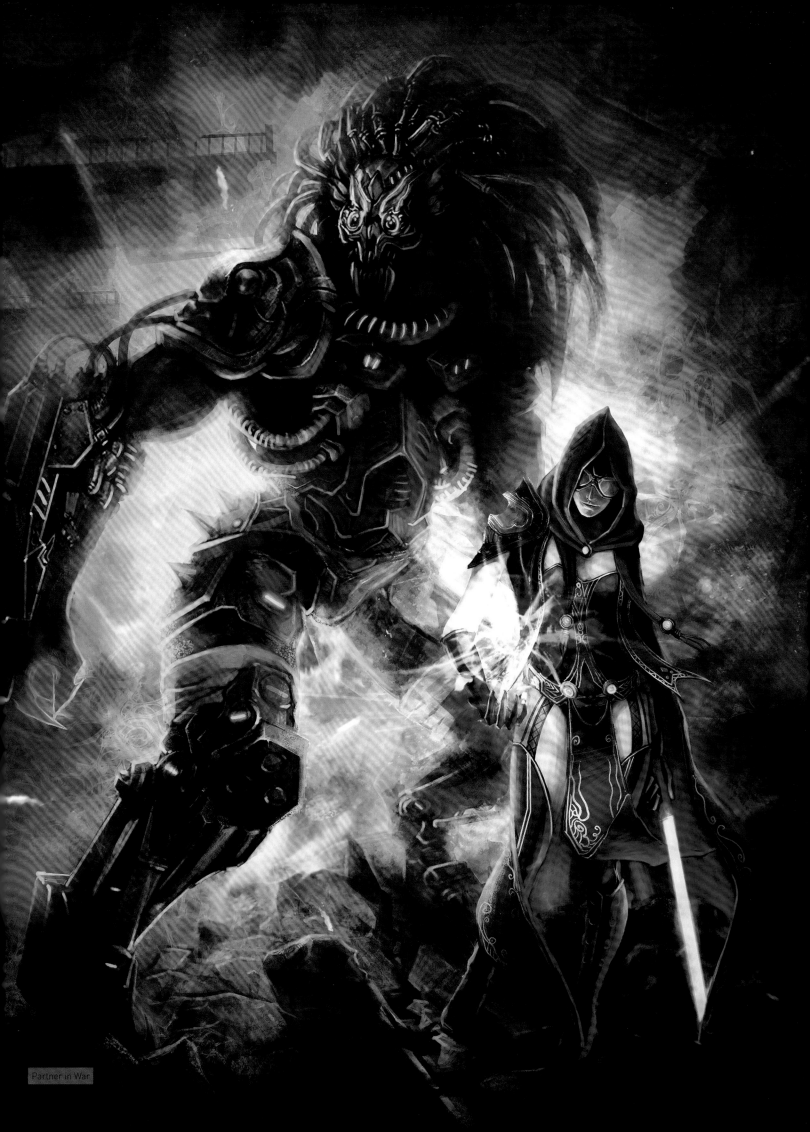

Partner in War

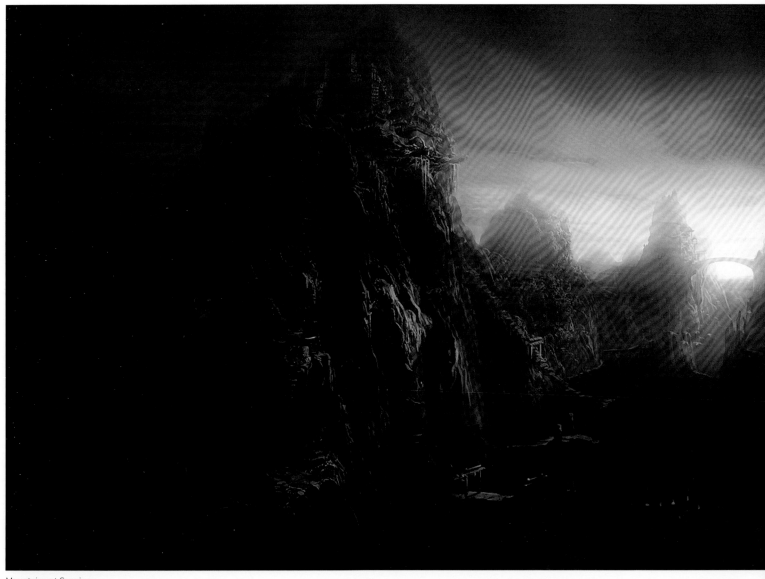

Mountains at Sunrise

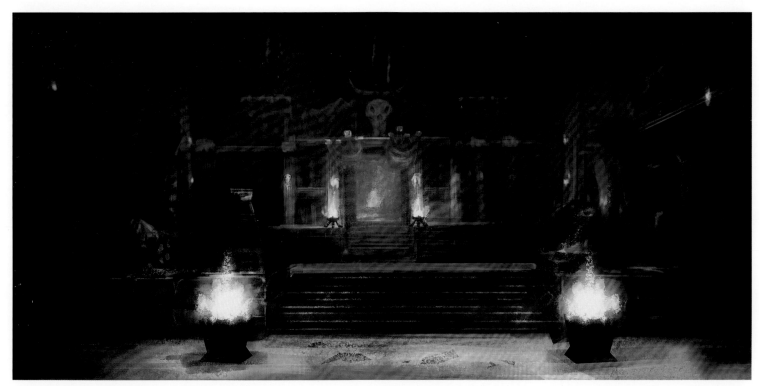

Entrance design for a game scene

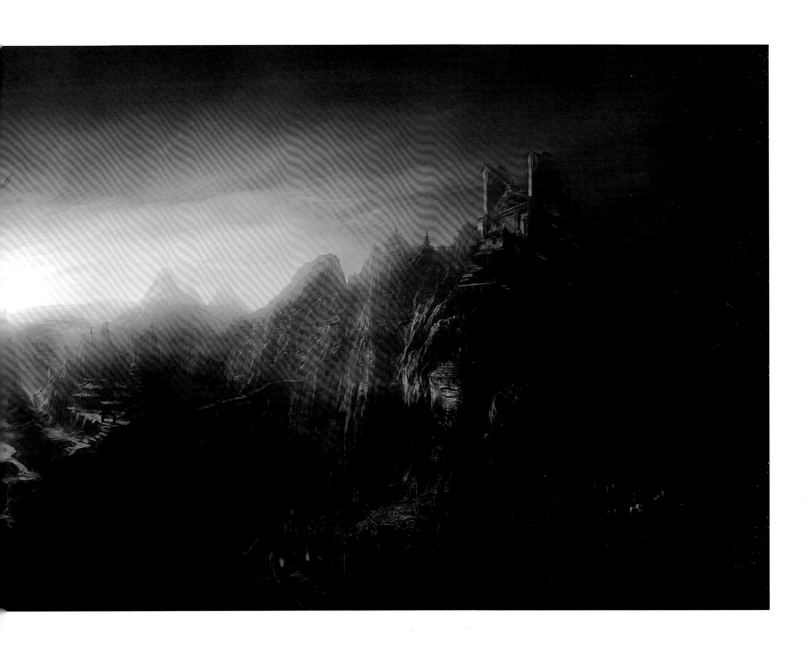

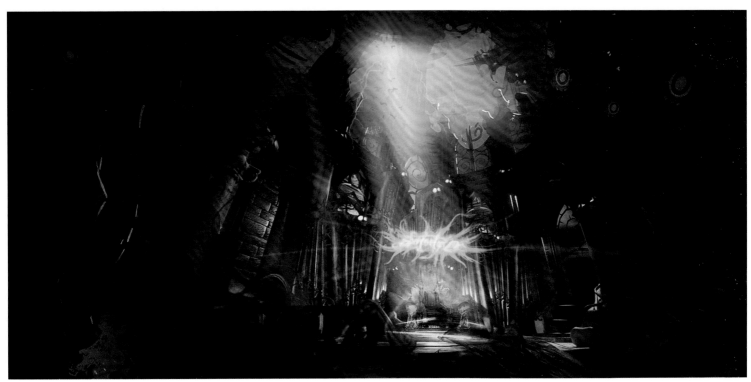

Concept design for BOSS scene

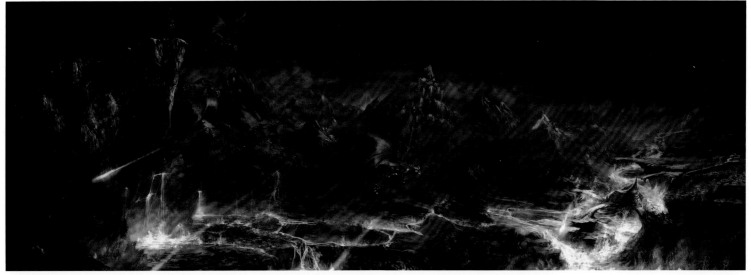

Land in Flames

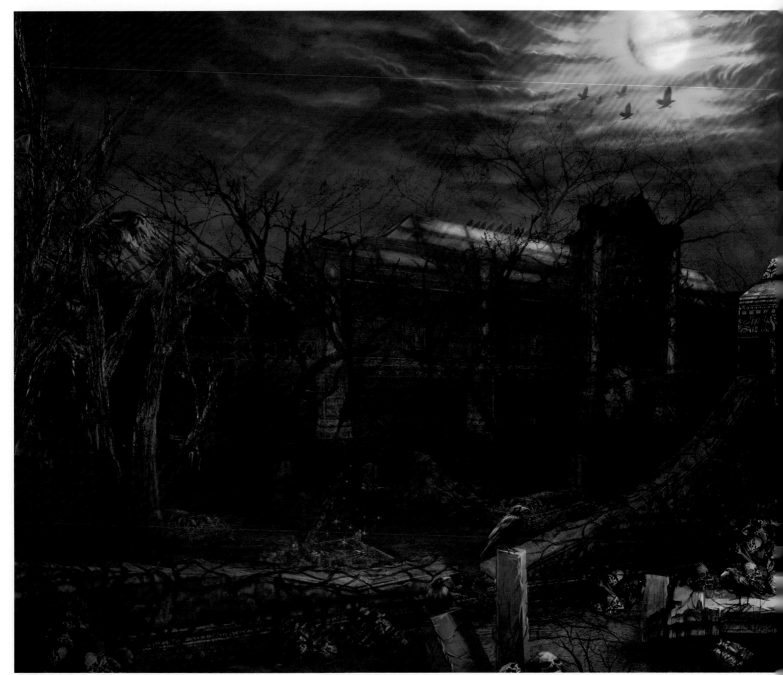

Castle of Death

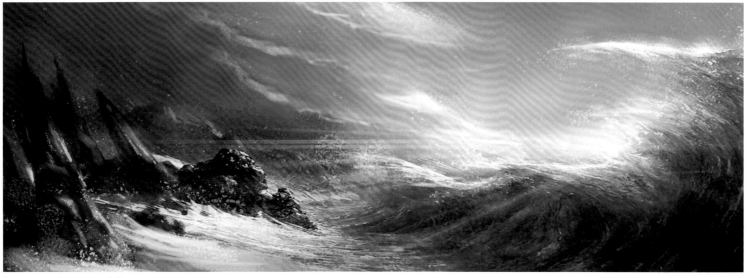
Daily practice for speed painting

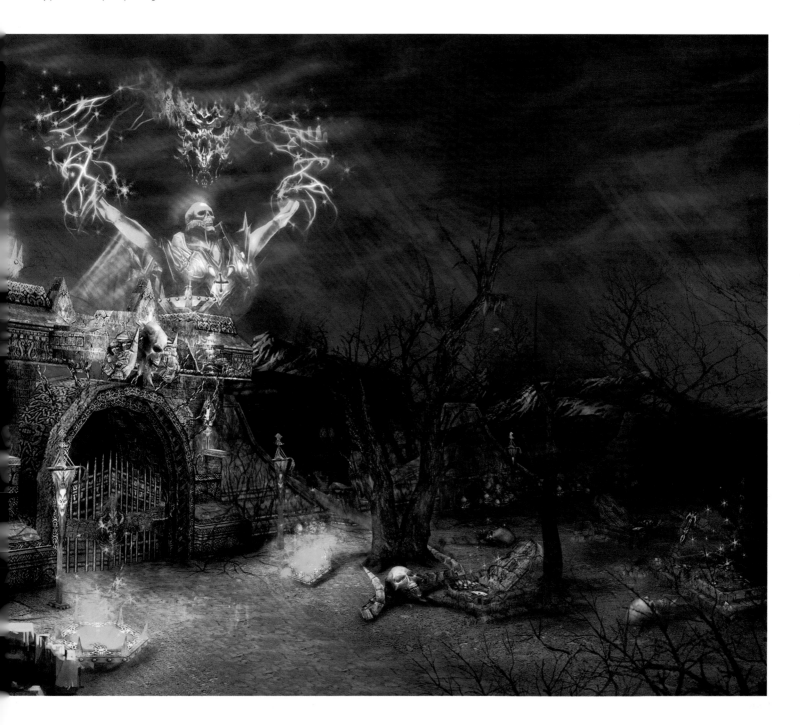

王
海
军

W
a
n
g

H
a
i
j
u
n

Wang Haijun

Screen Name: Pirate
Blog: blog.sina.com.cn/whj
Profession: Game concept artist, freelance illustrator

PROFILE

Wang Haijun works as contributing illustrator for Applibot in Japan, lecturer for CCGAA, jury member of the organizing committee for Creative China—Illustrator Talent and won Best Adobe Design for Game Characters. His works were included in *Selected CG Works by China's Top 100 Illustrators*, *CG Artists Alliance Yearbook*, and *MASTER 1*. He has also participated in various game projects such as "Noah Legend," "Expedition," "Paraworld," "Xiu Mo," "Mo Dao," "Aurora World," "Legend of Spirits," and "Legend of the Cryptids."

INTERVIEW

You have so many experiences to share with young artists. What do you want to share most?

Painting is a path ridden with challenge and fun. It is a spiritual product crystallizing the subjective reflections of what real life is like in the artist's mind. A professional painter might need to spend all his life bettering himself to become a good painter. There is no shortcut in painting. Don't believe in achieving something overnight. What we can do is to think and practice every day, observe life in an attentive way, take notes of the people and things around you, do everything in an earnest manner, and maintain a peaceful but aspirational mind. Then one day, you will realize how much you have achieved. It will be a process of spiritual elevation.

Which artist or designer has influenced you most?

I admire a lot of artists. Some of them are famous, while others are not. I like domestic or foreign artists who inspire me. Compared with their artistic achievements, I tend to value personality and self-cultivation more. My favorites include the American painter John Singer Sargent who remained single his whole life to commit himself to painting, the fantasy art master Frank Frazetta, the Japanese artist Yoshitaka Amano, and domestic traditional artist Wang Kewei. I see in them how artists love and enjoy life while pursuing truth through perseverance.

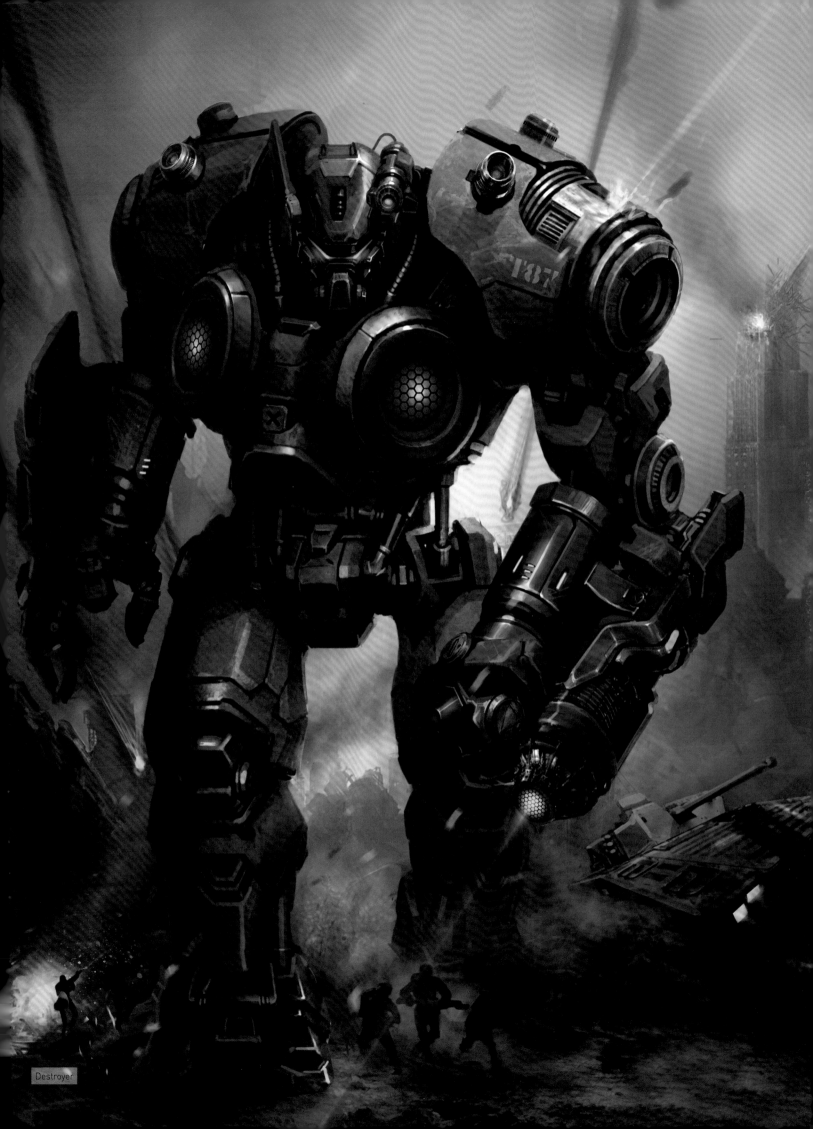

Destroyer

Noah Legend—Fighter

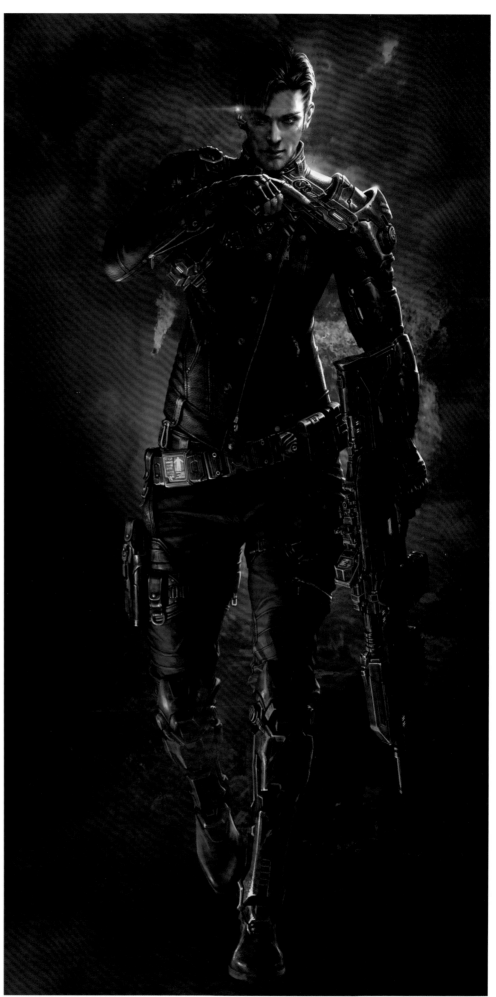

Noah Legend—Male Armorer

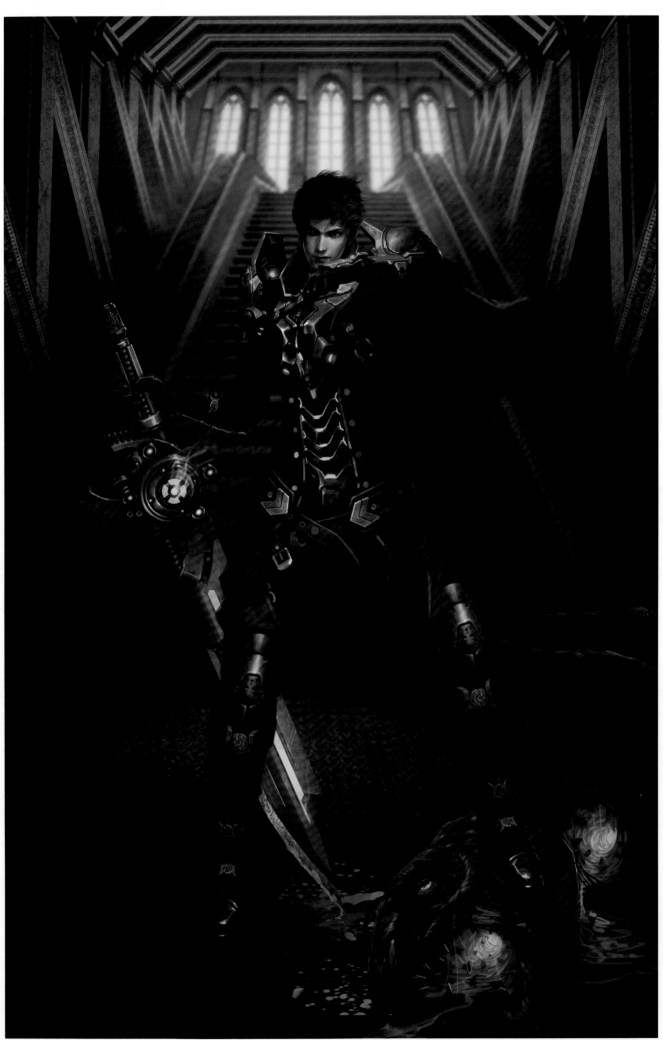

Noah Legend—Warrior
with Sword

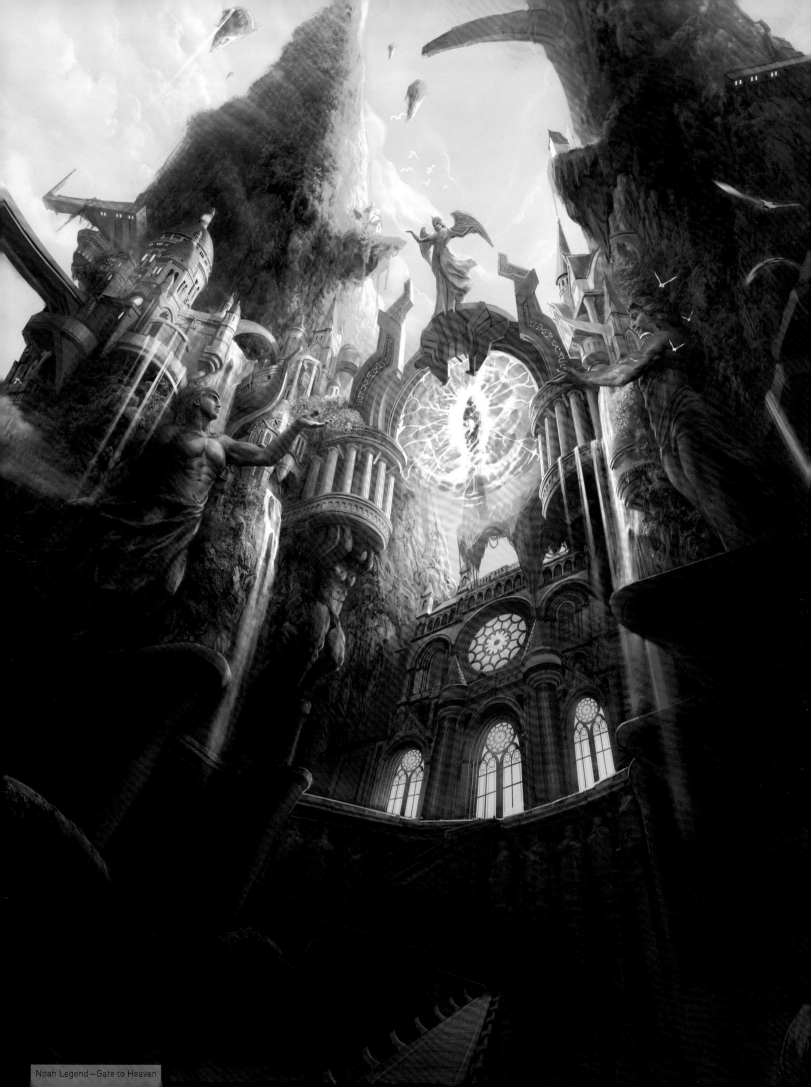

Noah Legend—Gate to Heaven

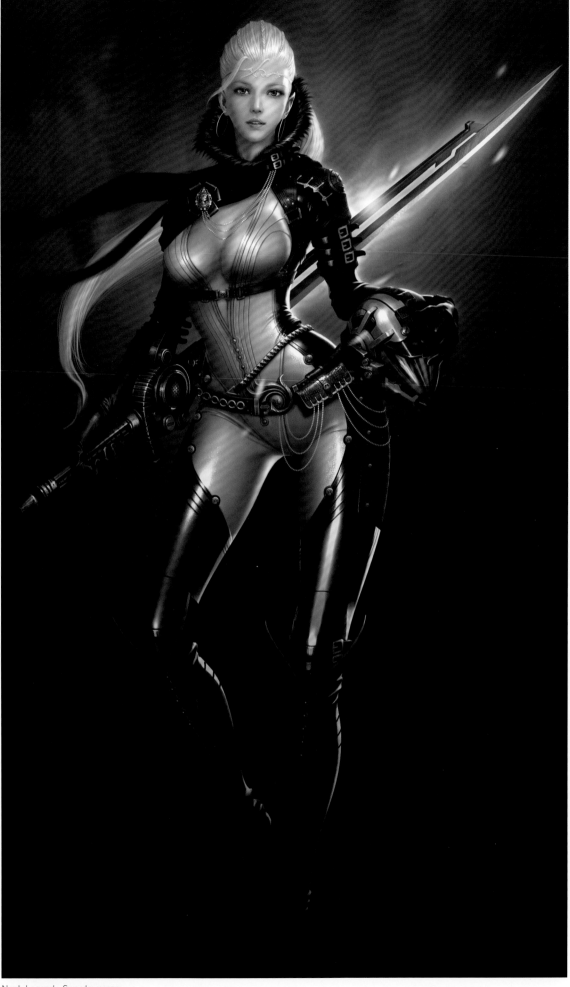

Noah Legend—Swordswoman

Noah Legend—Una

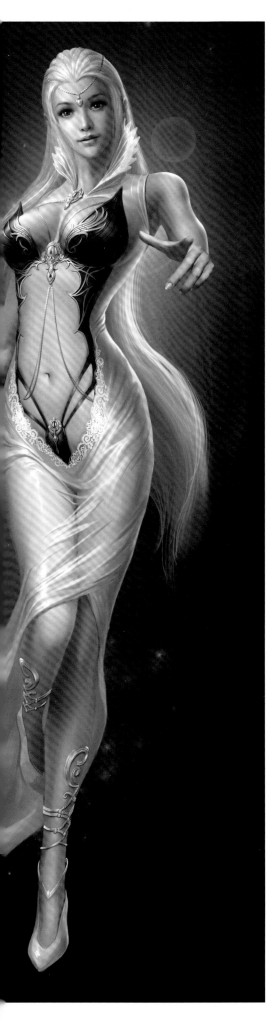

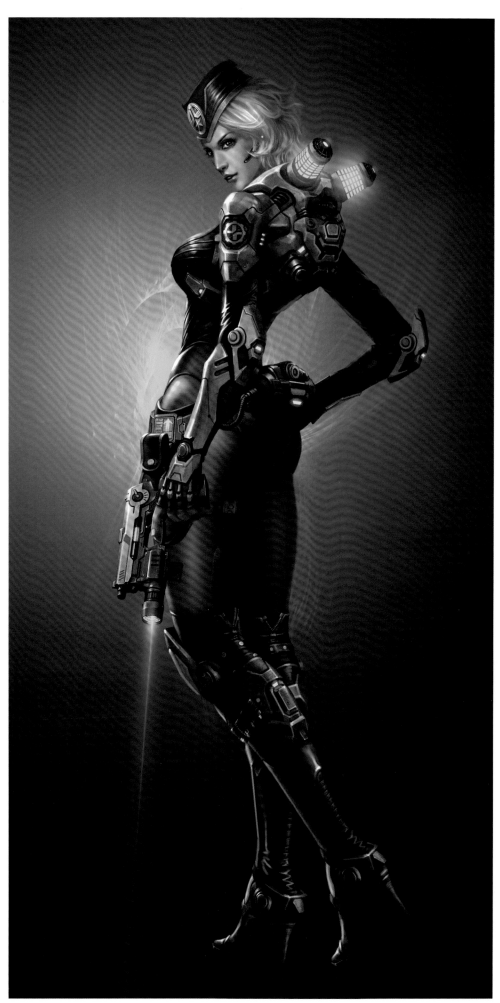

Noah Legend—Armorer

Tian Chao

Screen Name: Flying Leaf
Blog: blog.sina.com.cn/feiyekuaidao
Profession: Freelance artist

PROFILE

Tian Chao has been passionate about painting since childhood and trained in traditional art. He graduated from the Oil Painting Department of Chengdu Academy of Fine Arts in 2009 and served as concept artist at various animation companies thereafter. He joined Chengdu Jiuzhong as the leader of the concept art team in the same year, and became a freelancer at the end of 2012. Tian has participated in design work for the animation series "Super Baozi."

INTERVIEW

How do you spend your free time?
 I often watch movies, read comics or play games. My favorite is watching movies. Watching good movies is a way to relax myself and trigger inspiration.

Which is more important for you as an artist, artistic sensitivity or creative technique?
 Artistic sensitivity always goes beyond techniques. Perseverance the solution to skill improvement. Artistic sensitivity is achieved by enhancing the level of thought. It is necessary for creating new things. Only a clear understanding of what we want can motivate us to make the self-improvement we need. Otherwise, we will simply imitate others and lose ourselves.

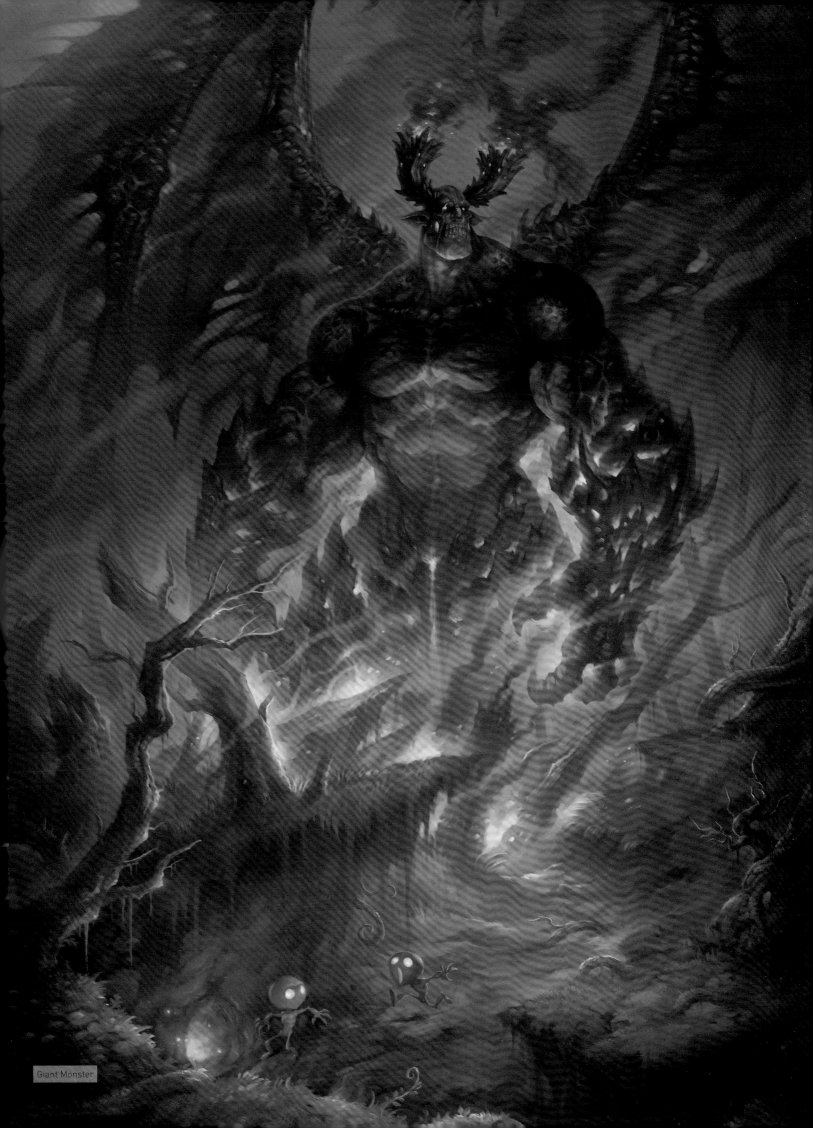

Giant Monster

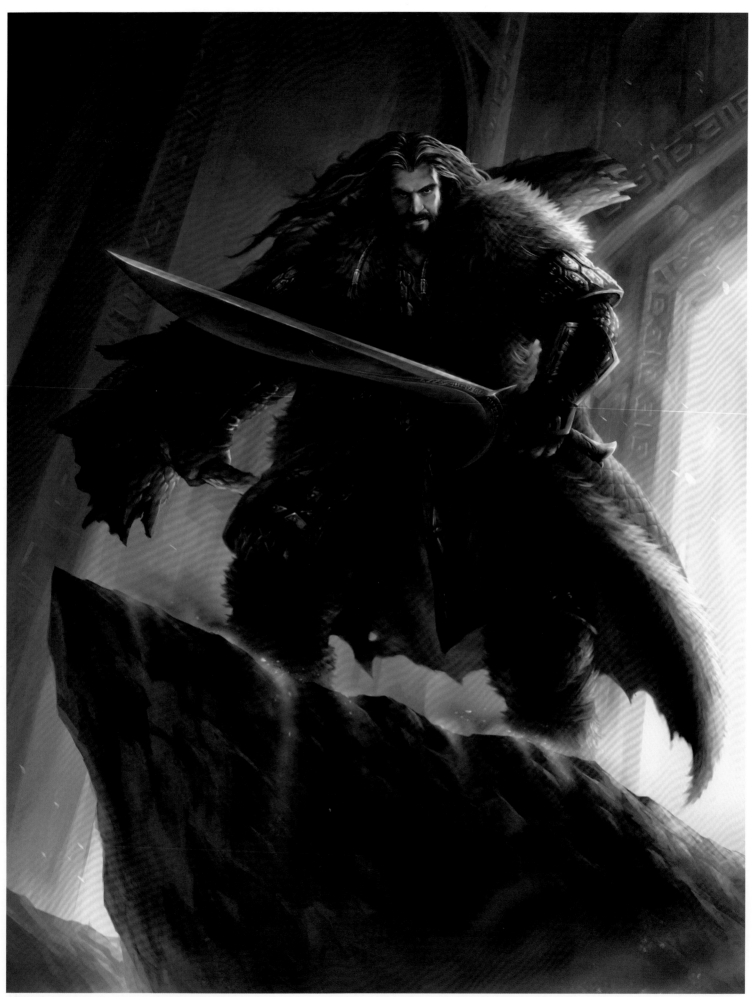

The Hobbit—Thorin Oakenshield

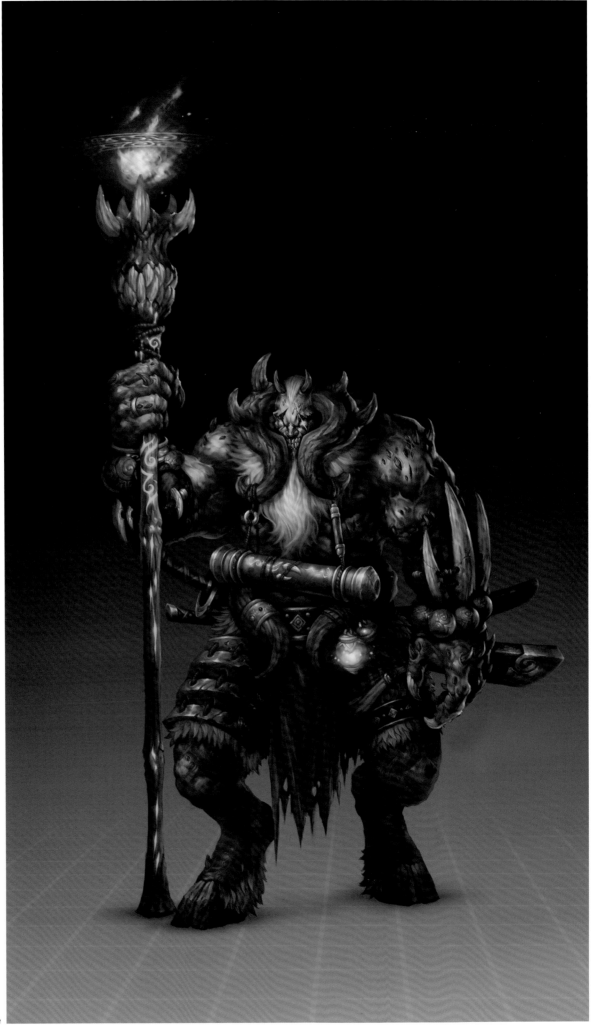

Ogre Mage

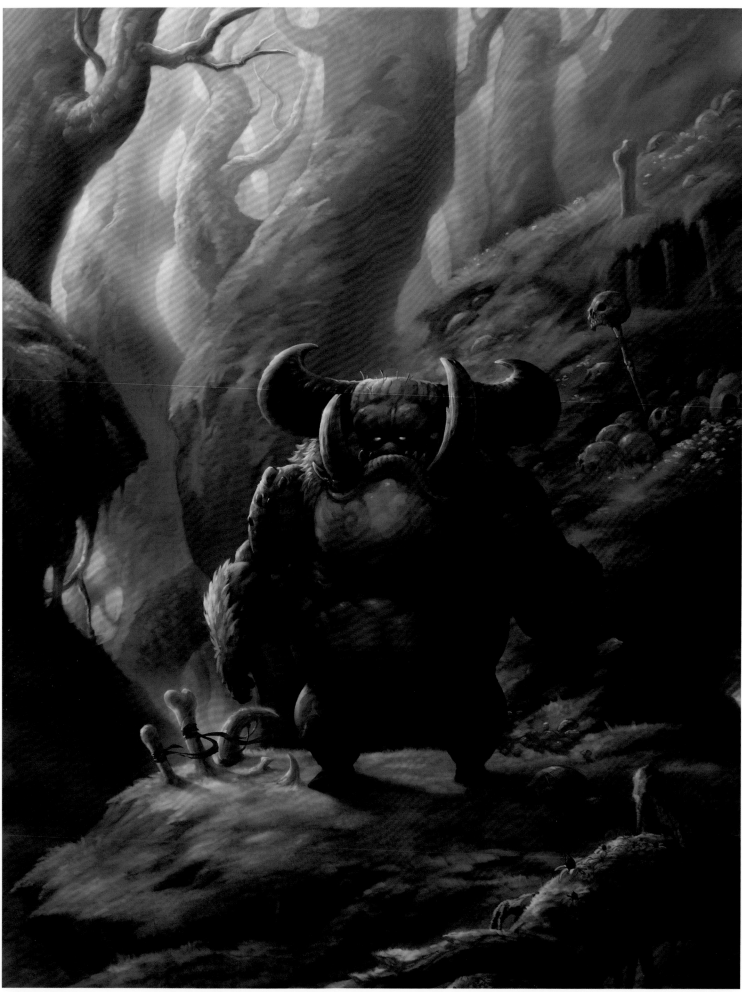

Skeleton Collector

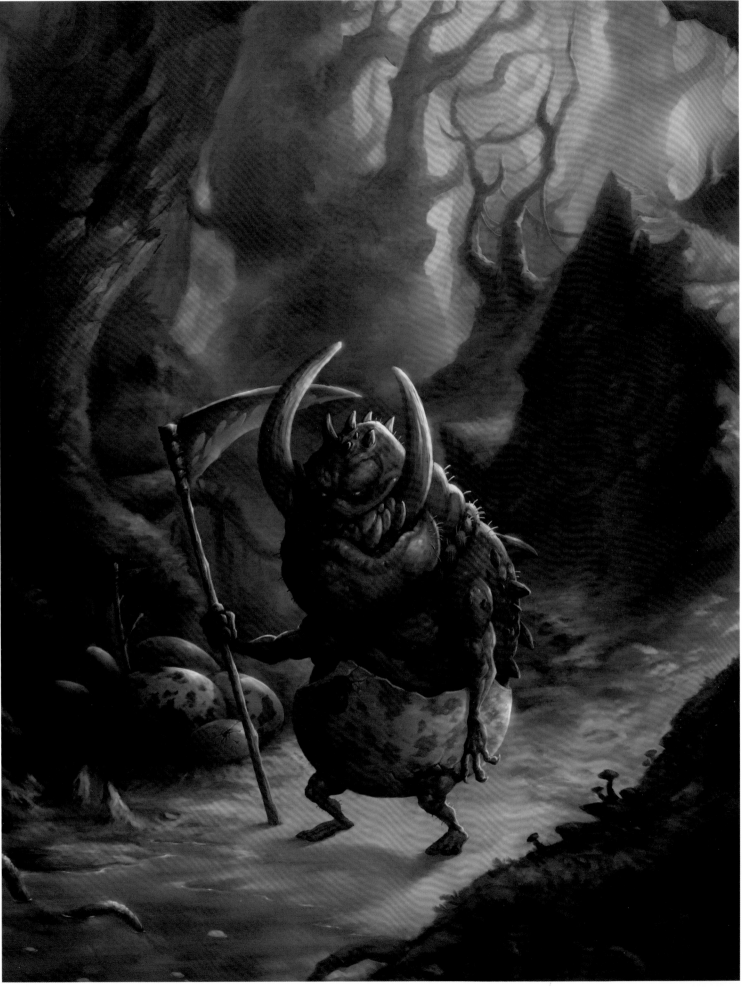

Egg Thief

Hua Lu

Screen Name: hualu
Blog: hualu.cghub.com
Profession: Freelance artist

华 路 H u a L u

PROFILE

Hua lu graduated from the Engraving Department of Nanjing University of the Arts. After graduation, he became engaged in game, movie concept and CG illustration. His work has been included in *EXPOSÉ*, *EXOTIQUE* and other global CG yearbooks. He was awarded EXPOSÉ 10 Master Award in the fantasy category, and ImagineFX 2012 RISING STAR by internationally recognized CG magazines.

INTERVIEW

How long have you been engaged in this industry? How do you feel about this industry?

With over seven years of experience in this industry, I have learnt that painting should be a habit, and art comes from life. We should accumulate life experience and enjoy the process.

What do you think is the most important element in the creative process?

In my opinion, the most important element is to grasp an original and fresh idea or inspiration, stick to it in the creative process, and put it on paper in various ways, so the final work retains its original vitality while still being exquisitely refined. In general, we should start with basic skills. It requires lasting and industrious practice to put what's in your mind on paper. Secondly, we should have a clear idea of what we want to draw, ranging from the personal painting styles and themes to be depicted, to every stroke on the paper.

What is of overriding significance for enhancing creativity?

Whether it is illustration art or concept art, what is most needed is creativity and competent art skills. "Creativity" here can be defined in two ways. Firstly, it is about content—how to infuse more design concepts into your work. In this respect, I think everyone depends on movies, books, games and other media to create a reservoir of inspiration. I want to share with readers two methods of my own. Firstly, sketch—sketching by noting down sweeping ideas and inspiration in a simple way enlarges our reservoir. The second is reading fantasy books, and I highly recommend this. Visual media is a passively experience, but literary descriptions require your own imagination. In this way, you can train your imaginative abilities through reading by outlining pictures in your mind and giving depth and content to your work. Such creativity will never drain. Secondly, it is about creativity on painting styles. In my opinion, creativity in terms of technique does not deserve equal attention, as we should try to infuse creativity into our painting styles rather than paint in a singular and mechanical way. This is something everyone should experiment with and think about.

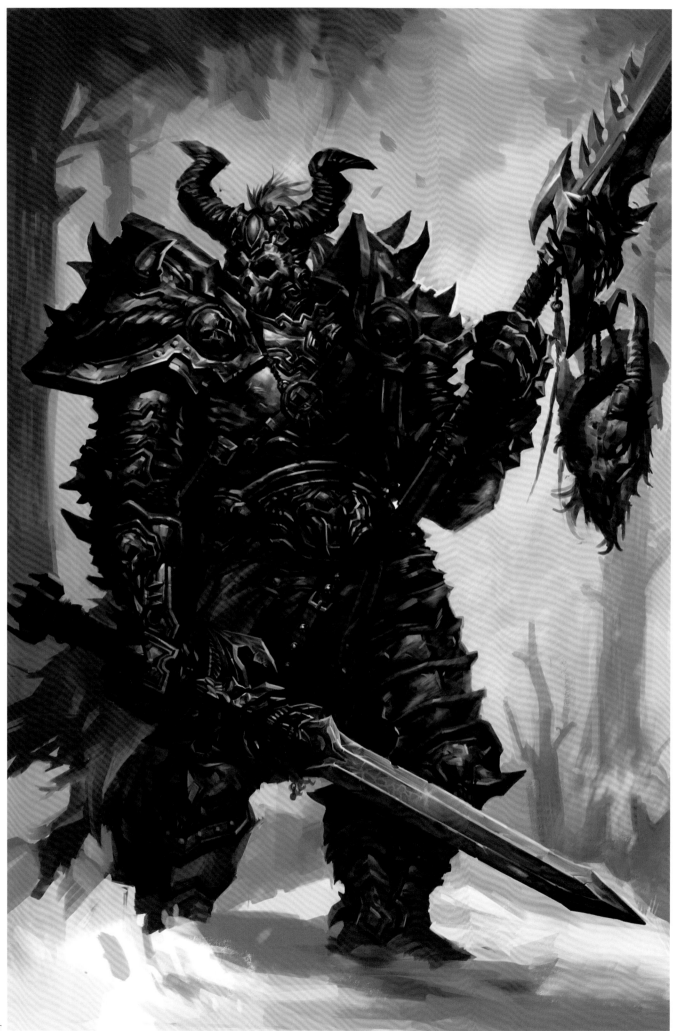

Berserker

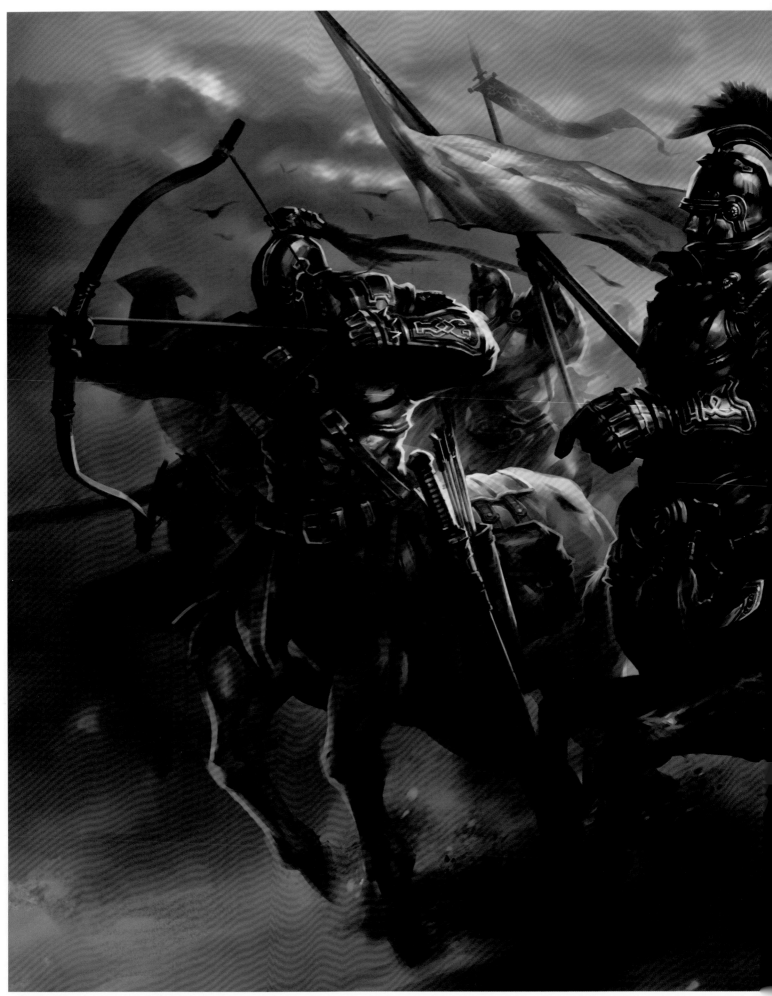

Centaur Scouts

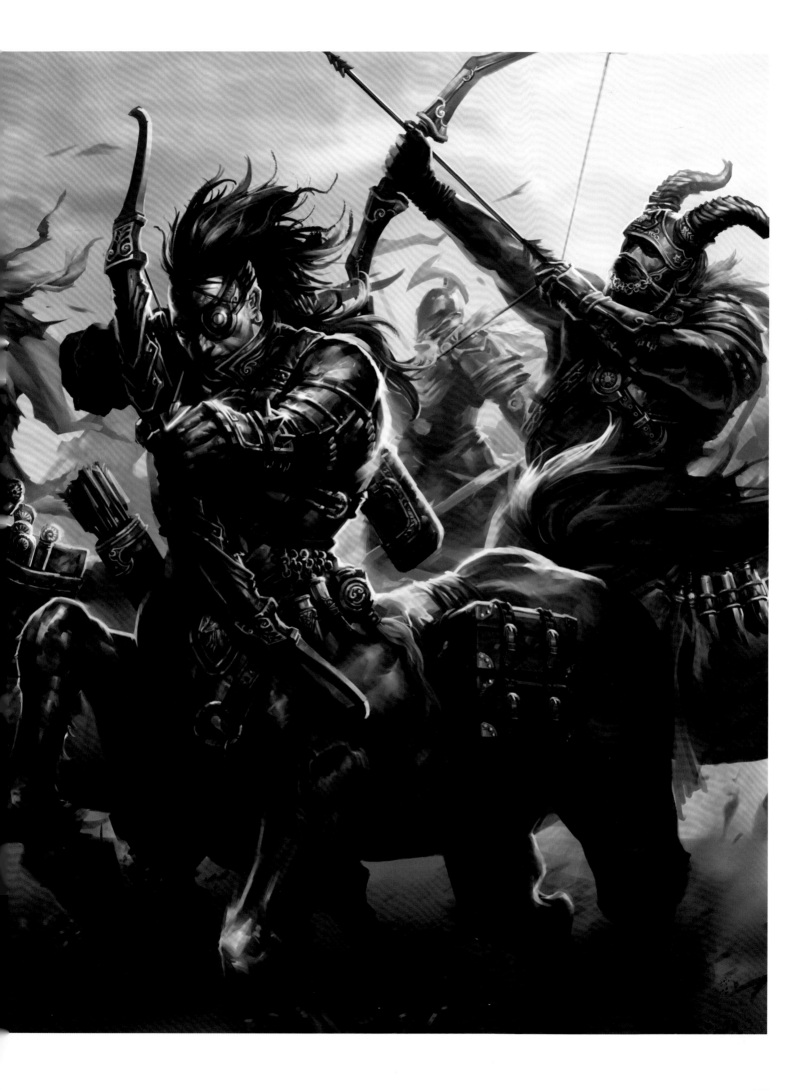

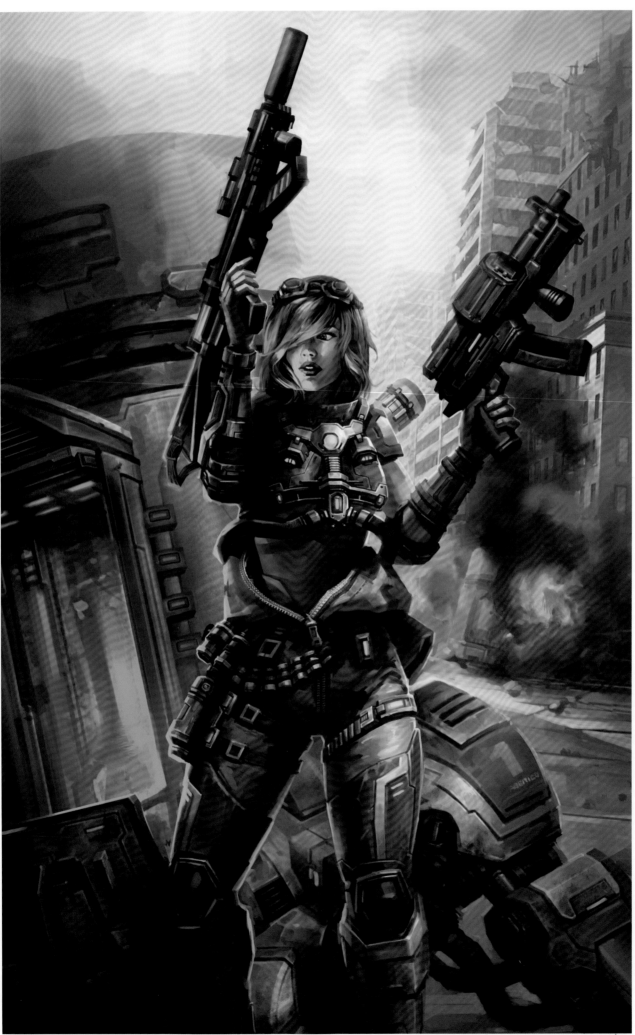

Nova

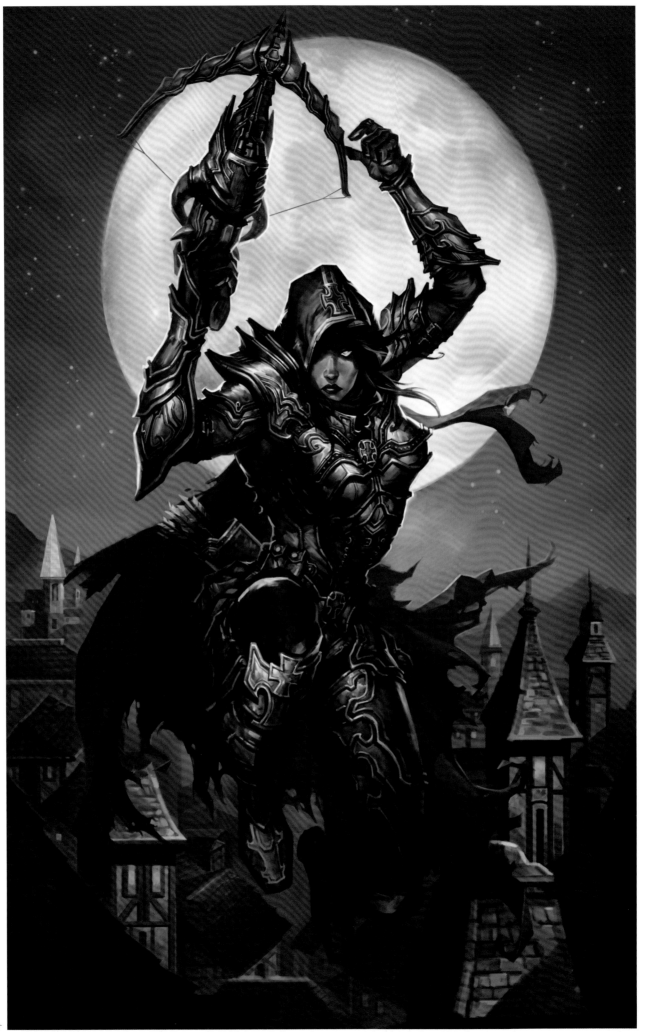

Demon Hunter

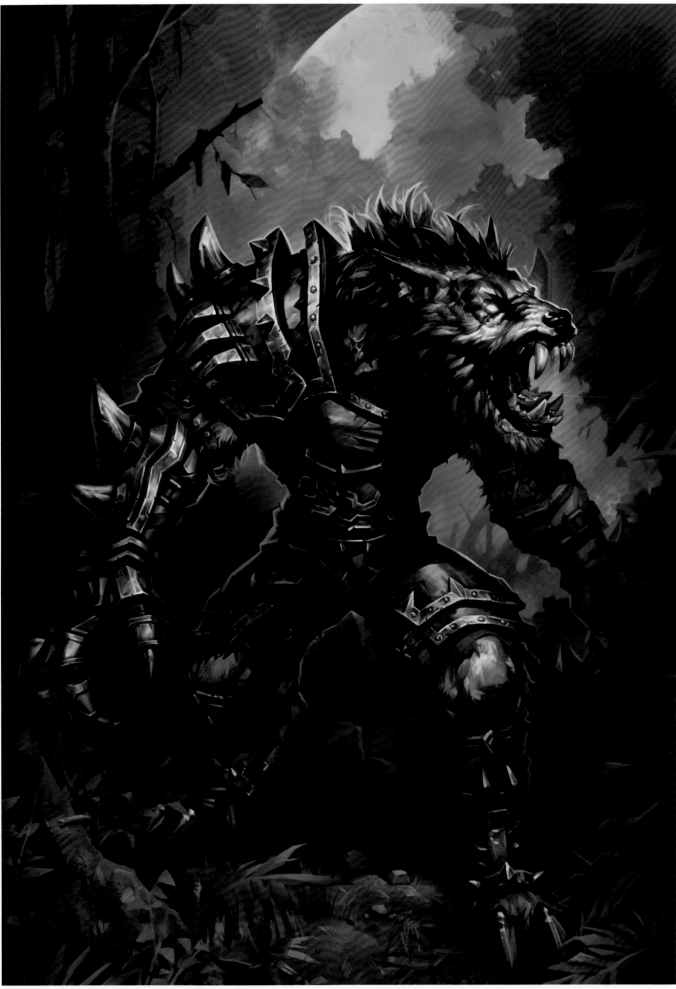

Werewolf

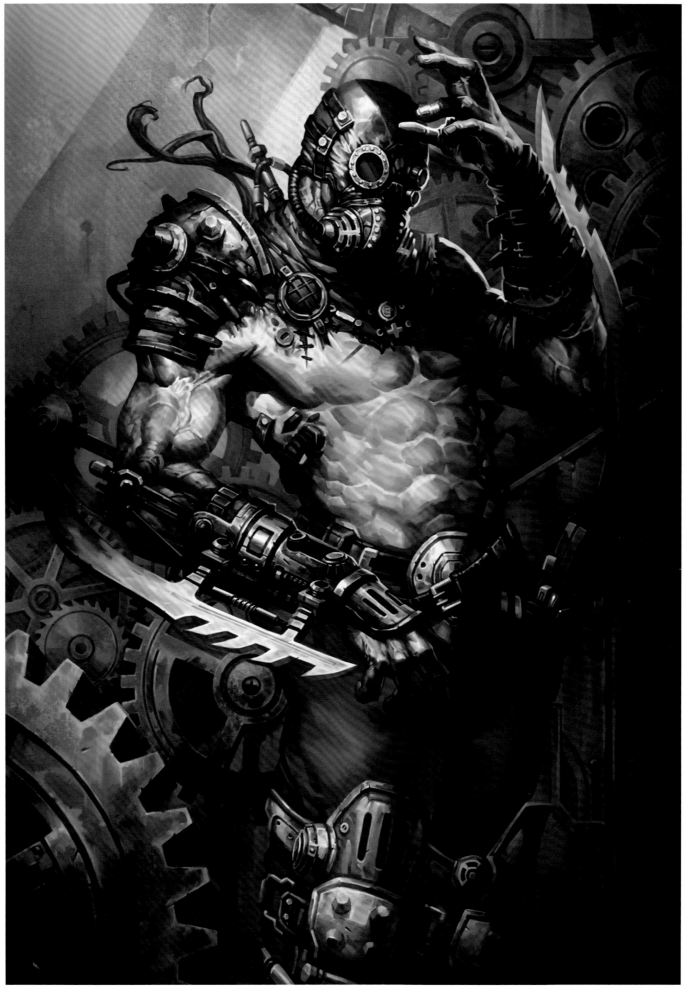

Soul Reaper

Li Kai

Screen Name: Dry Orange
Blog: blog.sina.com.cn/fuckorange
Profession: Freelance CG artist

PROFILE

Li Kai graduated from the Oil
Painting Department of Harbin
Normal University. He is involved
in illustration, game, animation,
movie, TV, fashion, GK and other
art and design work. He currently
lives in Beijing.

INTERVIEW

How long have you been in this industry? What
has impressed you most?

I have been in this industry for over a
decade. What impresses me most is the
importance of a healthy mentality. I have
chosen to engage in art and persevered
with an objective that I can never give up. I
like to see everything as a process of self-
improvement, a process to pursue truth and
better myself. As long as I remain happy in this
process, this pursuit will last for a lifetime.

What do you think is the most important
element in the creative process? What is
of overriding importance for enhancing
creativity?

It should be explained in two ways. As for
commercial projects, meeting the clients'
requirements and providing quality and
competent services should be a top priority.
For an individual portfolio, the most important
thing is to display your own aesthetic
understanding and creative blueprints. As to
how to enhance creativity, I suggest reading
more, since language is the origin for all
imagination. In this information age, the
Internet offers us an overflow of images, which
would inhibit our imaginative power.

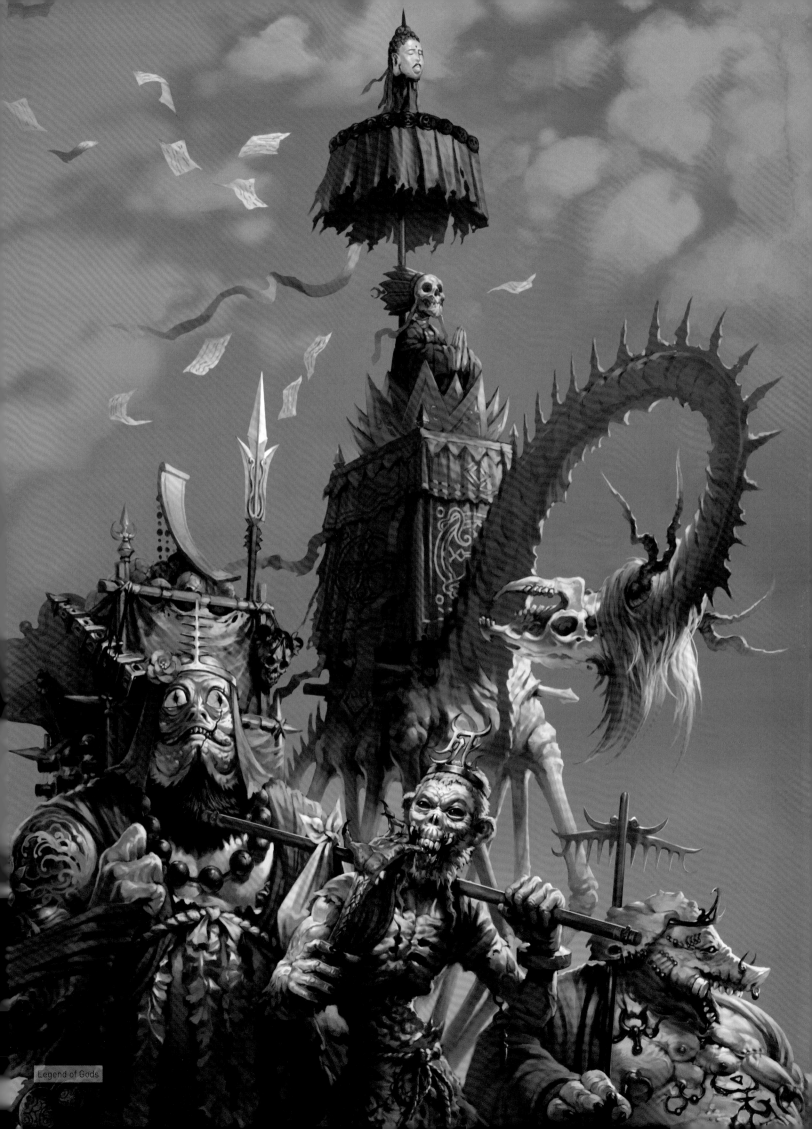

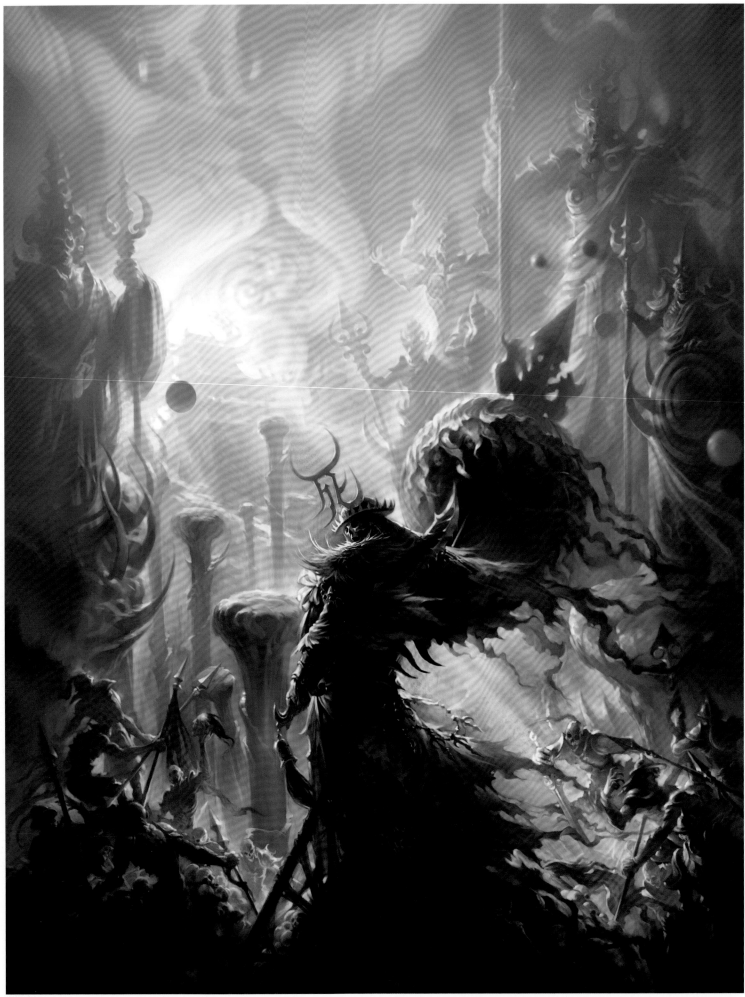

Canopy

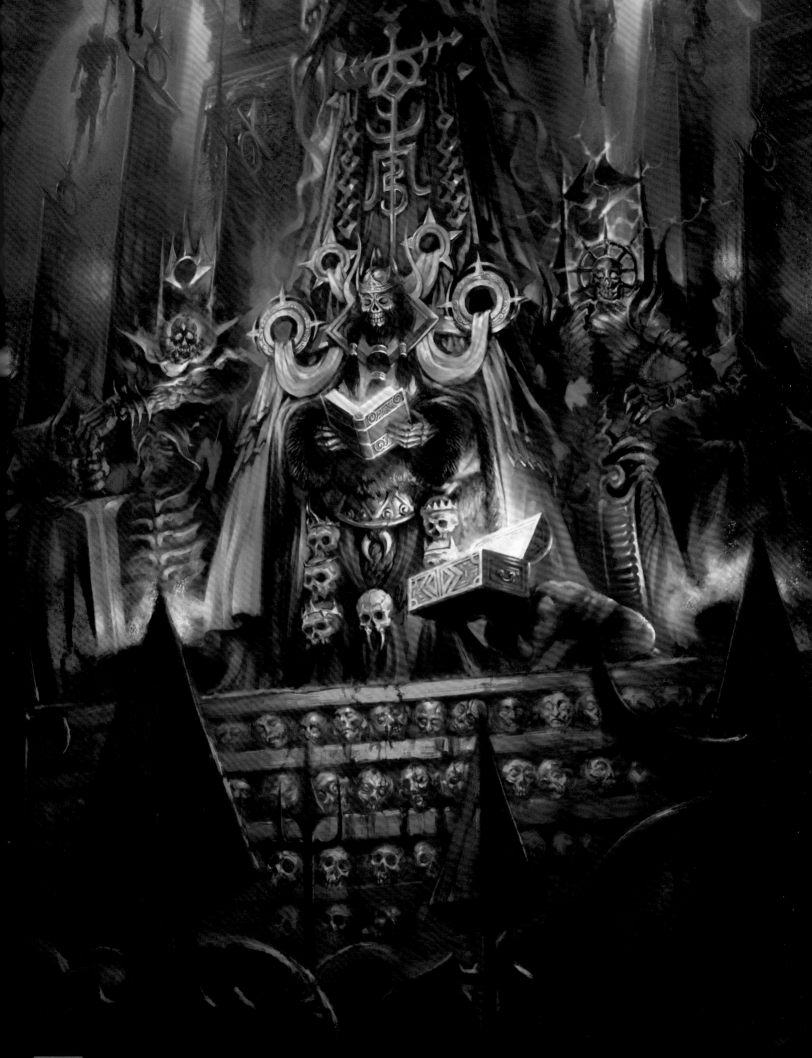

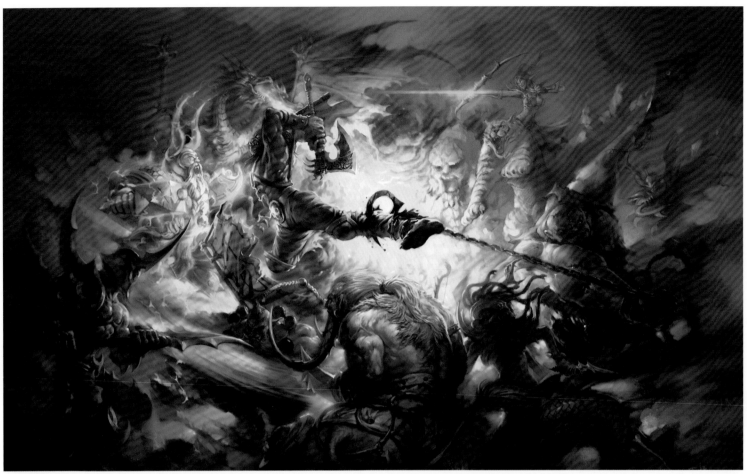

DOTA Melee

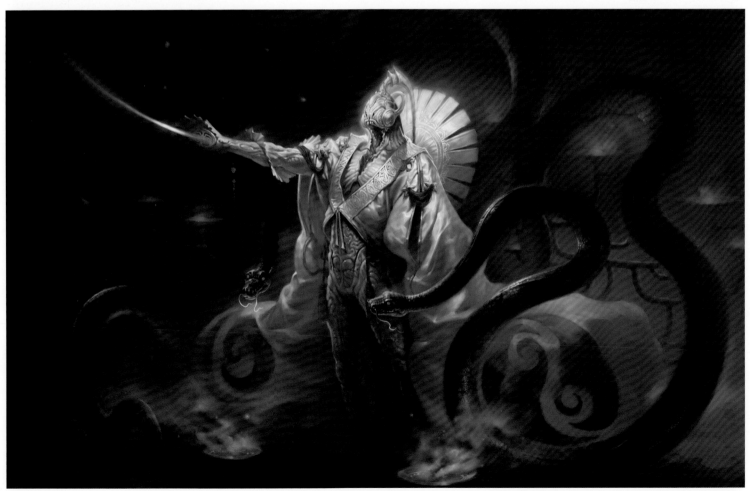

Man of Python

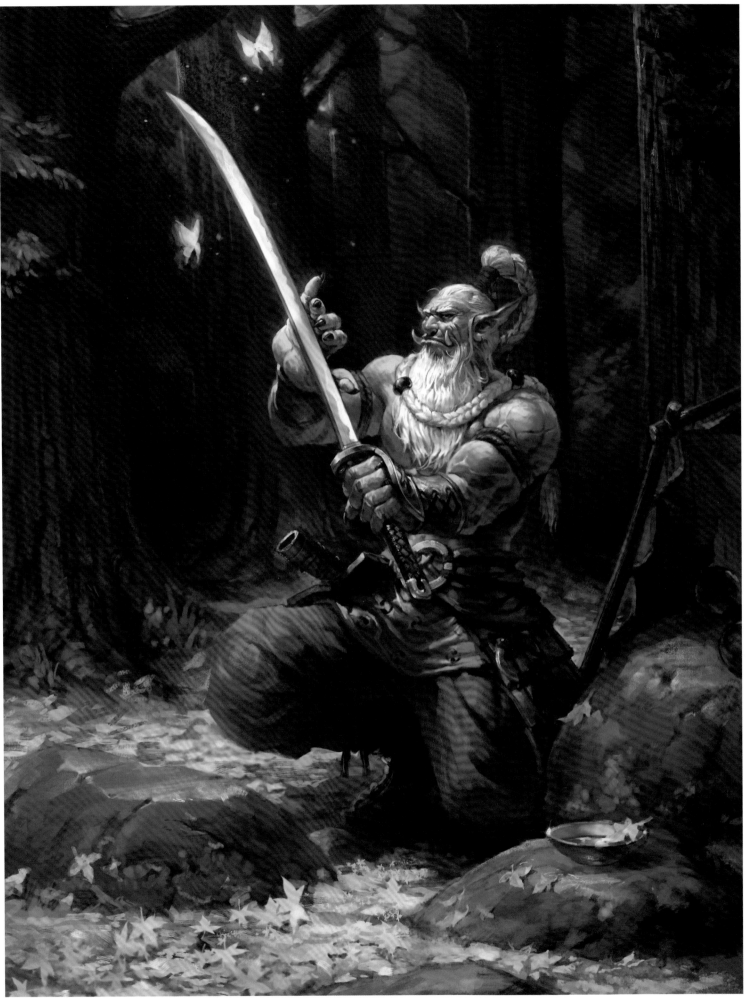

Blade Master

Tang Yan

Screen Name: Swift Fish
Blog: blog.sina.com.cn/swiftfish330
Profession: Game concept designer

唐
艳
T
a
n
g
Y
a
n

PROFILE

After graduating from the Graphic Design Department of Hunan Normal University, Tang Yan produced a significant number of novel and magazine illustrations for numerous publishers. She had worked as 2D character designer at NetDragon Websoft, and joined Tencent as 2D art designer in 2011. She has participated in the production of webgames such as "My Club" and "SGAME."

INTERVIEW

What do you think is the most important element in the creative process?

To do creative work well, we must practice basic skills diligently. In this respect, Ruan Jia is my favorite artist. I met him when I was working for NetDragon Websoft in 2009. Back then, he was already an outstanding painter, but still worked with plaster statues. His paintings of plaster statues are impressive in terms of texture and composition. In contrast, professionals with several years of working experience in this industry seldom pay attention to basic practice like that. Secondly, artists should form a habit to pay attention to creative advertisements, movies, game industry updates and other work in visual fields. A professional should learn and absorb creative concepts from others all the time. Most importantly, it is advisable to incorporate your passion into your work based on uniqueness of each game project. We should nurture each and every work with endless imagination and be responsible for it as a mother is for her baby. We should be touched by our work first, which is essential for a successful creative professional.

What is of overriding significance for enhancing creativity?

Enhancing creativity requires constant accumulation. It is also important to constantly strive for better results, think as a game player, and start from a controversial standpoint. For example, an ordinary character dressed in a common way is an uninteresting image. But if we put a big Chinese character for "embarrassment" on his back, and give him some popular dance motions, he will be a surprise to players, and this character design will be well-received. Even if it does not require a huge number of technical skills, it is already enough to create a great effect in a short time.

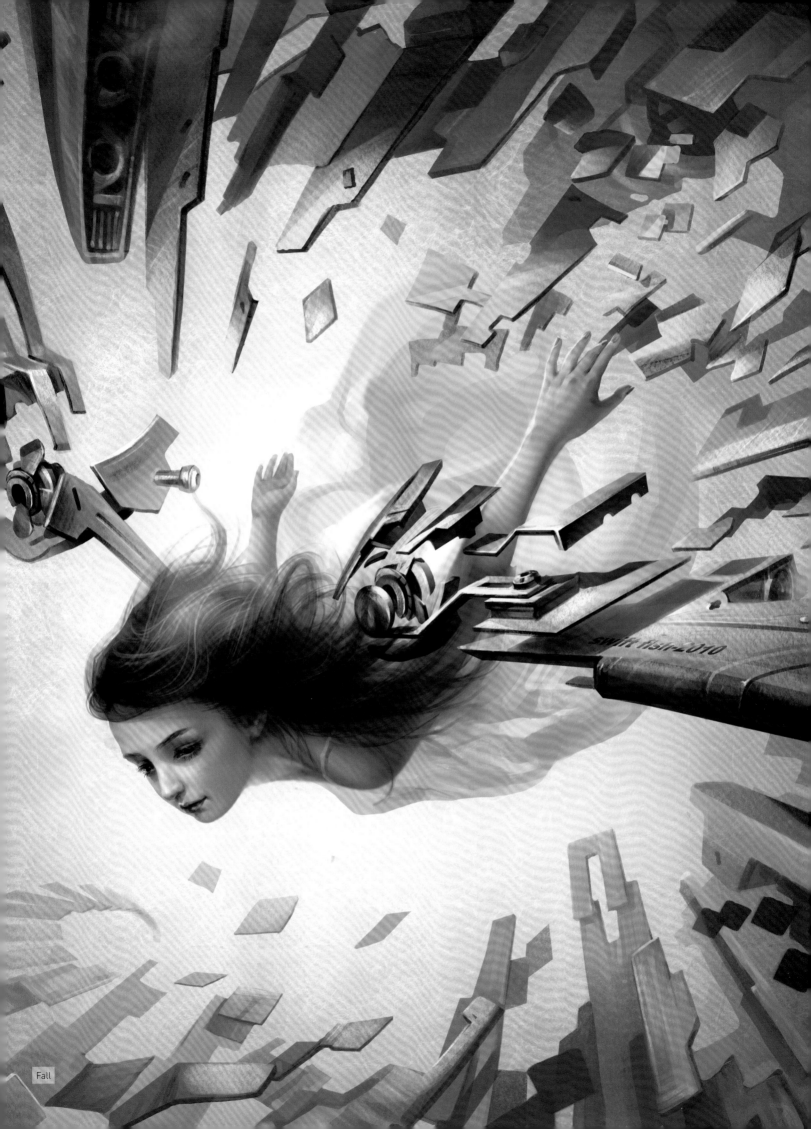

Fall

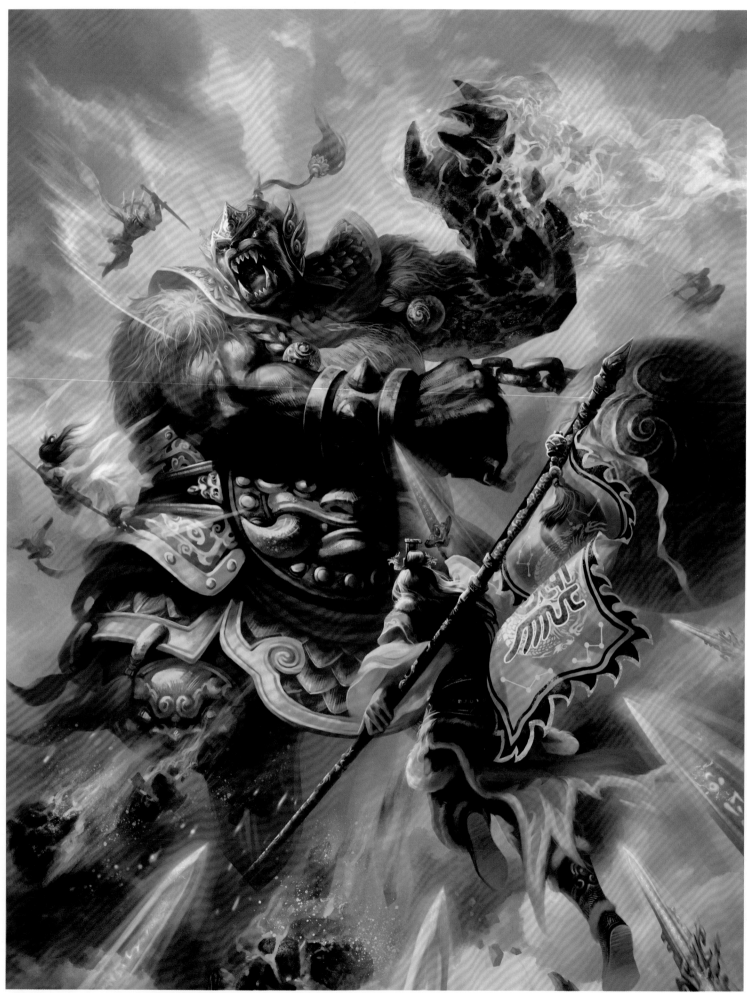
Danchuling

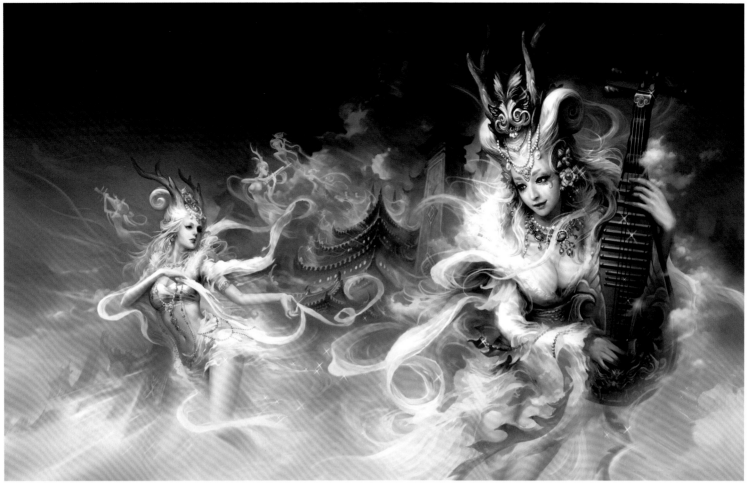

Goddess of Rain

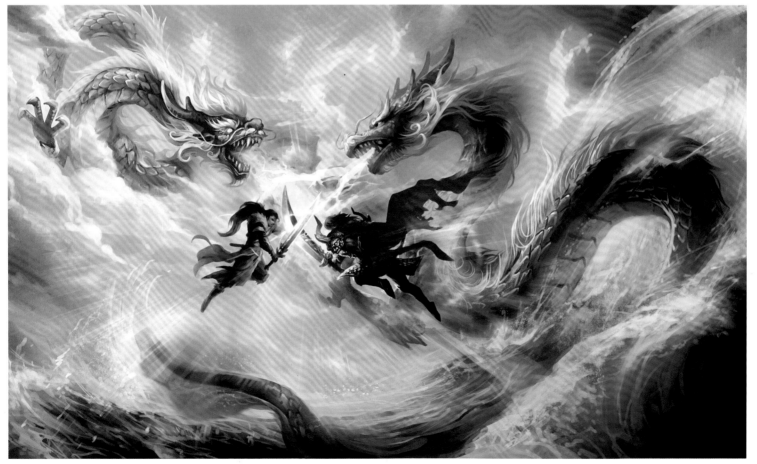

A Duel between Two Dragons

Geng Fei

耿 飞

G e n g F e i

Screen Name: Fei
Blog: blog.sina.com.cn/u/2889249001
Profession: Game concept artist

PROFILE

Having entered the game industry in 2007, Geng Fei is specialized in 2D creative work, including UI, scene and character design. Between 2008 and 2012, he served Zhuozhi Shidai Technology, Kongzhong Xinshi Information & Technology and Huanlong Hudong Technology as project art director for games.

INTERVIEW

How long have you been in this industry? What has impressed you most?

I have been in this industry for six years. What has impressed me most is the difference between game art and pure art. Compared with pure art, game art is more associated with features of commercial art. The key to success is to meet market demand within a short time. The balance between time and efficiency is the priority.

What do you think is the most important element in the creative process? What's essential for enhancing creativity?

The most important thing is accumulation of fundamental knowledge. Art can be compared with a towering building, and fundamental knowledge is the base. The final height of the building is determined by how firm the base is. A seamless integration of multi-discipline knowledge and basic painting skills are most important for enhancing creativity.

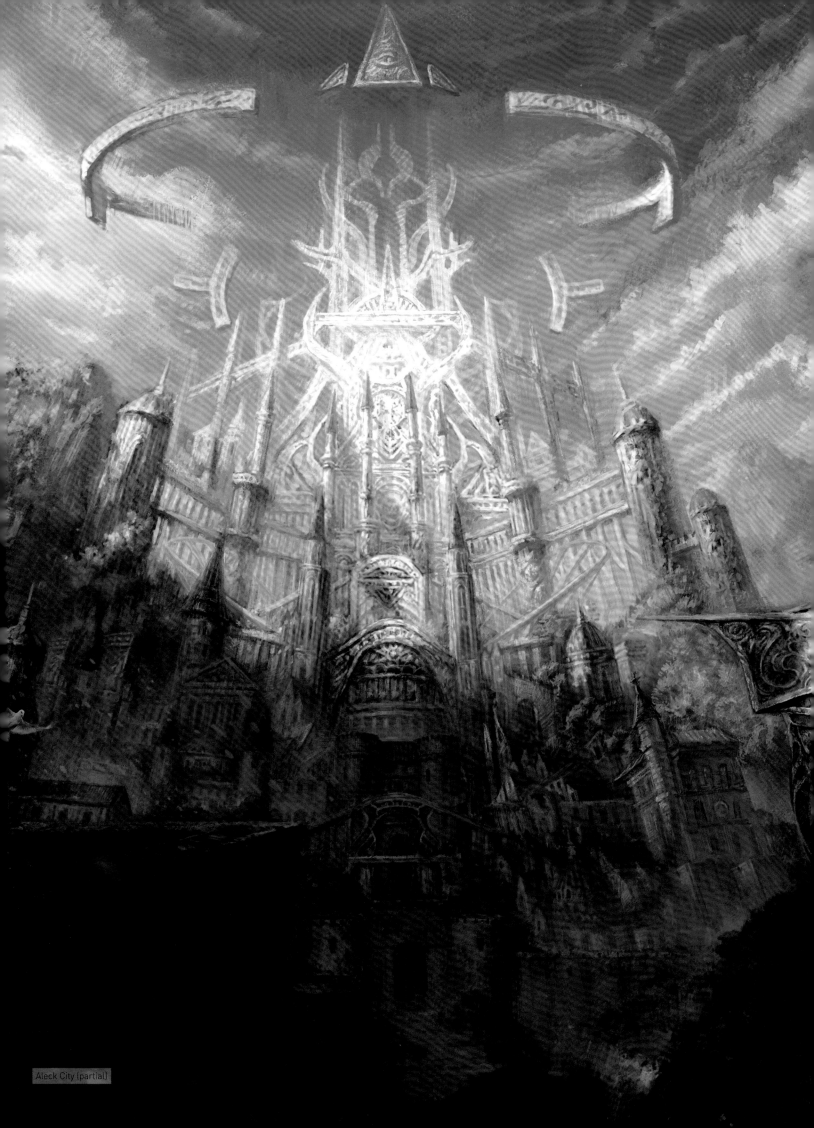

Aleck City (partial)

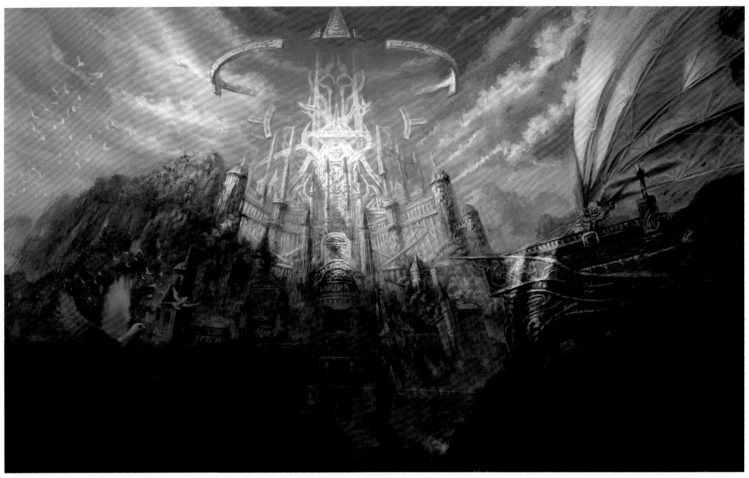

Aleck City

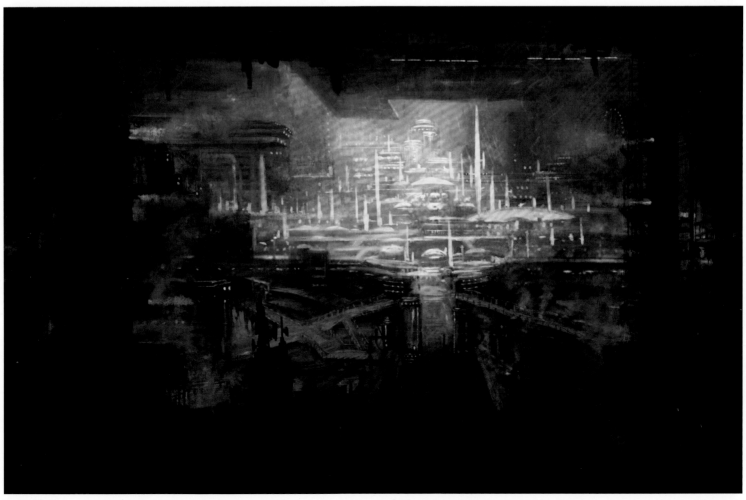

Future City

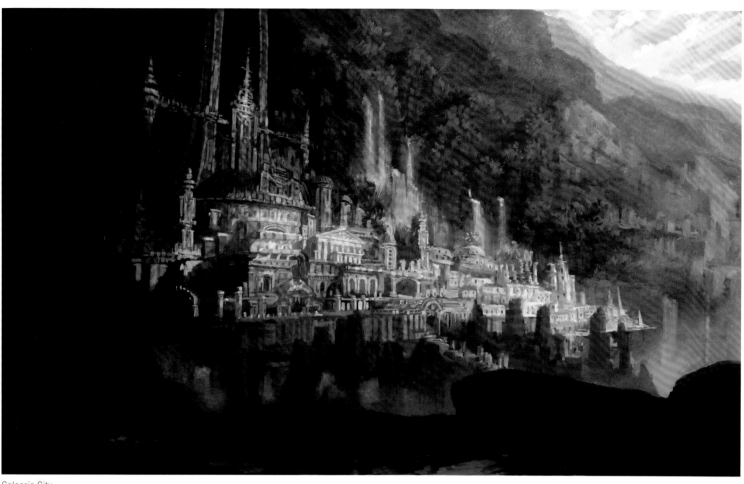

Coloccia City

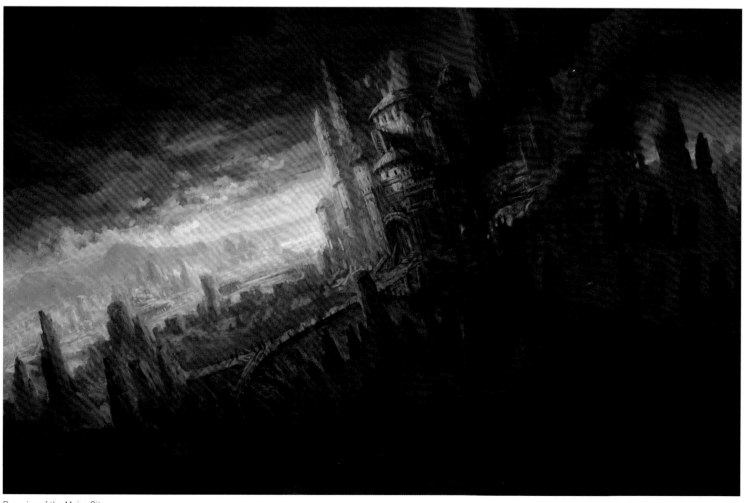

Remains of the Major City

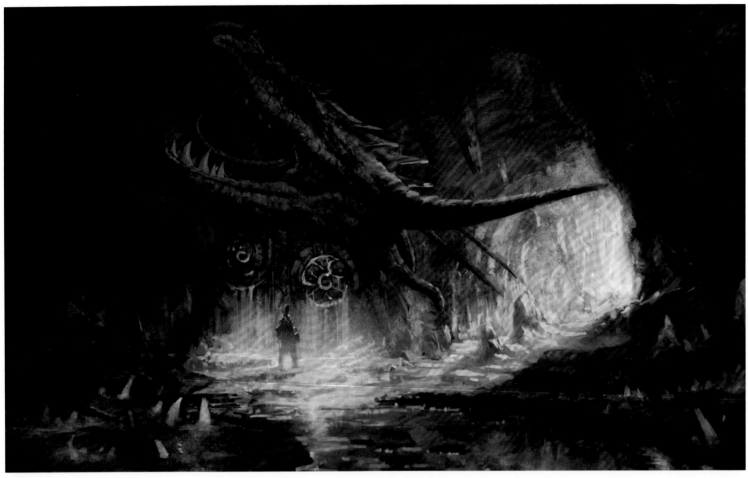

Cave

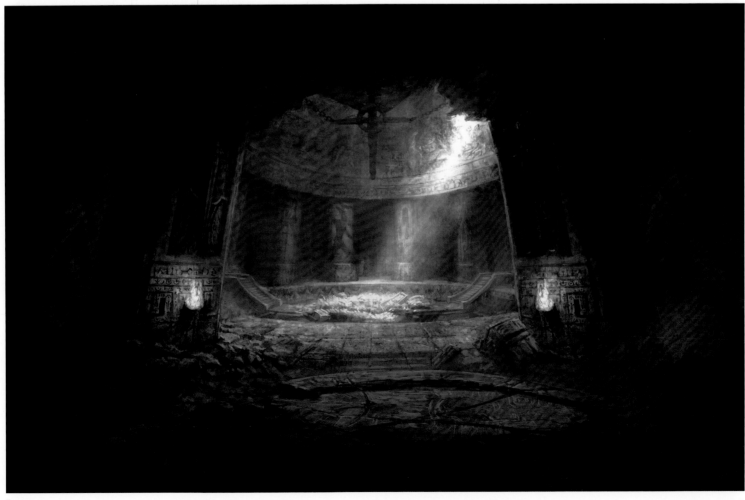

Treasure

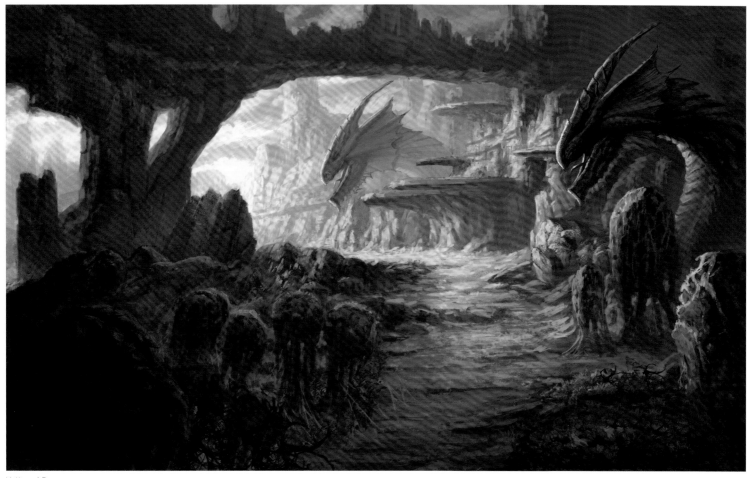

Valley of Dragons

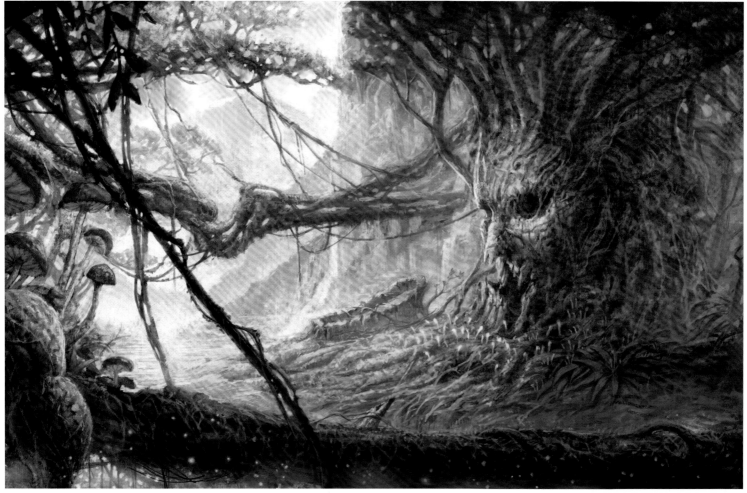

Valley

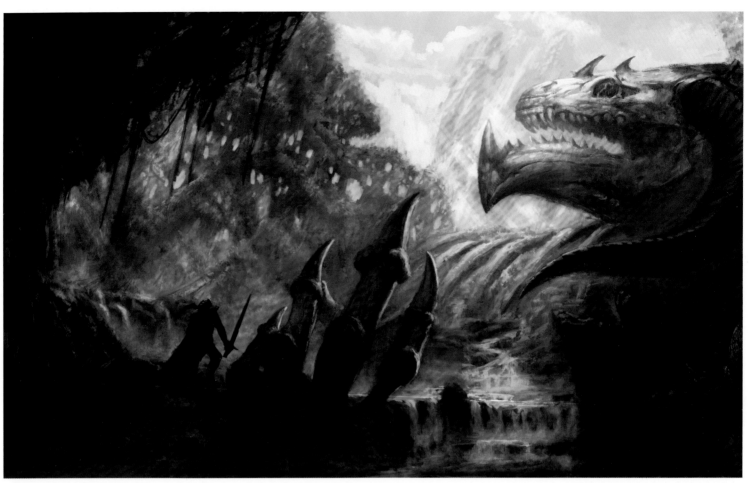

Relics

Zaku Tribe

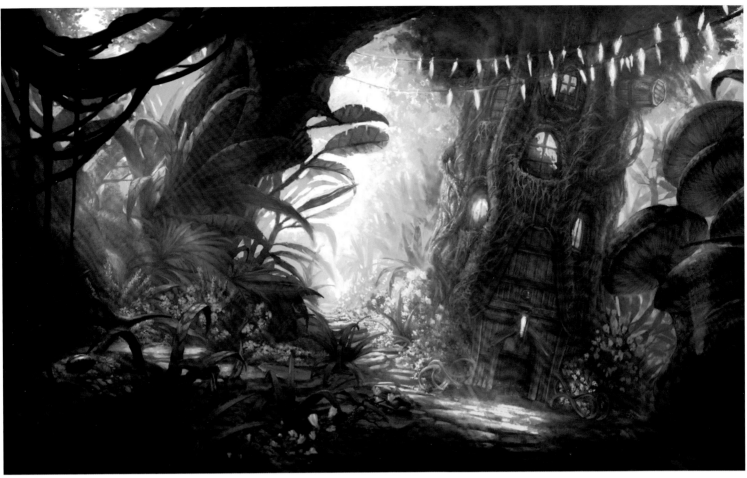
Tree House

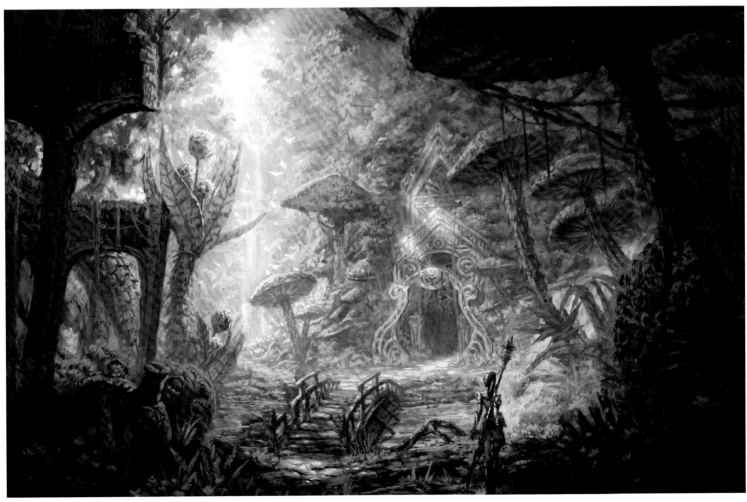
Help Island ©ZQGAMES

Sun Na

Screen Name: Zhiji ZOO
Blog: alicedie.cghub.com
Profession: Commercial illustrator

PROFILE

Sun Na graduated from the Industrial Design Department of School of Art and Design, Yanshan University, and currently works as game artist. Some of her work has been included in "EXOTIQUE 3," "EXOTIQUE 5" and "EXPOSÉ 6," and has been used for promotional illustrations for projects such as "Perfect World International," "Forsaken World," "Zhu Xian 2," "Xuanyuan Legend," and "Genghis Khan 2," among others.

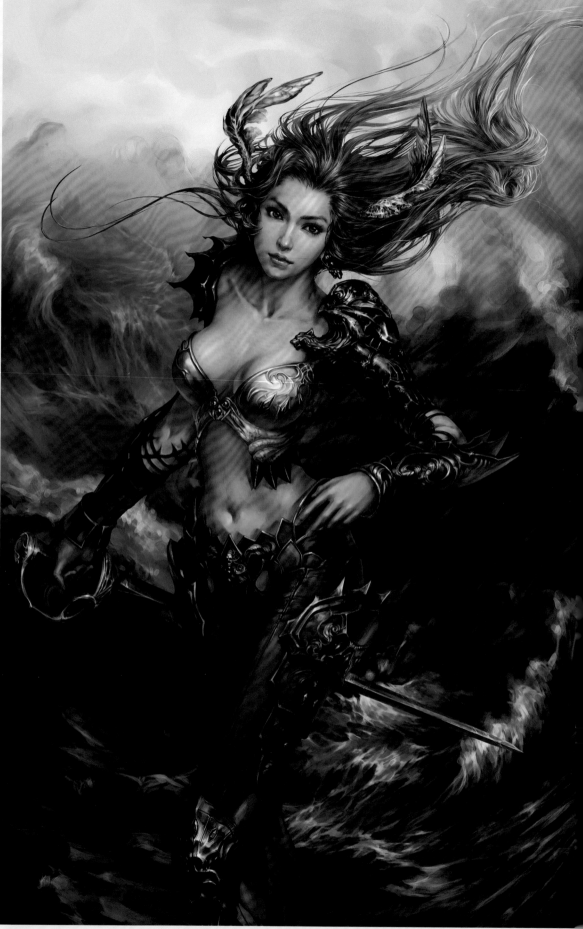

Perfect World

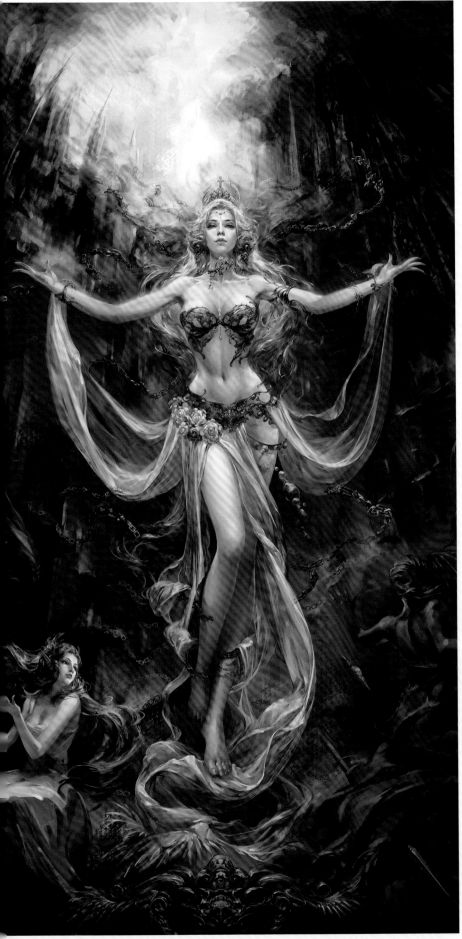

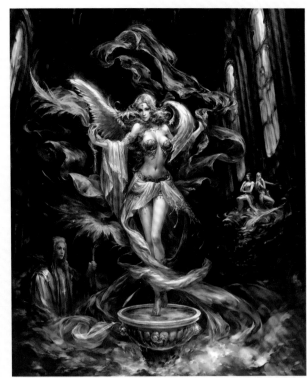

Forsaken World—Cilia

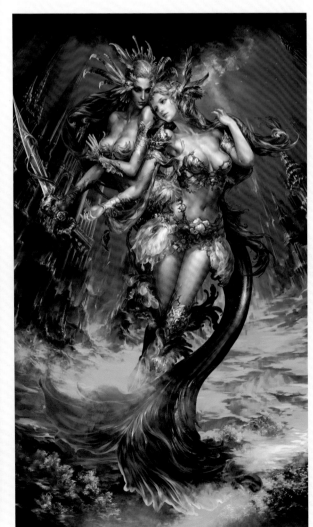

Forsaken World—Ascension

Perfect World International—Tale of Mermaids

Shi Yao

Screen Name: N/A
Blog: blog.sina.com.cn/shiyao219
Profession: Freelance artist

PROFILE

Shi Yao first entered the CG art industry in 2006 and the game industry in 2008. He previously worked as concept art team leader at companies such as Gamebar. He currently studies in San Francisco in the US while participating in film and animation projects.

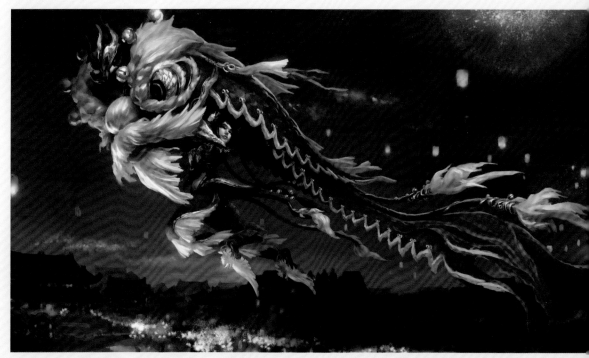

Lion Dance

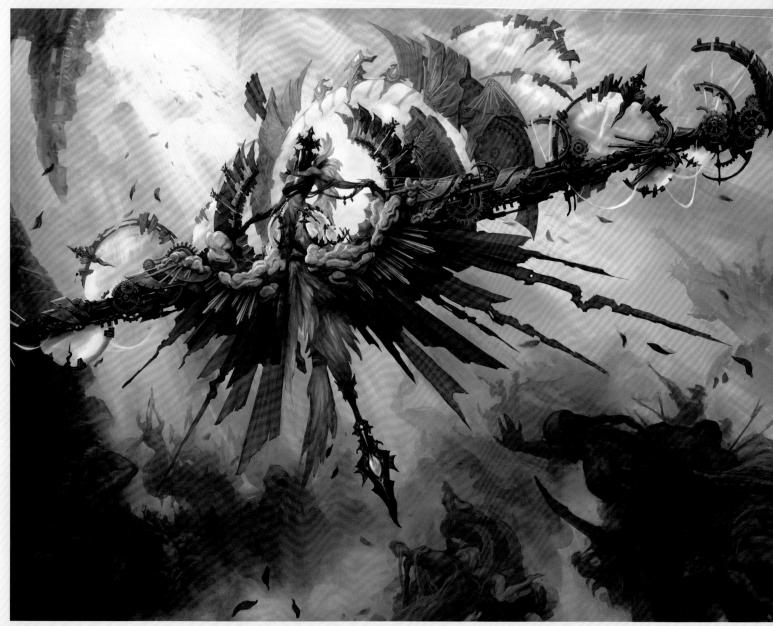

Goddess of Time

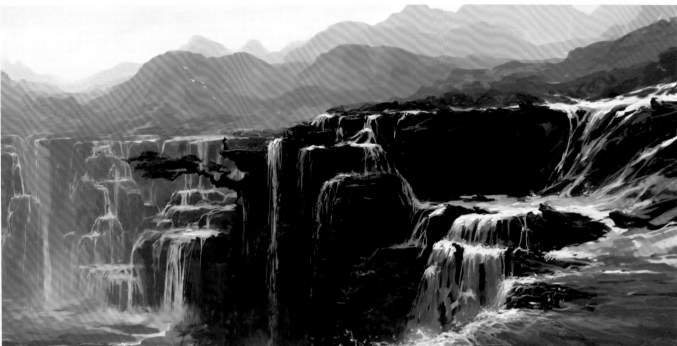

Countless Cascades

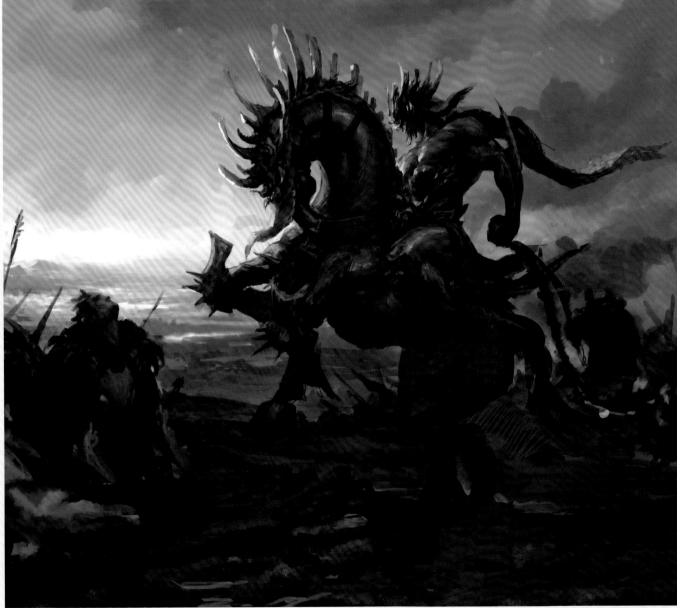

Thrill! The Mortal

Chen Sa

Screen Name: Speedy K
Blog: c-dash.blog.sohu.com
Profession: Project art director for games, card painter

PROFILE

After graduation from the Department of Environmental Art Design at Academy of Arts and Design, Tsinghua University, Chen Sa began her career of next-gen game development and management. She has participated in the game development for *World of Kung Fu*, *Loong* and *Painted Skin II*.

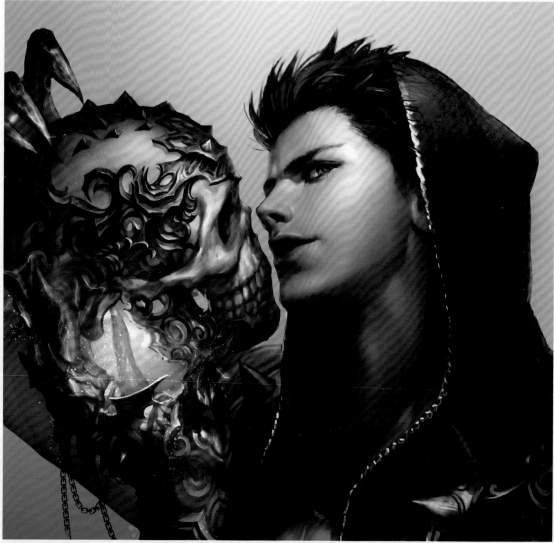

Halloween

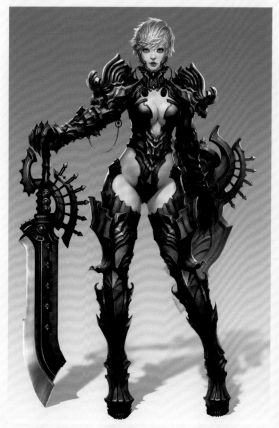

Character Design—Female Warrior

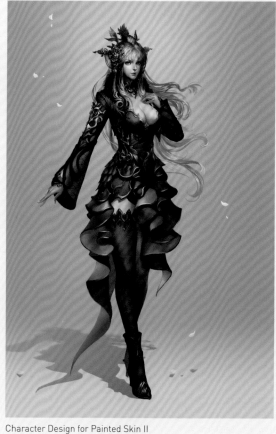

Character Design for Painted Skin II

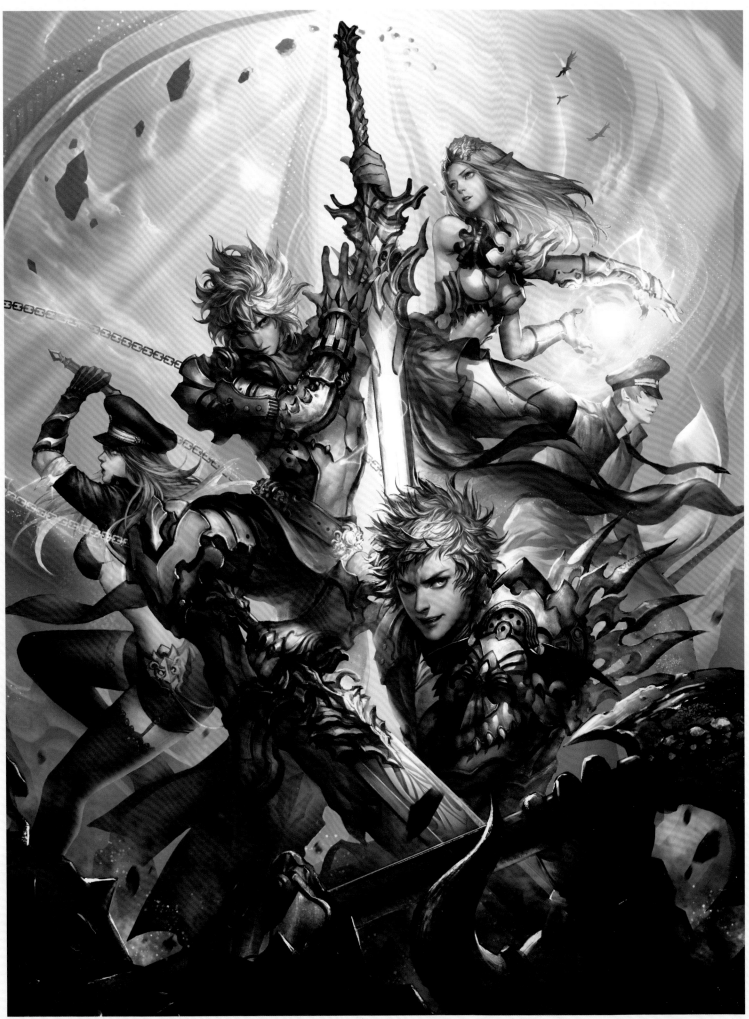

Promotional Illustration for Kingdom of Heaven

Han Jianhao

Screen Name: HJH
Blog: hanjianhao.deviantart.com
Profession: Game artist

PROFILE

Han Jianhao graduated from the Oil Painting Department of Central China Normal University in July 2003, and began game concept design in November 2004. He previously served Huayi Software as concept artist, Kingsoft as concept artist and art director, Xingyu Longying as art director, and Renren as promotional illustration artist.

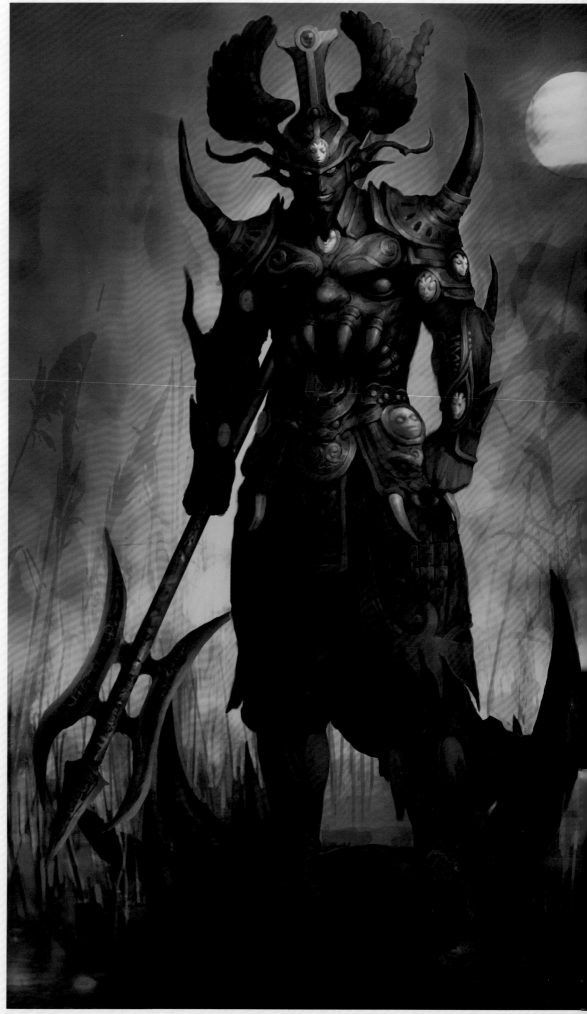

The Three Kingdoms—Lyu Bu

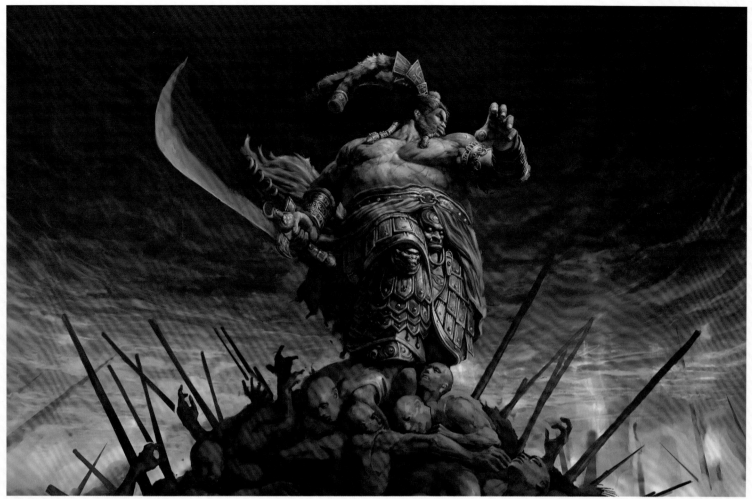

The Three Kingdoms—Xu Zhu

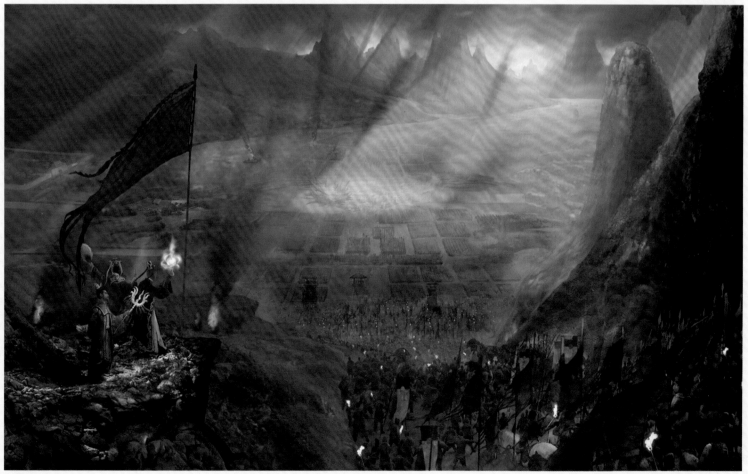

National War

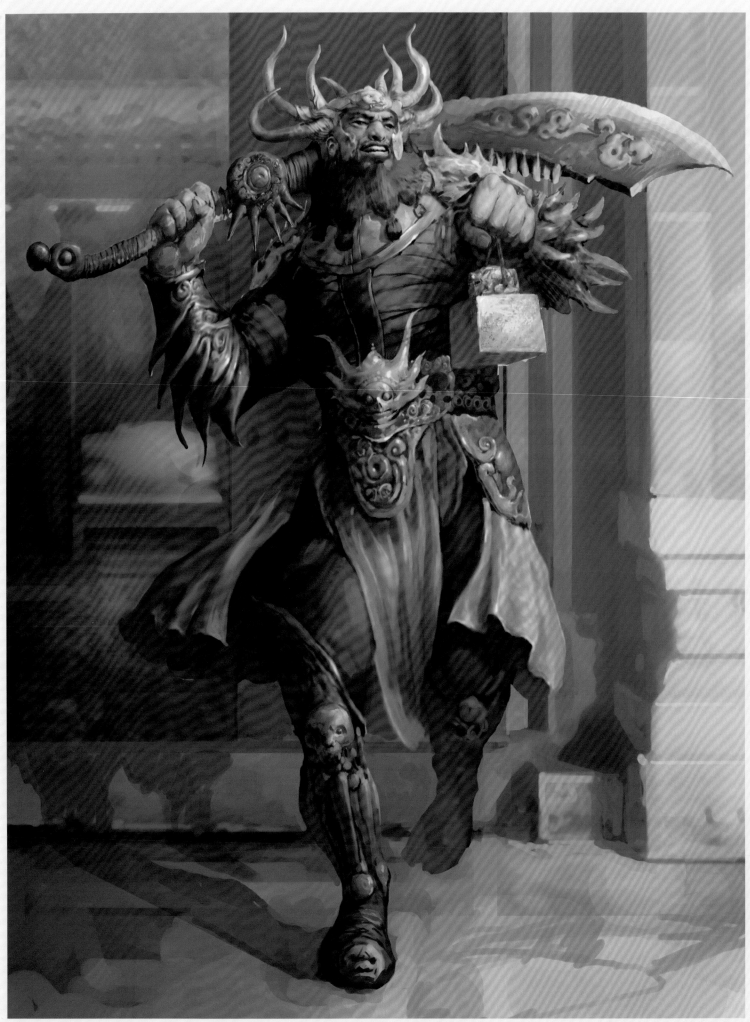

The Three Kingdoms—Dong Zhuo

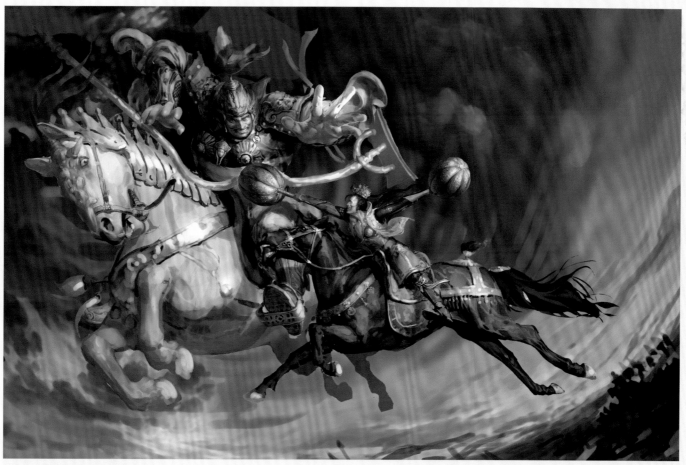

Li Yuanba Fights with Yuwen Chengdu

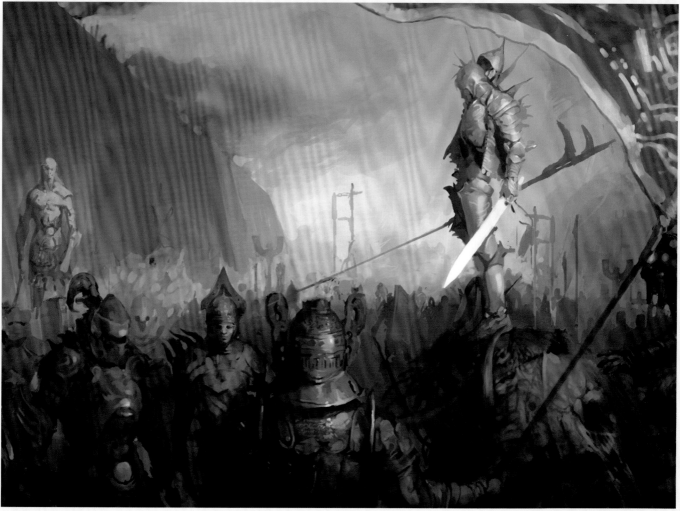

Mobilization Meeting

Zhang Su

Screen Name: rogner5th
Blog: rogner5th.deviantart.com
Profession: Concept Artist for game characters

PROFILE

Zhang Su has loved animation and manga since childhood. She first became engaged in concept art design for games in 2005, and previously worked for Kingsoft as concept artist for game characters and Perfect World as prophase CG concept designer for characters.

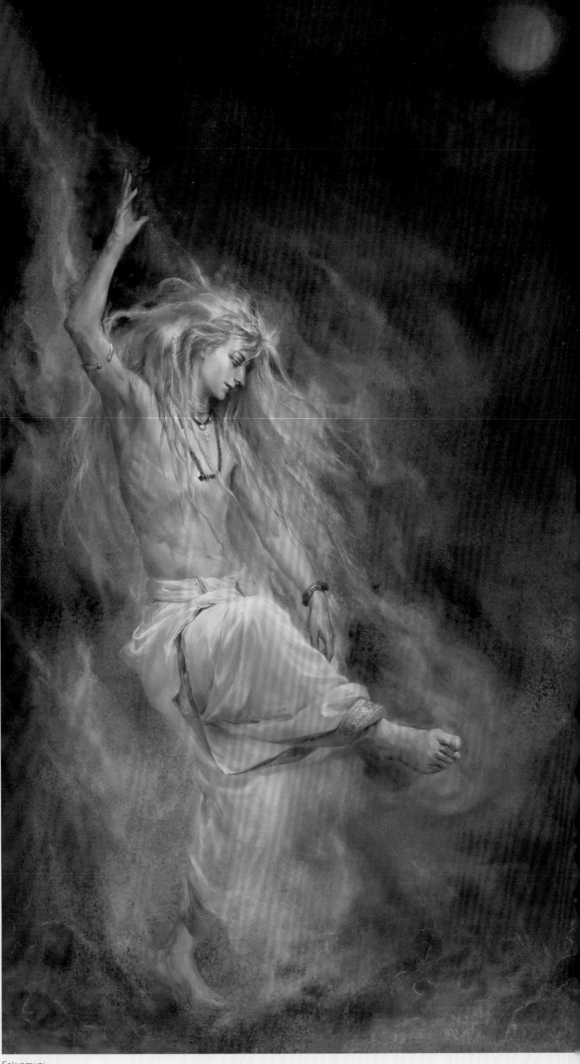

Sakyamuni

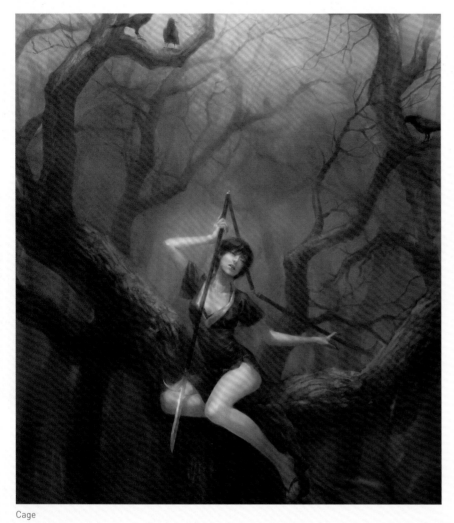

Cage

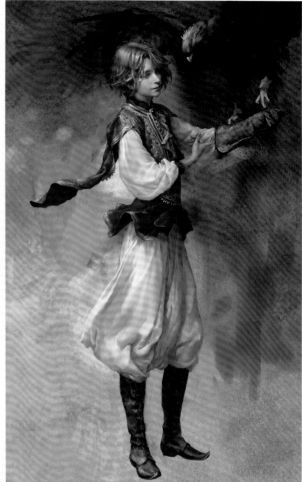

The Stratocracy of Altair

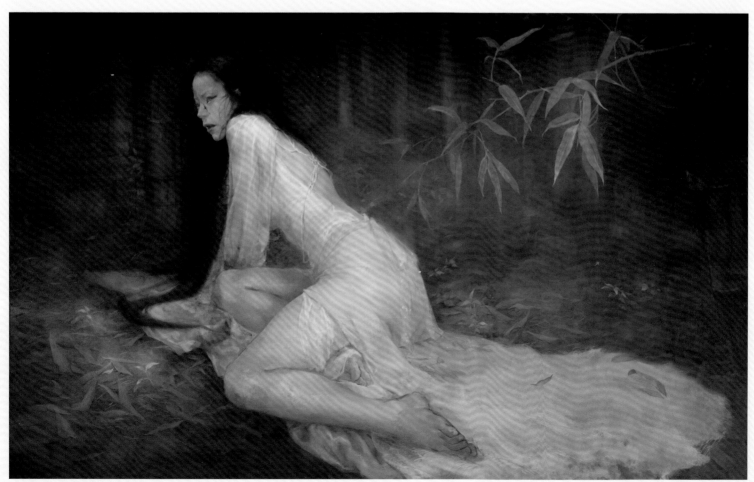

To My Heretical Muses

Huang Ruiqiang

Screen Name: EkineHuang
Blog: weibo.com/ekinehuang
Profession: Game concept artist

PROFILE

Huang Ruiqiang is passionate about painting and fascinated with game concept design and promotional illustration. He graduated as a film and animation major from Wuhan University of Technology in 2009, following which he became a game concept artist. He has previously worked at NetDragon Websoft, Wuhan Tii Game and currently works as concept artist at Sohu ChangYou.

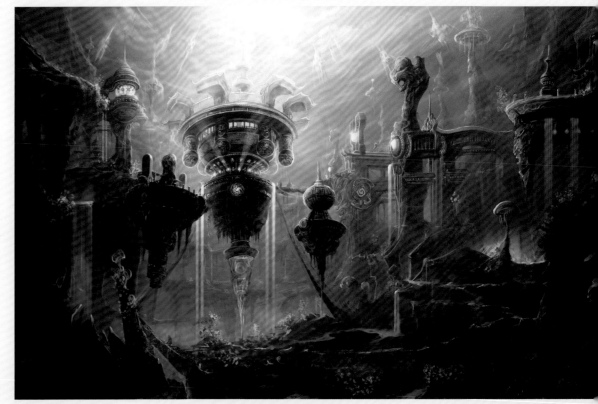

Lingyan Platform

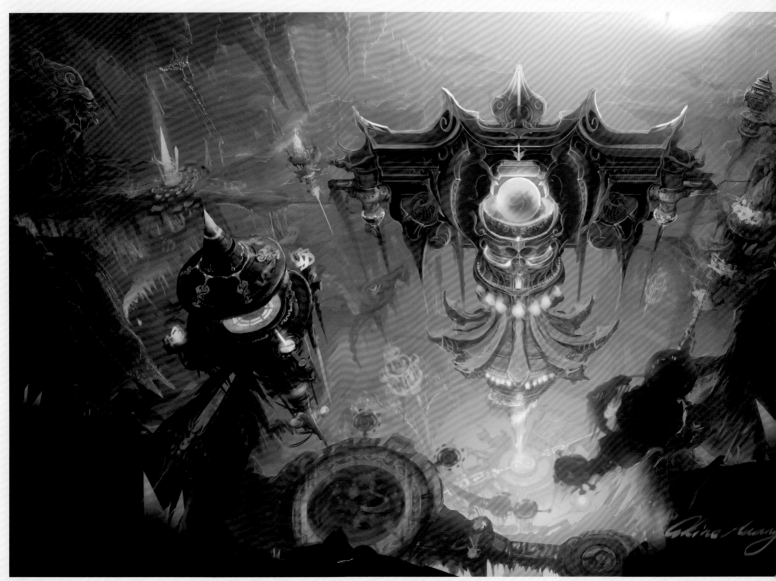

Fantasy World

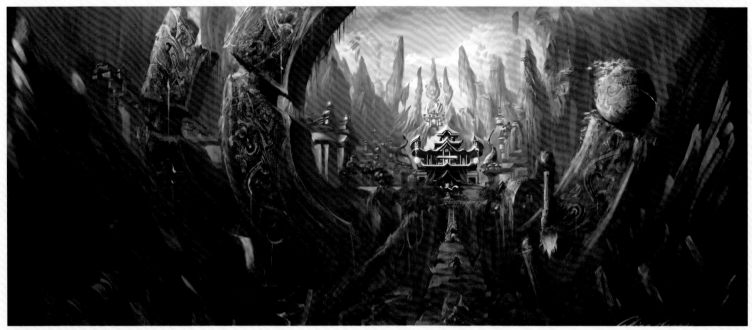

City of Immortal Spirits (unfinished)

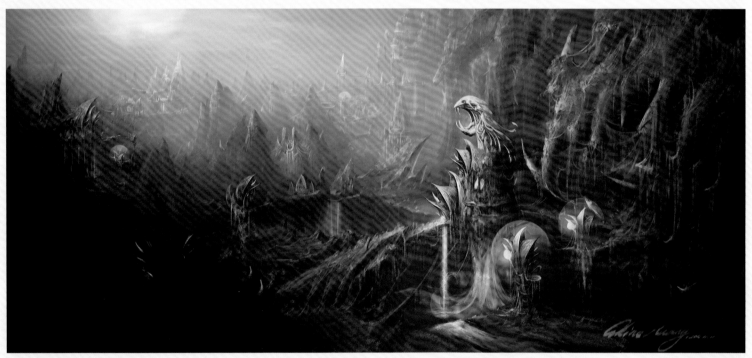

Nirvana

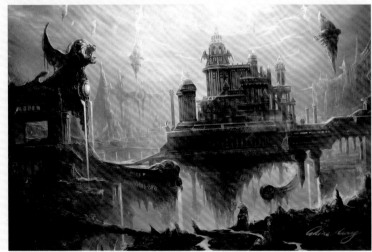

City of Griffin

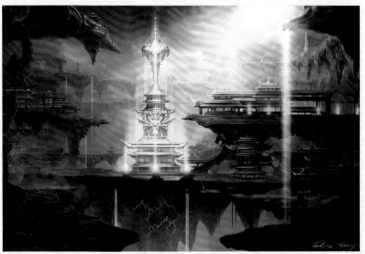

Capital of Black Eagle

Liu Chang

Screen Name: Lsltmr
Blog: lsltmr.lofter.com
Profession: Film art professional

PROFILE

Liu Chang was admitted to Beijing Film Academy in 2009. She participated in the digital painting work for the animation *Lee's Adventure* in 2011, and early concept design and rendering for *Mulan* and *Gone with the Bullets* in 2012.

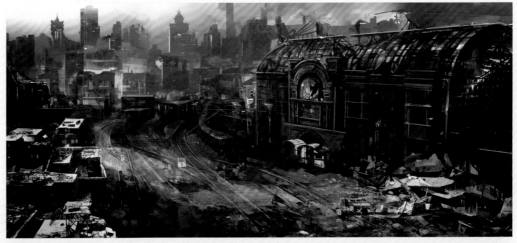

Rail Station after War

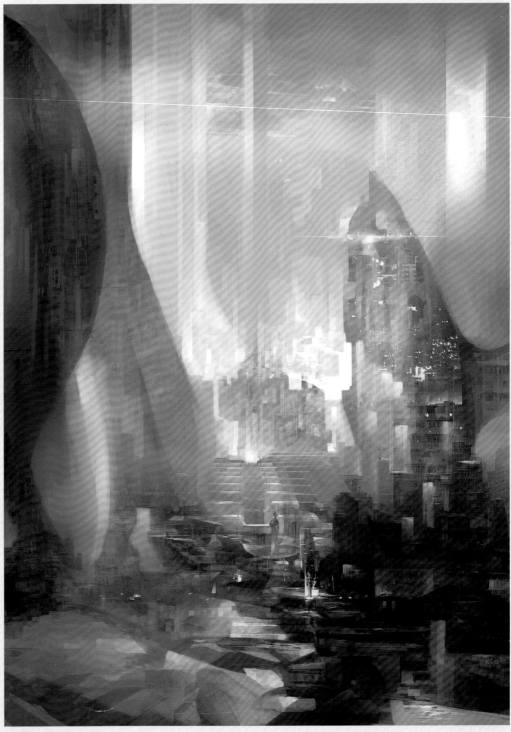

White Curling City

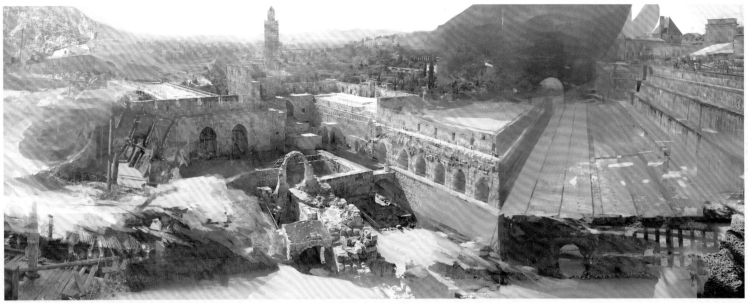

Attacking the City on Sunken Ships

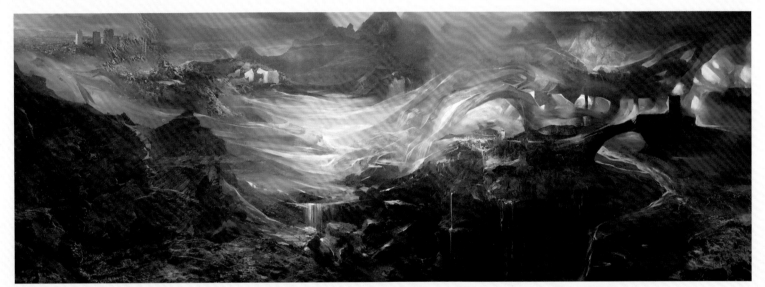

Clouds at the Bottom of Water

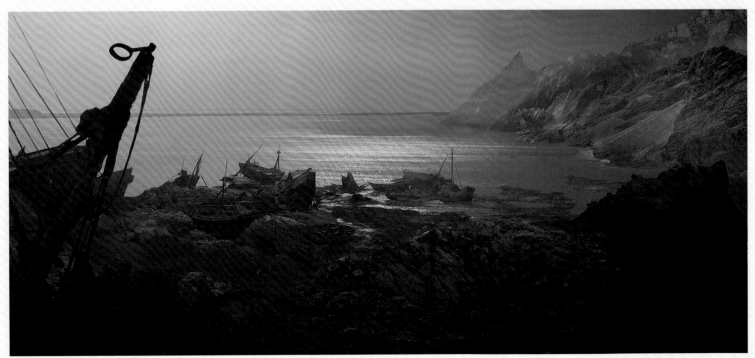

Shipwrecked Fleet

185

Zhang Weiyi

Screen Name: ZWY
Blog: weibo.com/u/2734409595
Profession: Game producer

PROFILE

With eight years' experience in the game industry, Zhang Weiyi served as leader of the concept art team, deputy director of the graphics department, project art director, and project manager at Dalian Kingsoft. He is currently engaged in mobile game production and game art outsourcing.

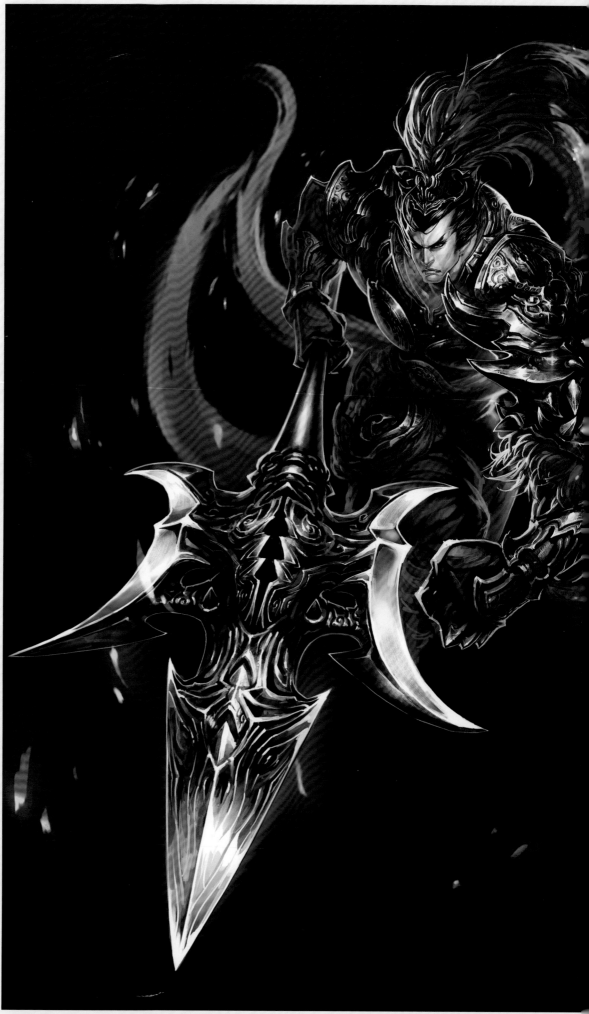

Lyu Bu

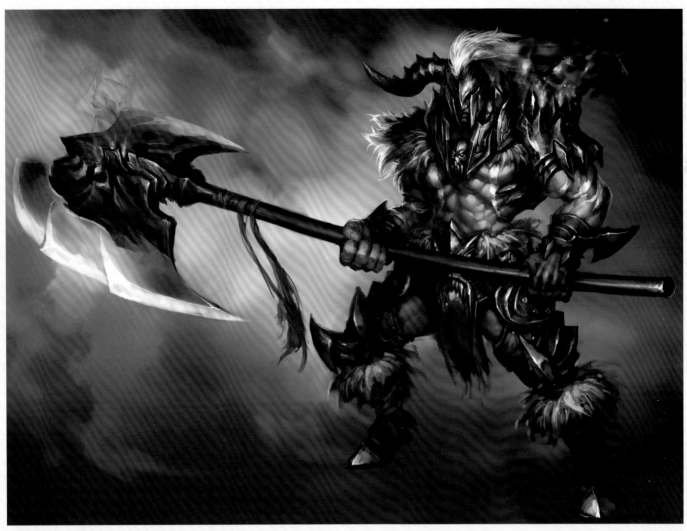

Berserker

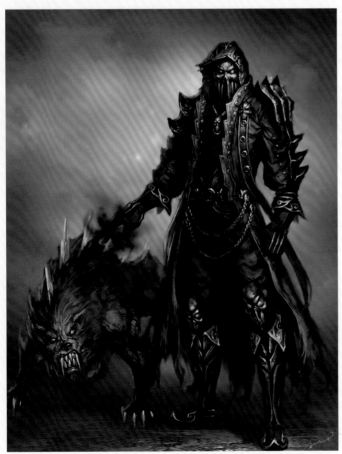

Sorcerer

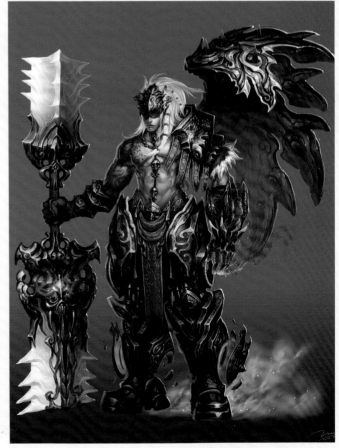

Lonely Warrior

Meng Zi

Screen Name: Baishu Shushu
Blog: weibo.com/u/2093858400
Profession: Student

PROFILE

Meng Zi started learning traditional painting in 2009 and explored CG painting techniques out of interest. She was admitted to the Academy of Arts & Design, Tsinghua University in 2011, and has participated in many fan illustration and portfolio production projects.

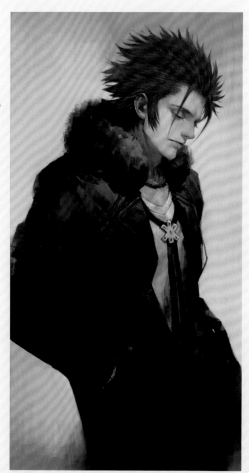

Fan Work for K

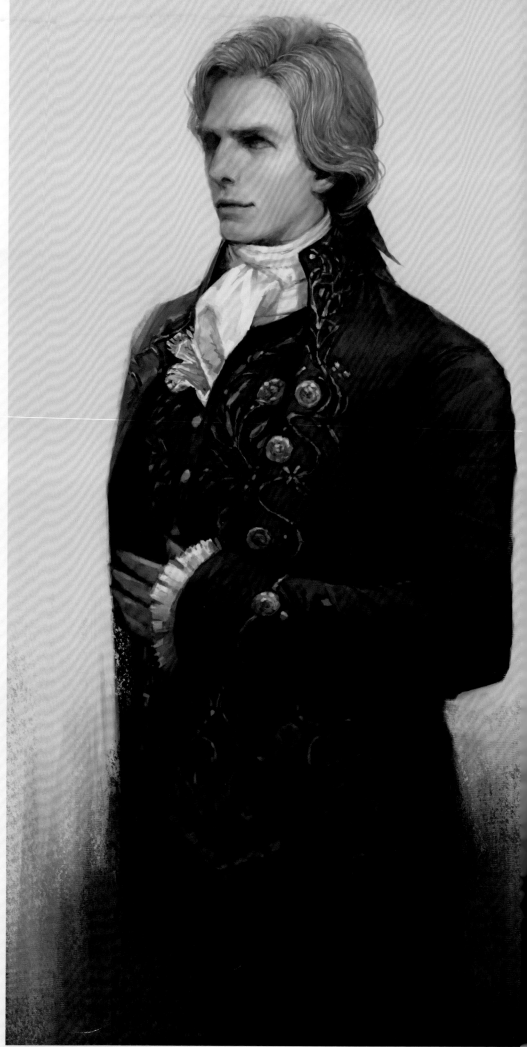

Fan Work for *Interview with the Vampire*

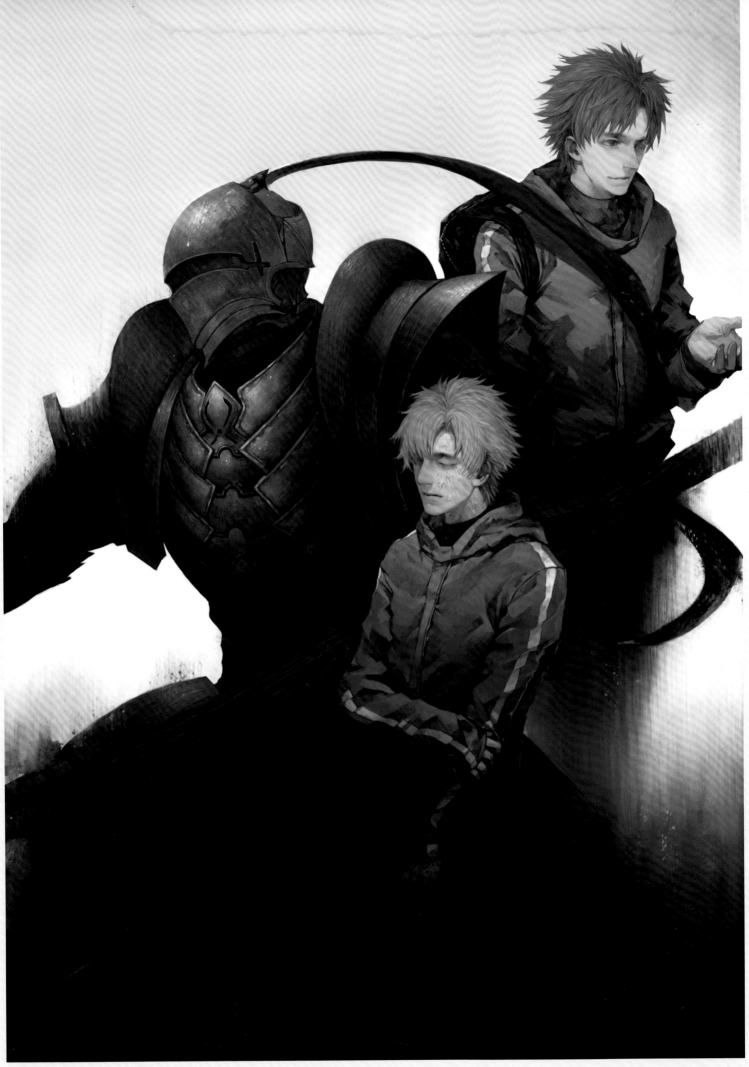

Fan Work for F/Z

Huoshen CG Workshop

The Most Competent Digital Art Training Center

Founded in 1999 as a digital art community, Huoshen witnessed the birth and blossoming of the CG industry in China. In 2006, Huoshen CG Workshop was established in Beijing as a digital art institute.

Rooted in professional digital art training, the institute's professional curriculum is staffed by some of the best teachers in the industry. Due to its high standards, the institute has won praise from students and professionals alike and produced many outstanding new artists in the game and animation industries.

Huoshen CG Workshop cooperates closely with leading artists from various sectors. The studio works hard to provide a free, open and unrestrained creative environment for artists, who are actively encouraged to engage in and pursue their own individual visions and passions and grow through a process of interaction and learning. Huoshen CG Workshop provides a platform to share and exchange experiences and ideas.

| CG Illustration | Game Concept Art | Comic Storyboard | Hand Painting Fundamentals | Online Courses |

Tel: 400-6175-291 | **Email:** luocan@huoshen.com

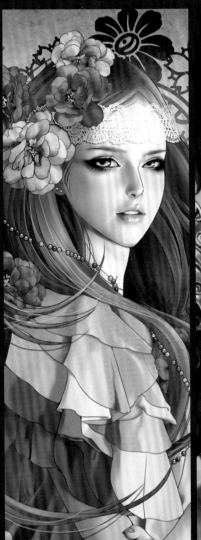
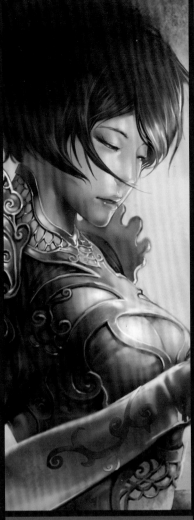
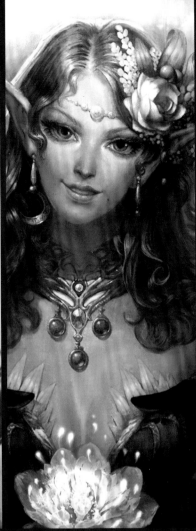
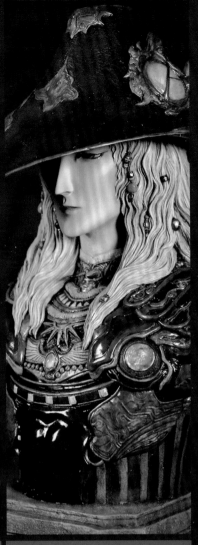

Illustration Courses

CG Illustration: Daily Workshop
Charm of Painting: Aesthetic Illustration Weekend Workshop
Passion for Painting: Watercolor-styled Illustration Weekend Workshop
2D Cute Painting: Illustration Weekend Workshop
CG Enlightenment: Online Workshop

Hand Painting Courses

Hand Painting Storm: Studio Workshop
Hand Painting Storm: Online Workshop

Game Courses

Game Design: Daily Workshop
Game Scene: Weekend Workshop
Game Character Design: Weekend Workshop
Game Scene: Online Workshop

Other Courses

Color Comic: Daily Workshop
Soul of Comic: Weekend Workshop
Creative Painting: Weekend Workshop
Dream Maker: Weekend Workshop
Soul of the Fairy: GK Workshop

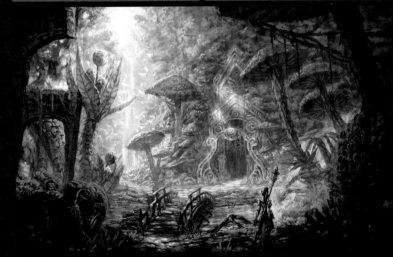
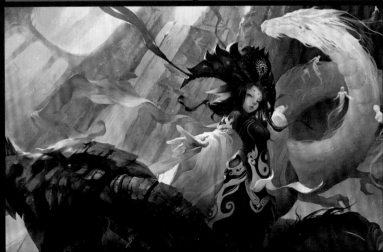

CG Galaxy Ⅱ : Top Chinese CG Artists and Their Works

Author: Huoshen CG Workshop
Commissioning Editors: Guo Guang, Mang Yu, Yvonne Zhao, Zhao Yiping
English Editors: Jenny Qiu, Vera Pan
Translator: Coral Yee
Copy Editor: Lee Perkins
Book Designer: Yang Youbin

©2013 by China Youth Press, Roaring Lion Media Co., Ltd. and CYP International Ltd. China Youth Press, Roaring Lion Media Co., Ltd. and CYP International Ltd. have all rights which have been granted to CYP International Ltd. to publish and distribute the English edition globally.

First published in the United Kingdom in 2013 by CYPI PRESS

Add: 79 College Road, Harrow Middlesex, HA1 1BD, UK
Tel: +44(0)20 3178 7279
Fax: +44(0)19 2345 0465
E-mail: sales@cypi.net editor@cypi.net
Website: www.cypi.co.uk
ISBN: 978-1-908175-25-0

Printed in China